IMAGES
of America

MARI SANDOZ'S
NATIVE NEBRASKA

THE PLAINS INDIAN COUNTRY

List of Sandoz's Works Cited

The Battle of the Little Bighorn. Philadelphia: J.B.Lippincott, 1966.

The Beaver Men: Spearheads of Empire. New York: Hastings House, 1964.

"The Broken Promise," *Omaha Daily News*, Junior Writers' Page 26, April 1908.

The Buffalo Hunters: The Story of the Hide Men. New York: Hastings House, 1954.

"The Buffalo Spring Cave." *Legends and Tales of the Old West*. Ed. S. Omar Barker. New York: Doubleday, 1962. 97–98.

Capital City. Boston: Little, Brown, 1939.

The Cattlemen: From the Rio Grande Across the Far Marias. New York: Hastings House, 1958.

Cheyenne Autumn. New York: McGraw Hill, 1953.

"The Christmas of the Phonograph Records." 73–87 of *Sandhill Sundays*. See latter listing.

Crazy Horse: The Strange Man of the Oglalas. New York: Alfred A. Knopf, 1942.

"The Far Looker." 223–224 of *Hostiles and Friendlies*. See latter listing.

"Fly Speck Billy's Cave." *Legends and Tales of the Old West*. Ed. S. Omar Barker. New York: Doubleday, 1962. 37–39.

The Foal of Heaven. Comp. Caroline Sandoz Pifer. Boulder, Colorado: Cottonwood Press, 1993.

The Great Council. Comp. Caroline Sandoz Pifer. Rushville, NE: News/Star Press, 1970.

Hostiles and Friendlies: Selected Shorter Writings of Mari Sandoz. Ed. Virginia Faulkner. Lincoln: U. of Nebraska Press, 1959.

The Horsecatcher. Philadelphia: Westminster Press, 1957.

"Introduction." *A Pictographic History of the Oglala Sioux*. By Amos Bad Heart Bull and Helen Blish. Lincoln: U. of Nebraska Press, 1966.

Love Song to the Plains. New York: Harper & Row, 1961.

"Martha of the Yellow Braids." 105–113 of *Sandhill Sundays*. See latter listing.

Miss Morissa: Doctor of the Gold Trail. New York: McGraw-Hill, 1955.

"The Neighbor." 89–103 of *Sandhill Sundays*. See latter listing.

Old Jules. Boston: Little, Brown, 1935.

Old Jules Country: A Selection from "Old Jules" and Thirty Years of Writing since the Book Was Published. New York: Hastings House, 1965.

"*Ossie and the Sea Monster*" and Other Stories. Comp. Caroline Sandoz Pifer. Rushville, NE: News/Star Press, 1974.

"Outpost in New York." 139–152 of *Sandhill Sundays*. See latter listing.

"River Polak." 164–177 of *Hostiles and Friendlies*. See latter listing.

Sandhill Sundays and Other Recollections. Ed. Virginia Faulkner. Lincoln: U. of Nebraska Press, 1970.

Slogum House. Boston: Little, Brown, 1937.

Son of the Gamblin' Man: The Youth of an Artist. New York: Clarkson N. Potter, 1960.

The Story Catcher. Philadelphia: Westminster Press, 1963.

The Tom-Walker. New York: Dial Press, 1947.

These Were the Sioux. New York: Hastings House, 1961.

"There Were Two Sitting Bulls," reprinted as "The Lost Sitting Bull." 87–107 of *Hostiles and Friendlies*. See latter listing.

"*Victorie*" and Other Stories. Comp. Caroline Sandoz Pifer. Boulder, Colorado: Cottonwood Press, 1986.

"The Vine." 117–125 of *Hostiles and Friendlies*. See latter listing.

Winter Thunder. Philadelphia: Westminster Press, 1954.

List of Editions of Sandoz's Letters Cited

Letters of Mari Sandoz. Ed. Helen W. Stauffer. Lincoln: U. of Nebraska Press, 1992.

Gordon Journal Letters of Mari Sandoz. (Letters appearing in issues of the newspaper from 1967–1971.) Ed. Caroline Sandoz Pifer. Boulder, CO: Cottonwood Press, Parts 1 (1991) and 2 (1992).

The Making of an Author: Mari Sandoz's Letters and Mementoes. Volumes 1,2, 3, and 4. Ed. Caroline Sandoz Pifer. Volume 1: Gordon, NE: *Gordon Journal*, 1972. Volumes 2 & 3: Boulder, CO: Cottonwood Press, 1982 & 1984; Volume 4: Gordon, NE: Ad Pad, 1997.

IMAGES
of America

MARI SANDOZ'S
NATIVE NEBRASKA
THE PLAINS INDIAN COUNTRY

LaVerne Harrell Clark

ARCADIA
PUBLISHING

Published by Arcadia Publishing
Charleston, South Carolina

Library of Congress Catalog Card Number: 0010749

For all general information contact Arcadia Publishing at:
Telephone 843-853-2070
Fax 843-853-0044
E-mail sales@arcadiapublishing.com
For customer service and orders:
Toll-Free 1-888-313-2665

Visit us on the Internet at www.arcadiapublishing.com

DEDICATION

In memory of Mother and Daddy, and for Dolly,
Eleanor James, and L.D.—for believing in me.

Pictured on the cover (far right, first row) in this 1851 photo by the Heyn Company of Omaha, is the revered Oglala peace chief Conquering Bear and other famous Sioux. Others in the photo are Little Wound and Jack Red Cloud, photographed when they participated in the peace treaty occurring just three years before Conquering Bear's death. As Sandoz frequently points out, his unwarranted killing led the Sioux to go on the warpath. (Smithsonian Institution, Neg. #57,076; Courtesy South Dakota State Historical Society—State Archives.)

CONTENTS

ACKNOWLEDGMENTS

My deepest thanks to all who contributed to my text and collection of photographs, especially to Father Peter J. Powell, Prof. Richard Loosbrock, and both the late Marie Surber Hare and Jules A. Sandoz Jr. for aiding in ways beyond the photographs in which they appear. Special gratitude to Caroline Sandoz Pifer, who as her sister's former literary executrix as well as biographer and editor, has shared her knowledge and furnished material assistance over the years. From the day when I first contacted her 30 years ago, following the advice of our mutual friend, Marguerite Young, I recognized how wise Mari Sandoz had been in selecting Caroline to represent her. My thanks, too, to Cheryl Wilson Wilkinson for permission to reproduce the fine painting she did of the Sandoz River Place, and for sharing recollections about her Sandoz friends. Also thanks to Roz Hopkins and her associates at Arcadia for seeing potential in this project and lending creative counsel, and to Carrie Radabaugh for help with its final stages.

Special thanks to the following institutions and their staff members for assistance and permission to use the photographs and sketches credited to them in this work: the Mari Sandoz Heritage Society, Chadron State College and friends and members on the Board there—including Donald Green, Chair; Prof. Michael Cartwright, former Dean of Liberal Arts; and Lloy Chamberlin, former curator of the Sandoz Room of the former Chamberlin Furniture Store in Gordon; the late Reva Evans and *The Gordon Journal*; John C. Powell and the Edward E. Ayer Collection, Newberry Library (Chicago); Gail De Buse, director of the Museum of Fur Trade, Chadron; the American Museum of Natural History and Mark Katzman, sr. clerk; Kay Lhotak and Della Hendrick, Robert Henri Museum, Cozad, Nebraska; the Museum of the Little Bighorn Battlefield National Monument and Kitty B. Deernose, curator; Mrs. Korczak Ziolklowski, chair, and the Board of Crazy Horse Memorial; the U.S. National Archives and archivist Sharon Culley; the National Anthropological Archives of the Smithsonian Institution and archivist Daisy Njoku; the Kansas State Historical Society; the South Dakota State Historical Society and archivists Valerie Hanson and Chelle Somsen; and the Nebraska State Historical Society, particularly Chad Wall, photo/reference archivist, and James E. Potter, associate director of research. My continuing thanks, also, for permission to quote from my essay on Mari Sandoz in Vol. 18, #4, *Arizona and the West*, precursor of *Journal of the Southwest*, and thanks to the journal's editors, Joseph C. Wilder and Jeff Banister, as well as to Brother Benet, Blue Cloud Abbey (Marvin, S.D.), editor of my *Revisiting the Plains Indian Country of Mari Sandoz*, for use of material from it.

My gratitude also to the following, who have assisted me in various capacities: the archival staff of the University of Nebraska—Lincoln Love Library, especially Joe Svoboda, former head of the Sandoz Collection; Mayebelle Hooper, Rushville, for making possible an afternoon of photographing and interviewing beyond our mutual Sandoz workshop in Chadron; the Smithville, Texas, Library and particularly Karen Bell and Connie Helgren for invaluable Inter-Library Loan service; the Fort Robinson Museum and Tom Buecker, curator, and Vance Nelson, former curator; and Alice Elsberry, present executrix, Mari Sandoz Literary Estate. Likewise, my gratitude to Jean Curry, curator at the Sandoz Room of the Ad Pad, Gordon; Fritz Wefso, local historian, Rushville; Bob Buchan, curator of the Sheridan County Historical Society Museum, Rushville; Dave Perkins, in charge of the Hay Springs Museum; Diane Rathman, curator of the Cherry County Historical Society Museum, Valentine; Becci Thomas, curator of the Knight Museum of the High Plains, Alliance; and to these individuals, for sharing Sandoz memories with me: Nellie Snyder Yost, Alfred A. Knopf, Nelson Nye, Harry Chisholm, Omar Barker, Emmie Mygatt, Elsa Spears Byron, Edith Seton Hall, Leland Case, Maybelle Hooper McConnaghy, and Edward and Hazel Musfelt. Lastly, bountiful gratitude is given to my dear husband, L.D. Clark, for his encouragement and understanding over a long time and a long trail.

INTRODUCTION

When the Mari Sandoz High Plains Center opens in Chadron in 2001, it will be one of three centers where Nebraska honors its outstanding writers; the other two honor Willa Cather and John G. Neihardt. The center will show how Mari Sandoz's 21 books recreate the frontier life of both settlers and the neighboring Sioux and allied Cheyenne Indians of her native sandhills region of northwestern Nebraska. This work is to contribute to that same purpose.

A striking feature of Sandoz's writings is that they concern so many diverse cultures, including those of the settlers, the Plains Indians, the cowboys, buffalo-hide hunters, fur trappers, and the forerunners of Plains frontiersmen—the Spanish, French, and Anglos who preceded them in the area. A master storyteller, Sandoz could relate "sandhill stories" that would cause audiences to split their sides laughing. She possessed a documentary way of thinking and dispatched kindness in an easy manner, while always standing her ground.

Mari Sandoz gave serious attention to her writing from the age of ten when she began to secretly cultivate such an interest. In 1908, after placing third in an Omaha newspaper's short story contest for children, she continued, despite her father's strenuous objection, to make a writing career her goal. Following his death in 1928, she began working on *Old Jules*, the biography which, on his deathbed, he ironically requested her to write. The work brought her the *Atlantic* non-fiction prize in 1935 and enduring fame. It made him an American legend. Beginning with *Old Jules*, and continuing throughout her productive and distinguished career, Sandoz excelled in capturing the heartbeat of her region and rendering it with perception and skill unique in American letters.

The necessary biographical facts of Mari Sandoz's life and works are encompassed within the text that follows to illustrate how and why this author, born in 1896 in the Niobrara River country of Nebraska's northwestern sandhills, came to hold an esteemed place as an American writer before her death in 1966, at almost 70 years-of-age. These facts reveal how to either understand or interpret a subject, Sandoz always gave it a "closer second look." Her practice demanded painstaking on-the-scene examinations and interviews. It further included her custom of taking a given manuscript in first draft back to its locale, then reading it on the scene, and walking back over its terrain. Scenes provided here from all over Nebraska, accompanied by the author's references to them in various writings, enable readers to see Sandoz's exact uses of different places as settings and also make it easy to examine directly the author's own statements concerning topics associated with them.

Sandoz repeatedly drew on stories from personal childhood recollections. Among her Native American acquaintances was the Sioux, Bad Arm. He fought not only at the Little Bighorn, but was also present at Wounded Knee. Moreover, he was a relative of the Oglala chiefs, father and son, who belonged to the Man Afraid of His Horses family. Another friend from those days was "Old Cheyenne Woman," a survivor of both the Oklahoma and Fort Robinson outbreaks. Along with these individuals, there were the frontiersmen who called at her homestead and whose conversations with her French-Swiss immigrant father—a foremost locator in the region—fascinated the child. These included French trappers, fur traders and their breed descendants, and old homesteaders. All such people later became integral parts of Sandoz's writings, contributing perhaps more to them than any other factor. Likewise, their flair for telling stories greatly influenced both the vitality and the highly-crafted style of her creations.

Between 1935, when *Old Jules* (considered by many to be her best work) was published, and 1964, when *The Beaver Men* appeared, Mari Sandoz completed the greatest ambition of her life—a six-volume series on the Great Plains. Other titles in the series included *Crazy Horse* (which Sandoz considered to be her best work), *Cheyenne Autumn* (which received her greatest critical acclaim), *The Buffalo Hunters*, and *The Cattlemen*. Viewed collectively, these six works

tell the story of the Native American and white occupancy of the Trans-Missouri West.

Sandoz published three additional books of nonfiction: *These Were the Sioux* (1961), *Love Song to the Plains* (1961), and *The Battle of the Little Bighorn* (1966), making a total of nine works in her major field of nonfiction. While her last book initially received measured praise and remained her most controversial offering for a time, it has since become widely praised, not only for debunking George A. Custer, but also for being the first to focus on the general's reason for engaging the huge Sioux encampment in the conflict. Certainly on its appearance, the work offered a fresh approach to the subject, particularly in its treatment of the question of the inner psychology and the reaction of the Sioux concerning the celebrated battle.

In addition, Mari Sandoz was a talented novelist of the Plains. Besides her nonfiction works, she published five books of fiction, three short novels, and four collections of shorter writings. She won many prestigious awards, both for her fiction and nonfiction. However, after the recognition *Old Jules* received, these awards are too numerous to list here. Her posthumous honors also reflect the wide, growing range of readership she enjoys today, and are provided in the text as space allows.

Because Mari Sandoz held firmly to the purpose she set for herself at the start of her writing career—which was, after looking closely at her native region, to provide the whole picture of how its occupants were "shaped by" and "shaped" their worlds—her legacy is a myriad of meaningful works. These capture the vital nature of the individuals who struggled for survival in this difficult land—a place hard to tame with fences and plows. Through her mastery of language, Sandoz bequeathed images that portray what the region gave to and took from its inhabitants—what they did and are still doing to it. Through their experiences, Sandoz achieved her place as a major interpreter of her homeland and of the many frontiers possessed by the human heart.

LaVerne Harrell Clark

One

THE NIOBRARA RIVER
YEARS: 1884–1910

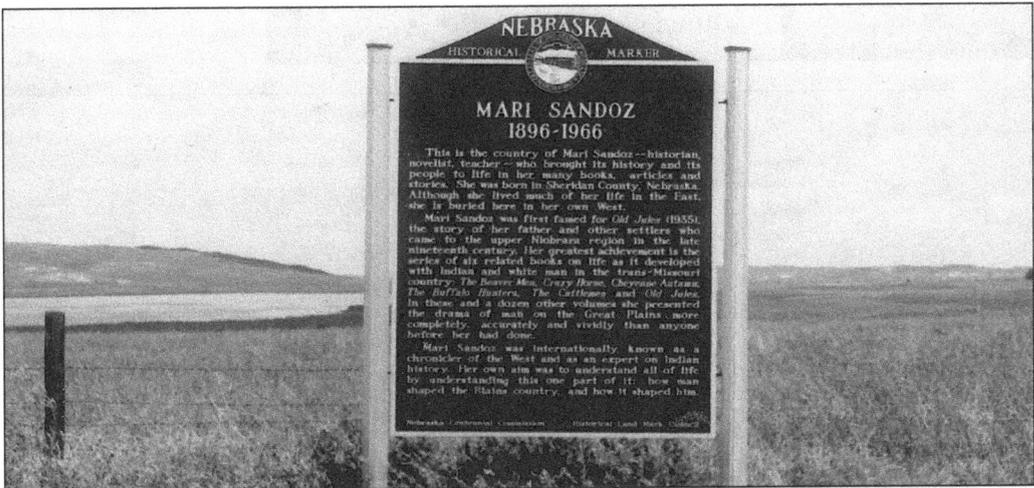

Nebraska Historical Marker, 40 miles south of Gordon, Nebraska. Mari Sandoz's life and writings are recognized by Nebraska in this, the northwestern area of her home state. This marker near the entrance to the ranch road leading to her sandhills burial site greets visitors to her grave at the Hill Place homestead, which is still owned by the Sandoz family. The grave site is open to tourists at all times. Approaching it, visitors familiar with *The Buffalo Hunters* will likely recall Sandoz's eloquent lines about death: "It had always been that the dead returned to the earth which fed them, as the flower returned, and the tree and the buffalo and all living things go back." (361.) Bunger Lake is visible before the sandhills which rise in the vicinity of the burial site. The lake calls to mind other Sandoz lines about "the wet-valley region. . . between the parallel sandhills, valleys half to a mile wide, stretching no telling how far eastward in the curious blue haze always over the sandhills." (*The Cattlemen,* 431.)

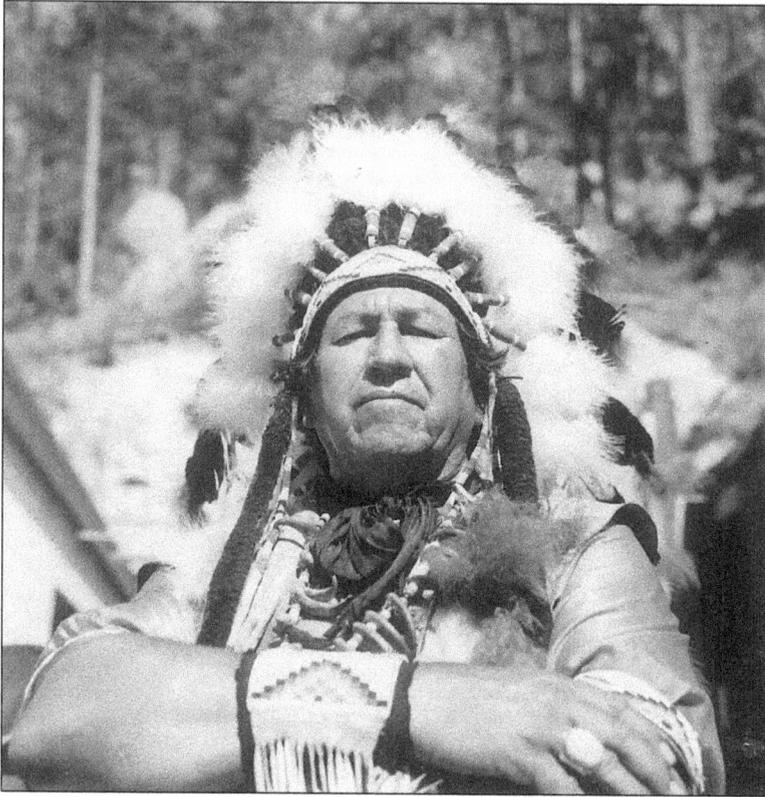

Sandoz's Early Familiarity with Neighboring Plains Indians. Though Mari (Susetta) Sandoz was born in what was called the "free-land" region of the Nebraska Panhandle, her birth came just a few years after the confinement of the Sioux and Cheyenne on neighboring reservations to the north—within close enough proximity to allow them to continue to revisit their old campsites. One preferred location lay across the Niobrara from her birthplace.

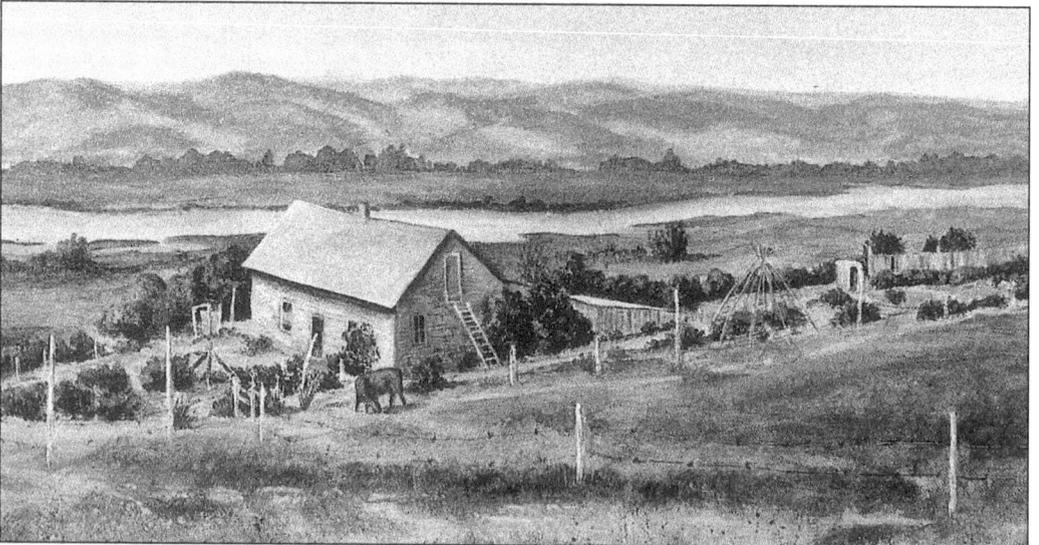

The Birthplace, c. 1908. Now dismantled, the old house stood beside the "Running Water," about 14 miles southeast of Hay Springs, Nebraska. This painting of the place, as it looked around the time of Mari's birth on May 11, 1896, was made from a photograph of Henri Surber's by an artist who has been a friend of the Sandoz family since childhood. Surber was a friend whom Jules Sandoz had located on a nearby claim. (Painting by and Courtesy Cheryl W. Wilkinson.)

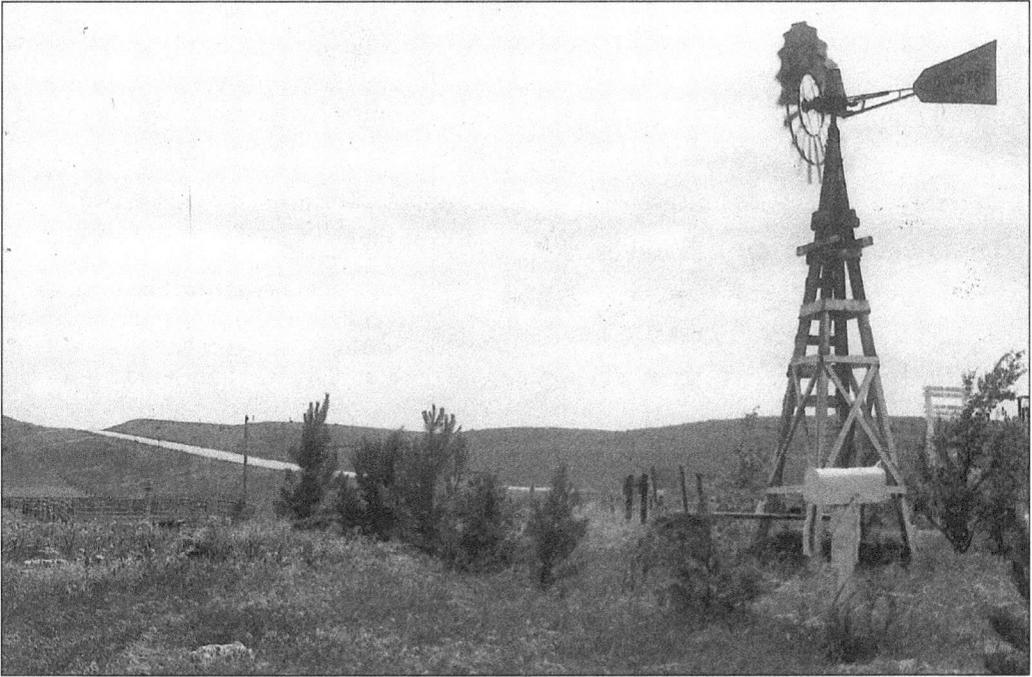

The Sandhills Country Near the Burial Site. "This patch of sandhills stretching from the Niobrara River to the Platte was the Jötunheim of my childhood," wrote Mari Sandoz, using the term for "outer world" from Scandinavian mythology. She noted further that "out of this almost mythical land, apparently so monotonous, so passionless, came wondrous and fearful tales. . . ." (*Sandhill Sundays*, 24.) Today this windmill, like others close by, marks the property of descendants of sandhills homesteaders that Mari's father located on claims.

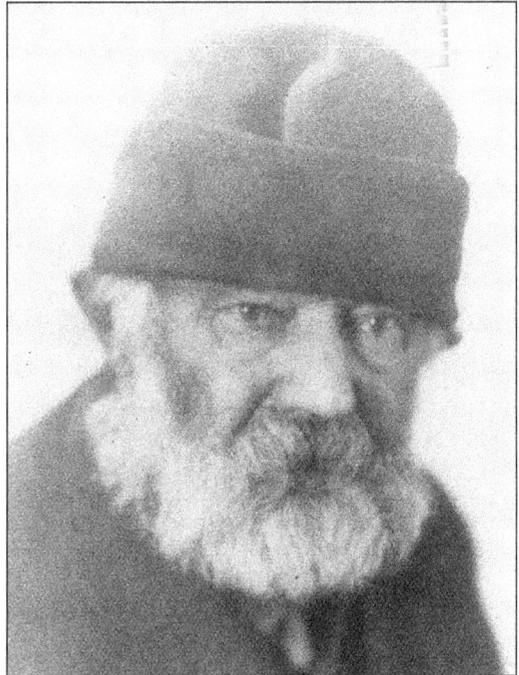

"Old Jules," 1858–1928. This was the name by which Mari's French-Swiss immigrant father became known in the sandhill country—a name she immortalized in the first of her 21 books, the 1935 biography of the same name. He came to be known as such after he settled on a claim in Sheridan County near what became her birthplace, and afterwards located other homesteaders around him. (Courtesy Mari Sandoz Estate.)

11

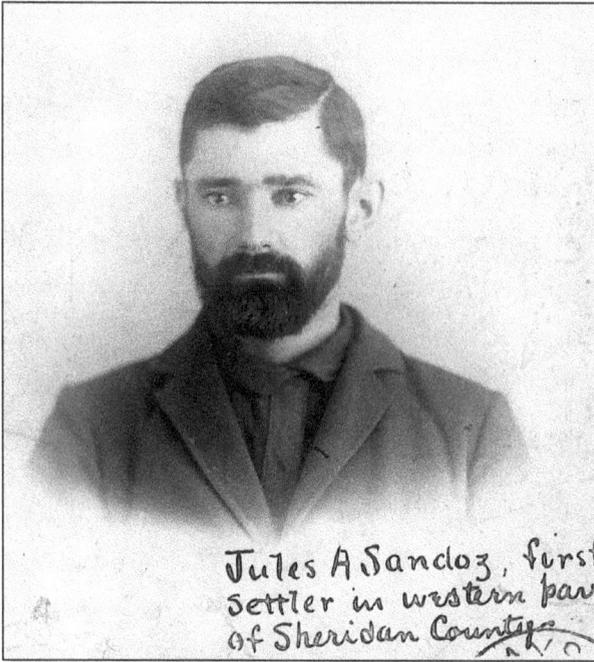

Jules Ami Sandoz, 1881. After attending the University of Zurich and then working for a time as a railway postal clerk, Jules quarreled with his parents and subsequently emigrated from his birthplace in Neuchatel, Switzerland, to spend the remainder of his life in Nebraska. He originally lived on a homestead near the town of Verdigre in the state's northeastern section. (Courtesy Nebraska State Historical Society.)

Jules A Sandoz, first settler in western part of Sheridan County

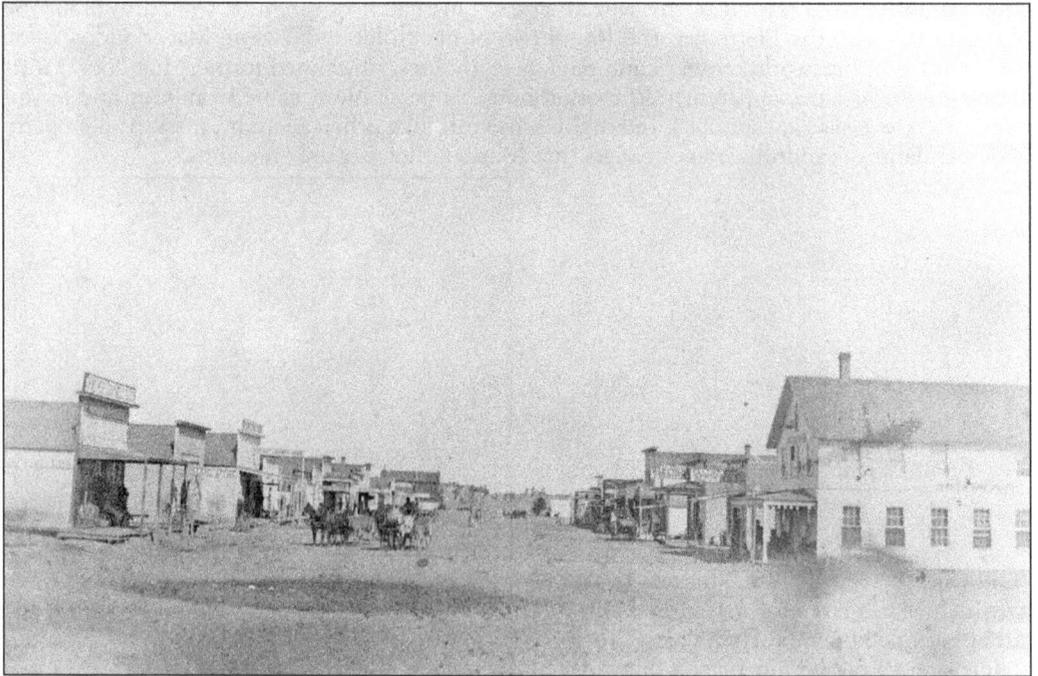

Valentine, Nebraska, 1884. Sandoz described the town as Jules saw it during this same year when he made his way west upon leaving Verdigre to settle permanently instead in Sheridan County. At the time, Valentine was the land office town at the end of the railroad on the northern frontier of the sandhills rising west and south from the Niobrara, whose course he followed in his wagon until he reached his destination. (Courtesy Cherry County Historical Society Museum, Valentine.)

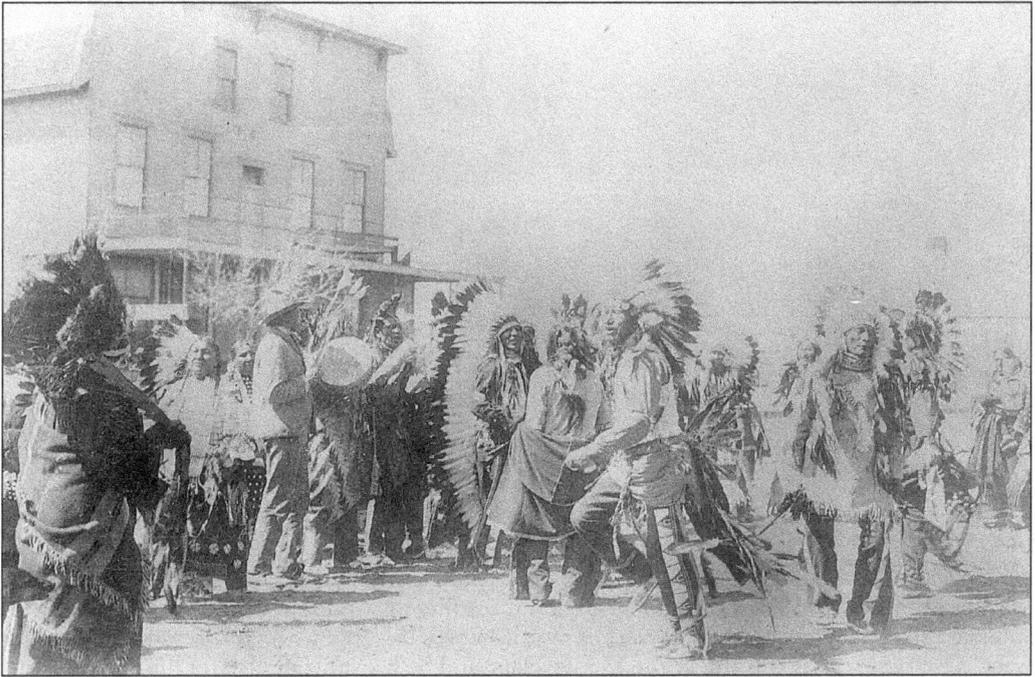

Sioux PowWow, Valentine, c. 1901. Sandoz wrote of how the Sioux came in to Valentine "every day from the great reservations to the north." (*Old Jules*, 5–6.) This photo, made there of Lakota powwow activities shows the kinds of gatherings in which these Indians sometimes participated while trading and visiting this frontier outpost, which did not incorporate as a town until the year after Jules's visit. (Courtesy Cherry County Historical Society Museum, Valentine.)

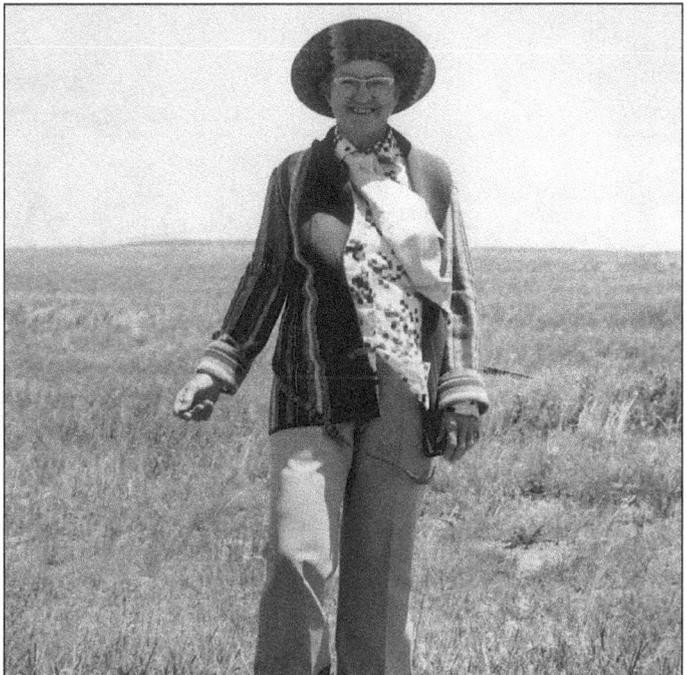

Caroline Sandoz Pifer at the Site of her Father's 1884 Dugout. Pifer, the youngest child and the sister Mari selected to be her literary executor, stands in the middle of the flat tableland called "Mirage Flats." As the first white settler in this tree-less, "absolutely bare" area, Jules Sandoz soon became acquainted with Sioux and Cheyennes who frequently camped nearby at their long-favored Niobrara campsites.

13

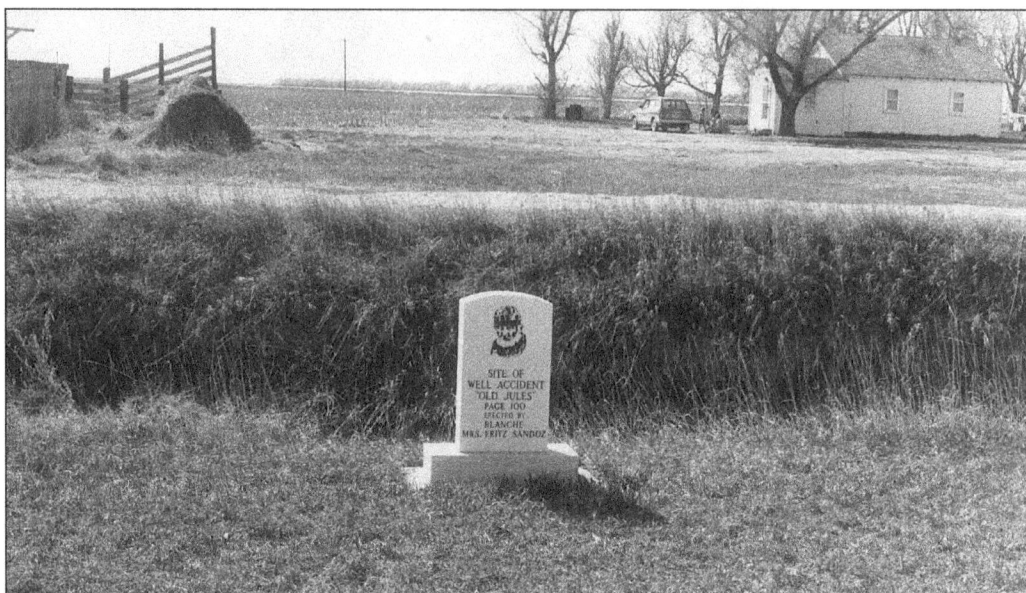

Marker at Site of Old Jules's Well Accident. According to Sandoz in *Old Jules* (44), her father "plunged sixty-five feet to the bottom" of a well he was digging, with "his foot doubled under him." This occurred at this site in the Mirage Flats, and he became crippled for life. This marker is located just across from the Sacred Heart Church of later days, for whose construction Jules donated 5 acres.

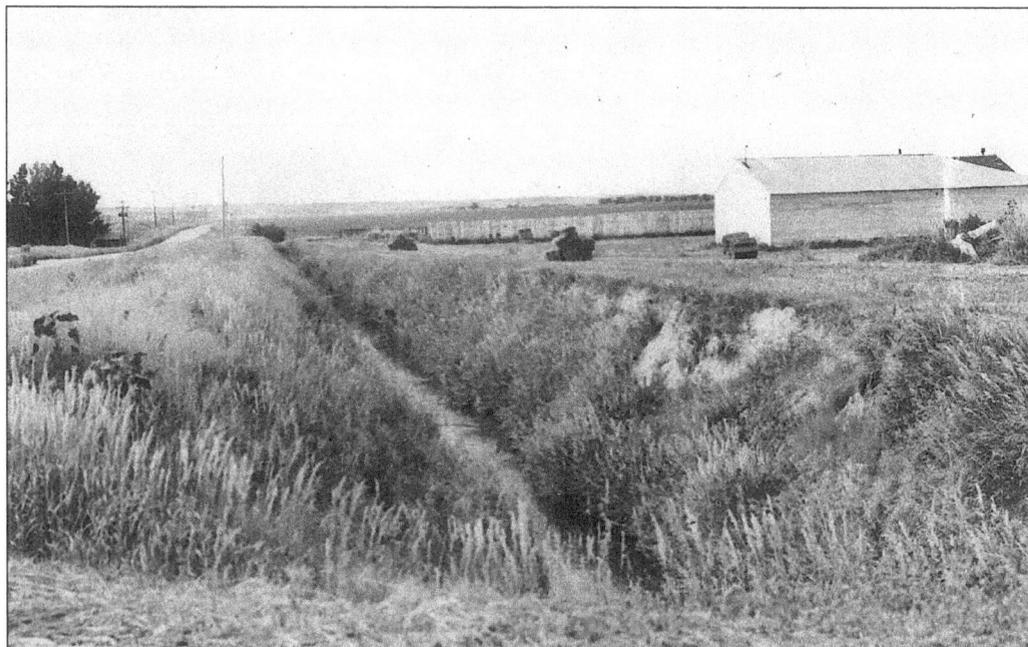

Irrigation Ditch. Running through the heart of the Mirage Flats and containing today's Niobrara water, the irrigation system is the realization of an 1890s dream of Old Jules and the homesteaders which he brought to the region. In *Old Jules* (150), Sandoz mentions their hopes for it: "The Mirage Flatters talked irrigation day and night, held meetings. Jules sent for government bulletins showing corn man-size with a little water."

14

Fort Robinson, Nebraska. The fort near Crawford is due west of Hay Springs. Its old hospital stood nearby and was overseen by the famed Dr. Walter Reed. Following his accident, Jules was taken there in a wagon by neighboring settlers. In *Old Jules* (43), Sandoz records how the wagon halted "before the log hospital," into which he, "his eyes sunken into a fever-burned mask, was carried. . . ."

The Old Hospital Site. Sandoz's letters—particularly the edition her biographer, Helen Stauffer, edited—show that during his eight-month confinement in the hospital which once stood under these trees, Old Jules became well acquainted with a number of Sioux and Cheyenne who still remained at the fort, and with the well-known interpreters, Billy Garnett and Baptiste Garnier, serving them. (See Stauffer's *Letters*, 31.) Both of the latter had Sioux mothers. Later, some of Jules's friends from these days came to visit and hunt with him.

15

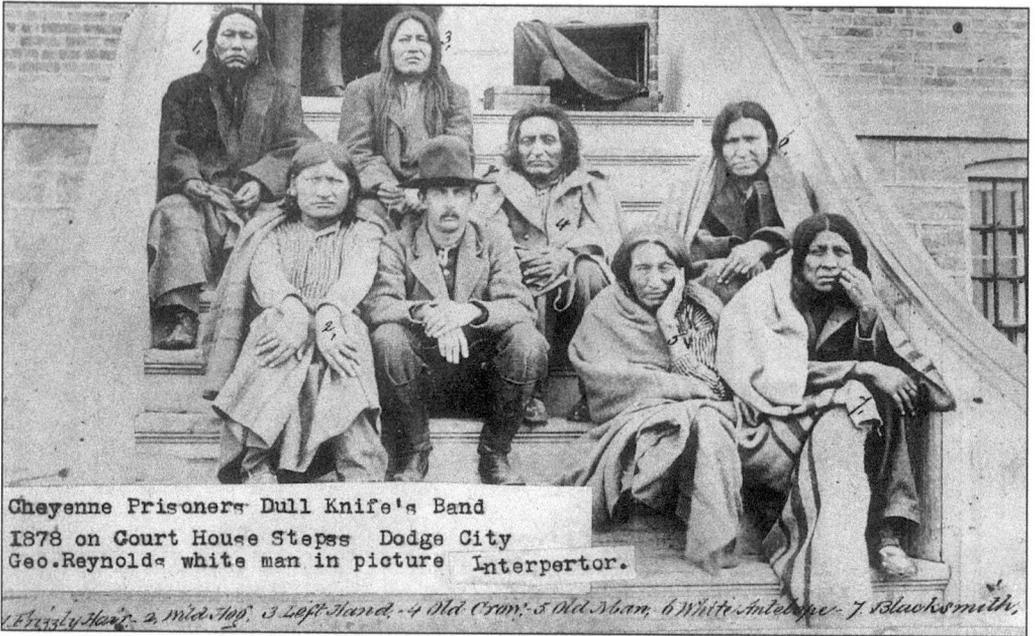

Cheyenne Prisoners Dull Knife's Band
1878 on Court House Steps Dodge City
Geo. Reynolds white man in picture Interpertor.

1 Grizzly Hair. 2 Wild Hog. 3 Left Hand. 4 Old Crow. 5 Old Man. 6 White Antelope. 7 Blacksmith.

Wild Hog, 1879. The former Cheyenne headman under Chief Dull Knife (first row, bottom left) is shown with fellow band members, all of whom were captured near Dodge City, Kansas, on their flight north from Oklahoma. The oral account that Wild Hog furnished to Mari's father was recorded by him in a journal which Mari later utilized in writing *Cheyenne Autumn*. (Courtesy Kansas State Historical Society.)

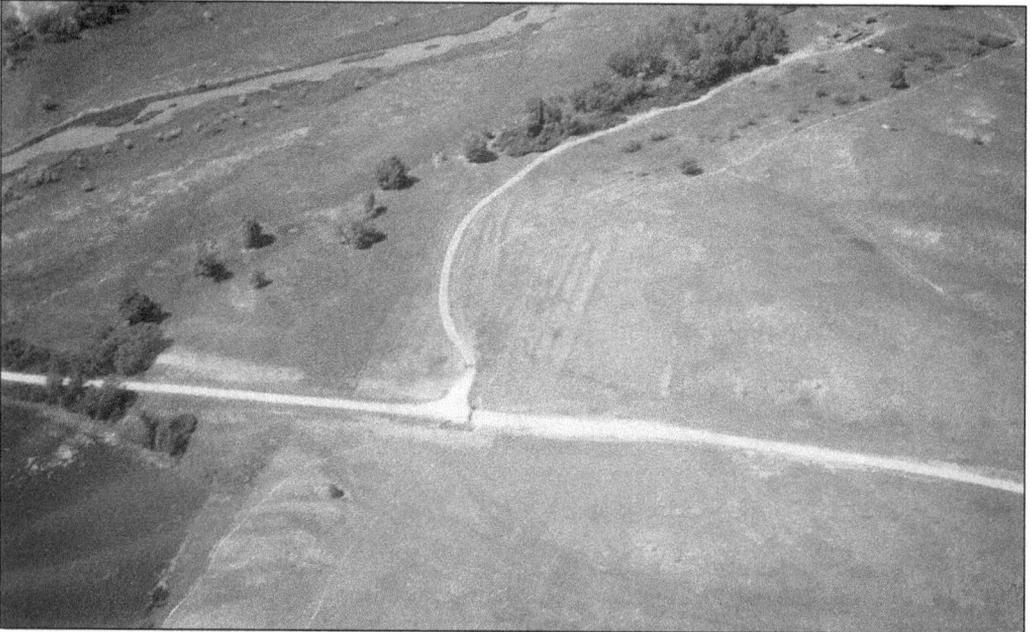

Aerial View of Niobrara and Site of Mari Sandoz's Birthplace. A while after Jules returned to his dugout in this area, following his hospitalization, he started work on "the best and only home he ever built." (*Cf. supra*, 10 bottom.) It stood to the right of the top line of trees seen here. (Photo by and Courtesy Richard Loosbrock.)

16

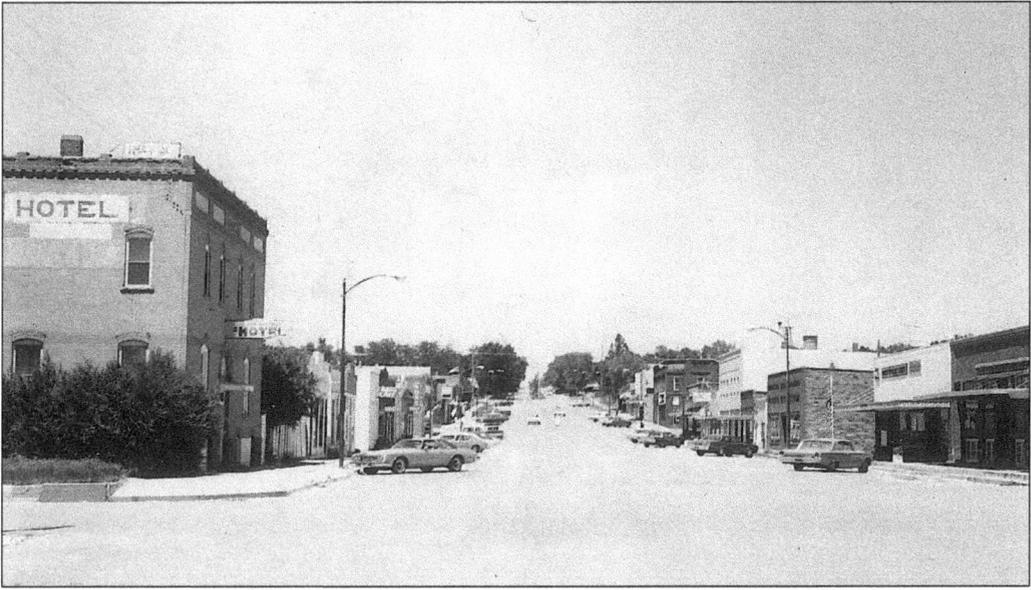

Downtown Hay Springs, 1976. Today the Hay Springs Museum on Main Street has a small, permanent display of Sandoz's clothing and memorabilia. Back in the mid-1880s, when the railroad reached Hay Springs and the town became a settler's trading place, Jules met clients he had agreed to locate at the train station. In 1885, he met Marie ("Mary") Elizabeth Fehr, a German-Swiss immigrant from the Schaffhausen area. When Jacob Fehr, the brother he was to locate, failed to arrive, Jules took Mary to his new home to await word of him.

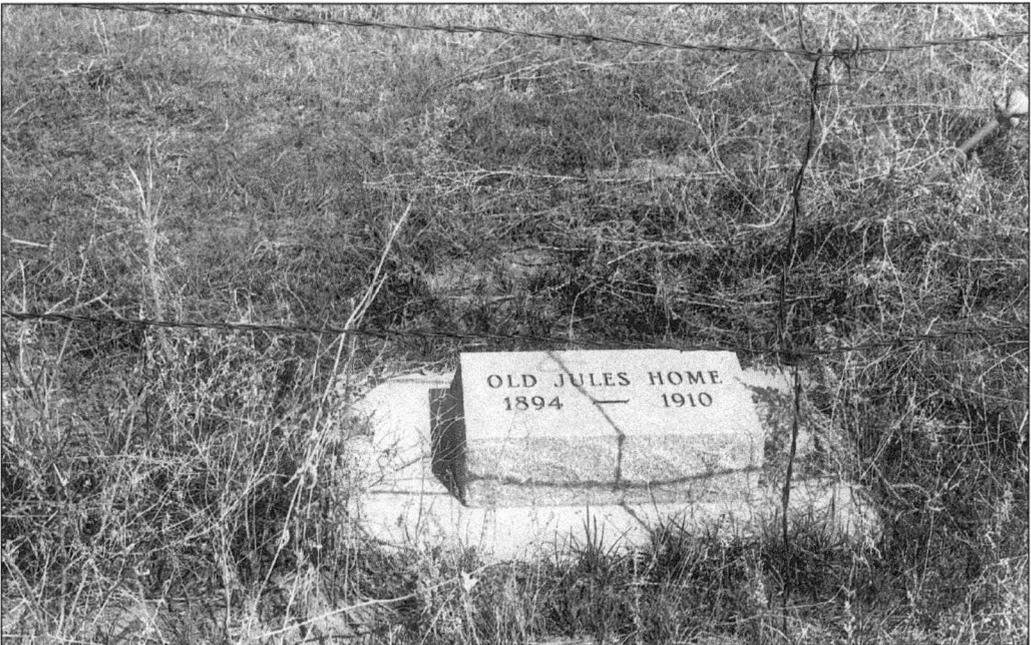

Marker for Old Jules's Home, 1894–1910. A letter soon came saying that Jacob had married and wouldn't be relocating. At that point, Mary, who had intended to keep house for her brother, agreed to become Jules's fourth wife. She was the last one, and also became the mother of all six of his children—Mari was the eldest.

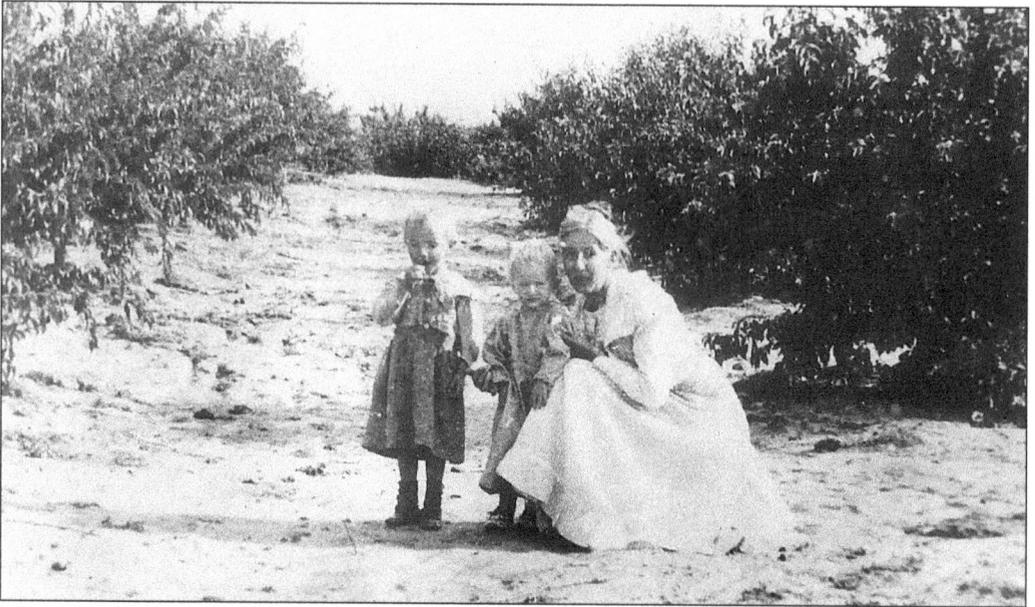

Mari at Age Three or Four in the "River Place" Orchard. She is standing before the young trees and plants, the names of which she already knew, and beside her brother Jules, who was 17 months younger. Caroline, the wife of their father's old friend, Henri Surber, is with them. The Surbers lived with the Sandoz family until Old Jules located them on a claim close by. (Photo by Henri Surber, Courtesy Marie Surber Hare.)

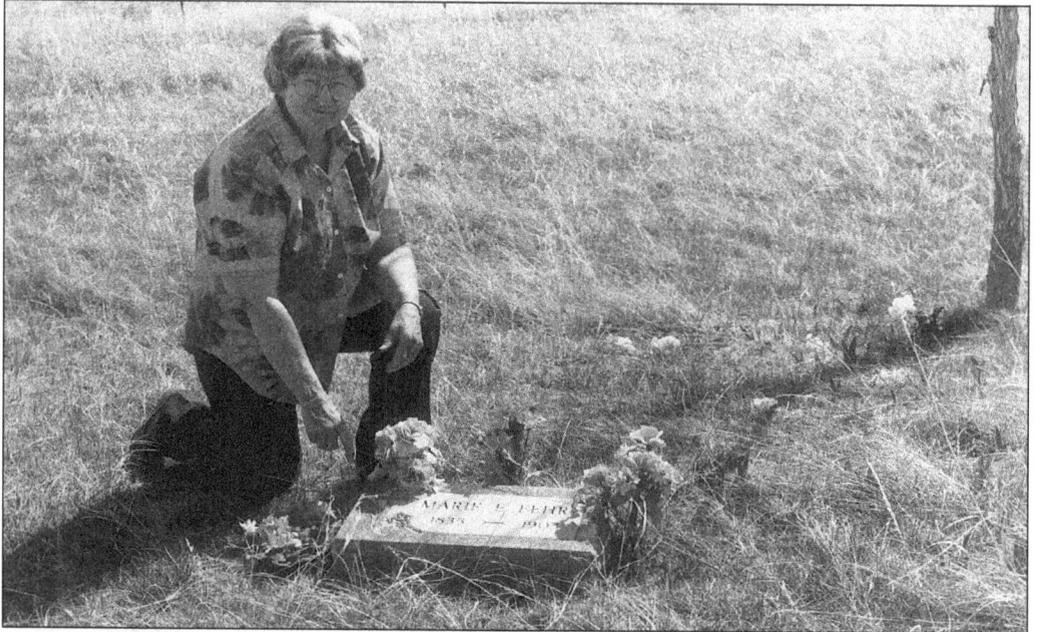

Headstone of Mary Elizabeth Fehr (1835–1902). Caroline Pifer is beside the marker of her maternal grandmother at the Beguin-Swiss Cemetery, near the River Place. The graves of a number of Old Jules's relatives are located close by. Mari's grandmother died a painful death from cancer, which thrust the child into helping her mother with James, a baby brother, and to assisting with other chores.

Mari's Brother James at the Grave of their Uncle Emile. Killed in 1908 by a gunman hired in the midst of the long conflict between the settlers and the cattlemen opposed to homesteading the free-land range, Emile was among the several younger brothers of Jules. Jules located him near the Beguin-Swiss Cemetery here and among other relatives who followed him to America. Emile's demise is described in *Old Jules*. (320, 325 *f.*)

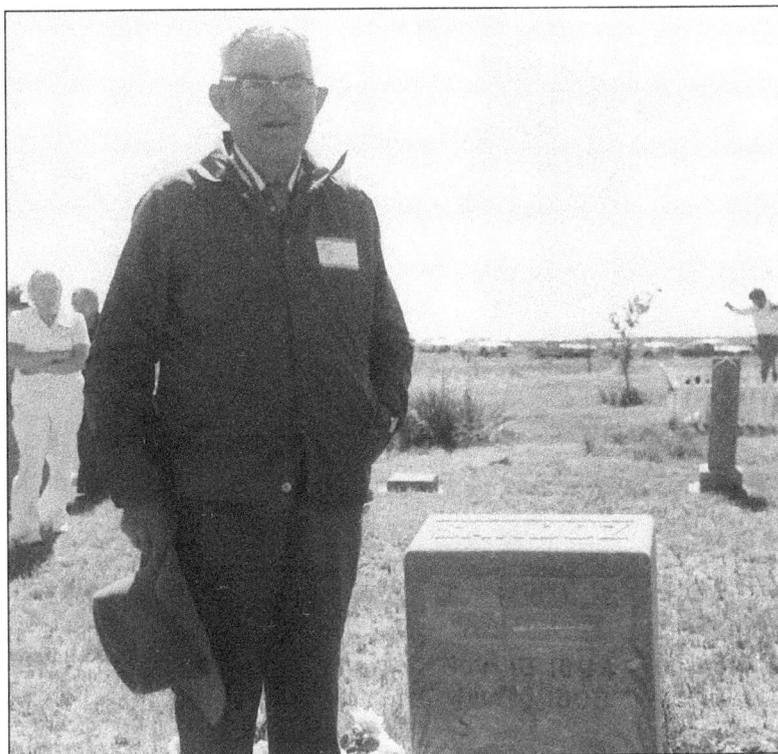

Elk Horn Arrangement. This hunter's arrangement, favored among sportsmen of the area, belongs to a modern-day Sioux from the former Brule country outside of White Clay, Nebraska. For over 25 years, Old Jules hunted deer and big game such as elk, antelope, mountain sheep, and grizzlies. Often his companions were Plains Indians. According to Sandoz in *Old Jules* (27–9, 157*ff.*), they called him "Straight Eyes" and taught him weather and game signs.

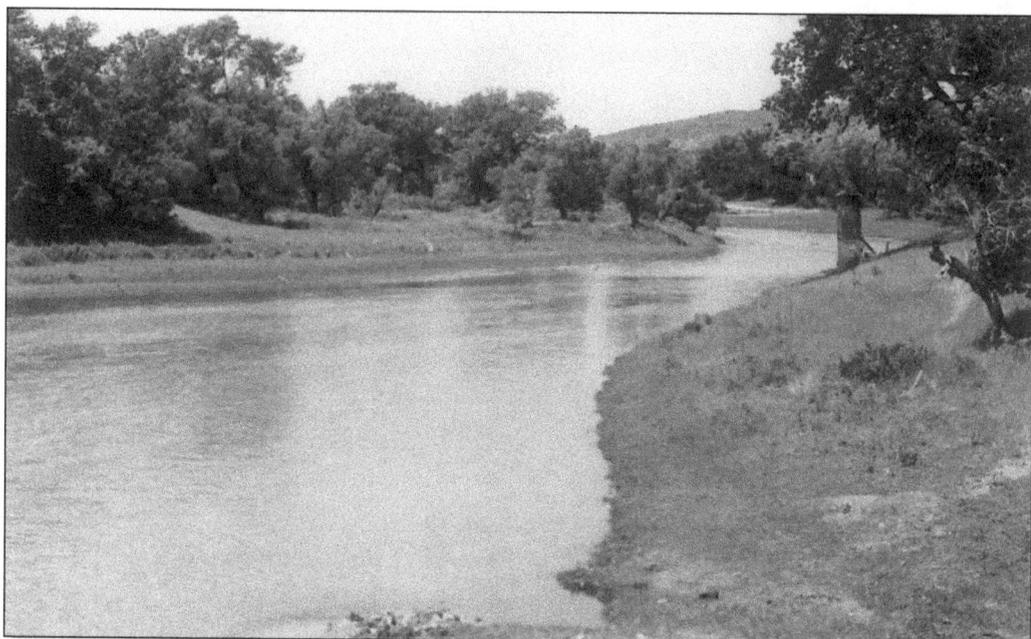

Ancient Crossing of the Niobrara. The "Running Water" of the Plains Indians is viewed here from "the River Place," as Sandoz family members call their birthplace. In *Old Jules* (26), Sandoz tells of the first visit the Oglala Sioux paid Jules at the crossing: "He was dipping a keg of water from the shallow stream as they galloped through a break in the buffalo-berry brush... 'Hou!' they called."

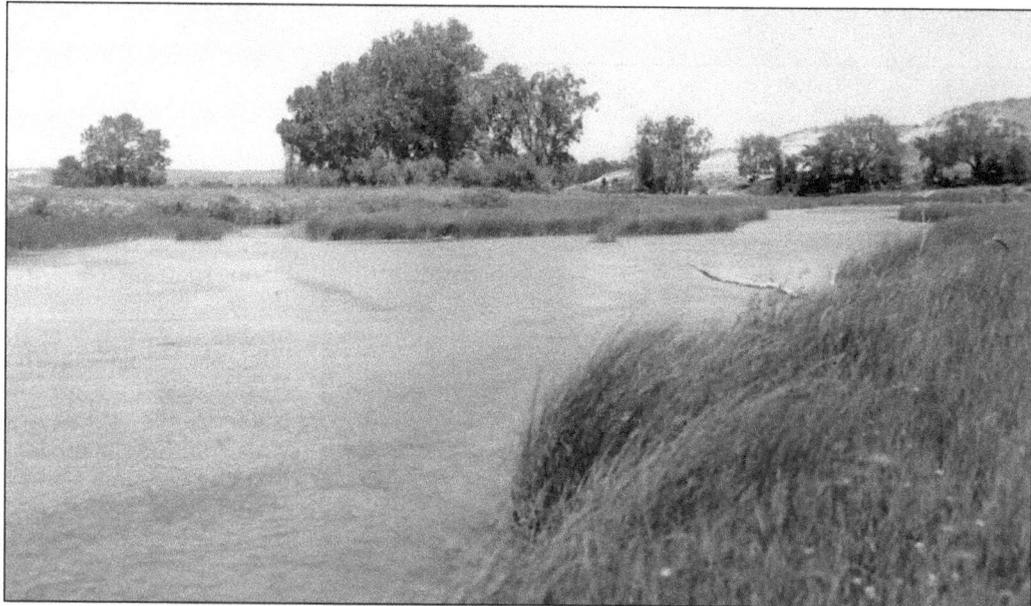

The Campsites Across the River. They had been used, as Sandoz noted in *Old Jules* (27), "no man knew how long." For most of the summer during her childhood, the Sioux, and sometimes the Cheyenne as well, frequented them from out-of-state reservations. After Crazy Horse's death, when their resistance crumbled, Sandoz in *Love Song to the Plains* (203) reminds us that the Sioux had been moved out of Nebraska forever.

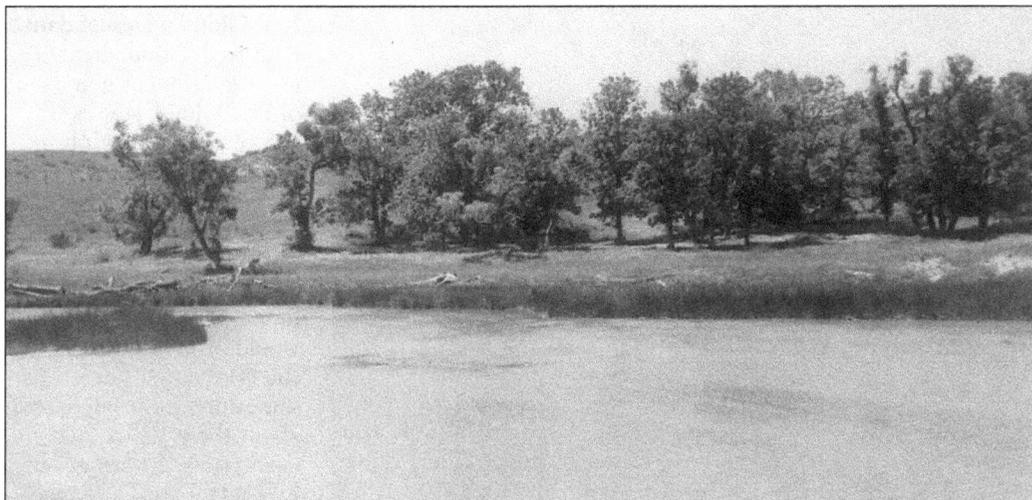

Mari's Campsite Observations. Though Old Jules was a strict father, he nevertheless always let his children play at the campsites. Therefore, Mari was soon "catching glimpses" of "the customs and beliefs of these brown-faced people" with which she would later fill her works. In *These Were the Sioux* (Foreword, 9–10), she recalled scenes from childhood experiences with these people and "their campfires," their "drumming in the night," and their "ways with thunderstorms."

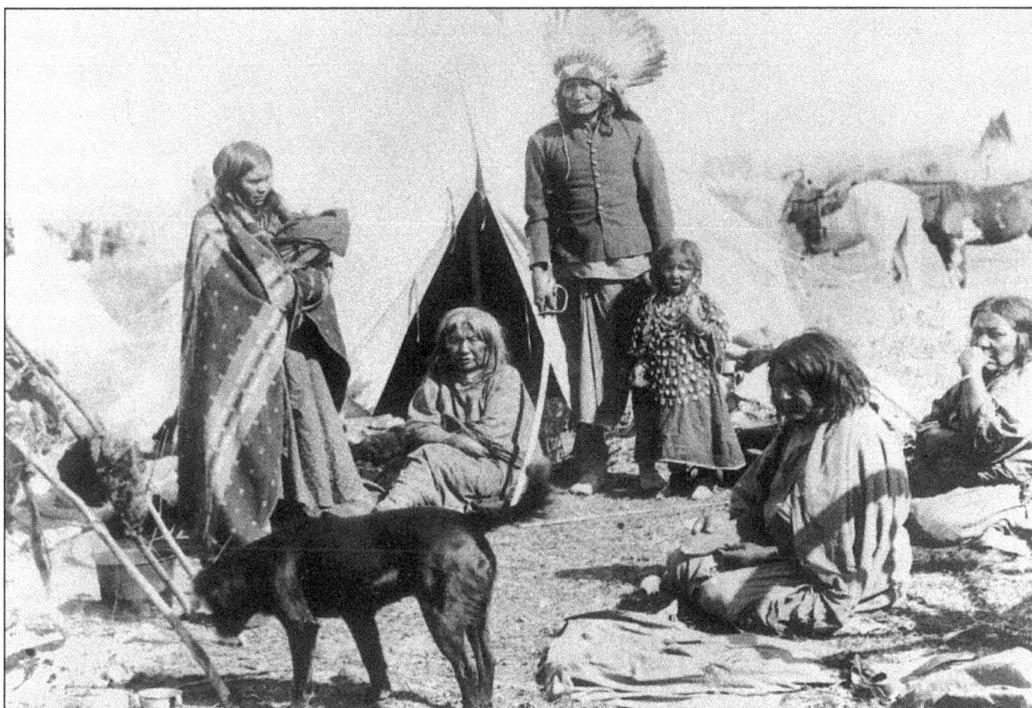

The Young Man Afraid of His Horses' Family, 1894. Among the Sioux whom Sandoz mentions by name as visiting the "River Place" are warriors like Bad Arm, who was related to this leader—the Oglala's last great hereditary chief. This photograph, then, dating just two years before Mari's birth, records visually the kind of camp scenes she describes in *Old Jules* (27). (Courtesy South Dakota State Historical Society—State Archives.)

Red Cloud's Descendant.
Paul Red Cloud, great-great-great-great grandson of Red Cloud, stands before a tepee of Holy Rosary Mission in Pine Ridge, South Dakota, 50 miles from Mari's birthplace. Sometimes five or six tepees of the kind in use by the Oglala here would be erected along the Niobrara. "There was something most engrossing about these Sioux and their tepees," Mari noted in *These Were The Sioux*. (Foreword, 9.)

Puberty Dreaming.
These Sioux youths—especially the one wearing the breastplate—could serve as models for those whose duties and dreaming Mari envisioned in connection with nearby Indian Hill, a place she modeled the visions on, which she included in *Crazy Horse* and *These Were the Sioux*. Another such site was Buffalo Spring, just to the east of the River Place near Deer Creek, and the setting for "The Buffalo Spring Cave."

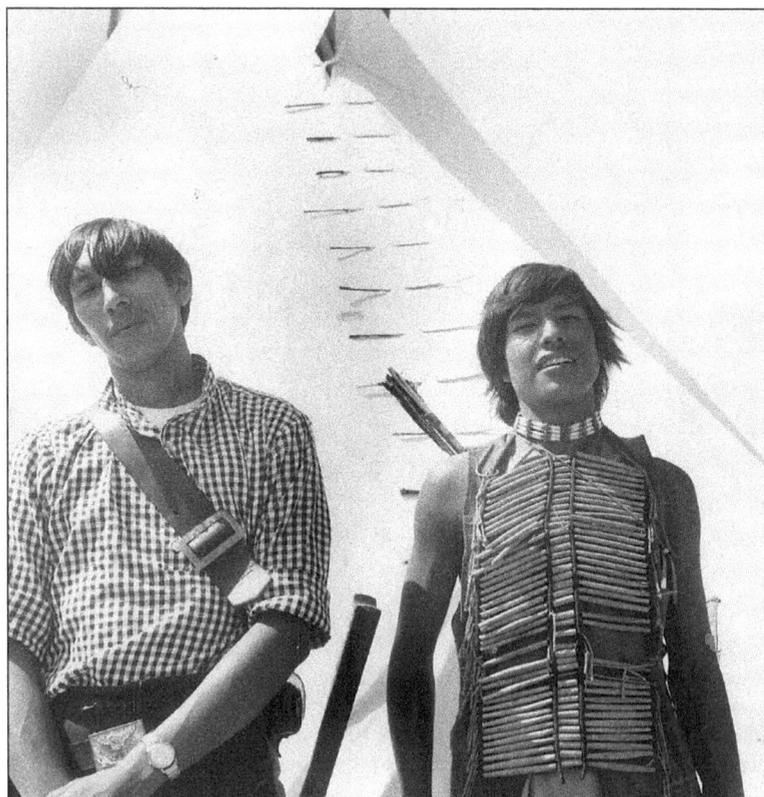

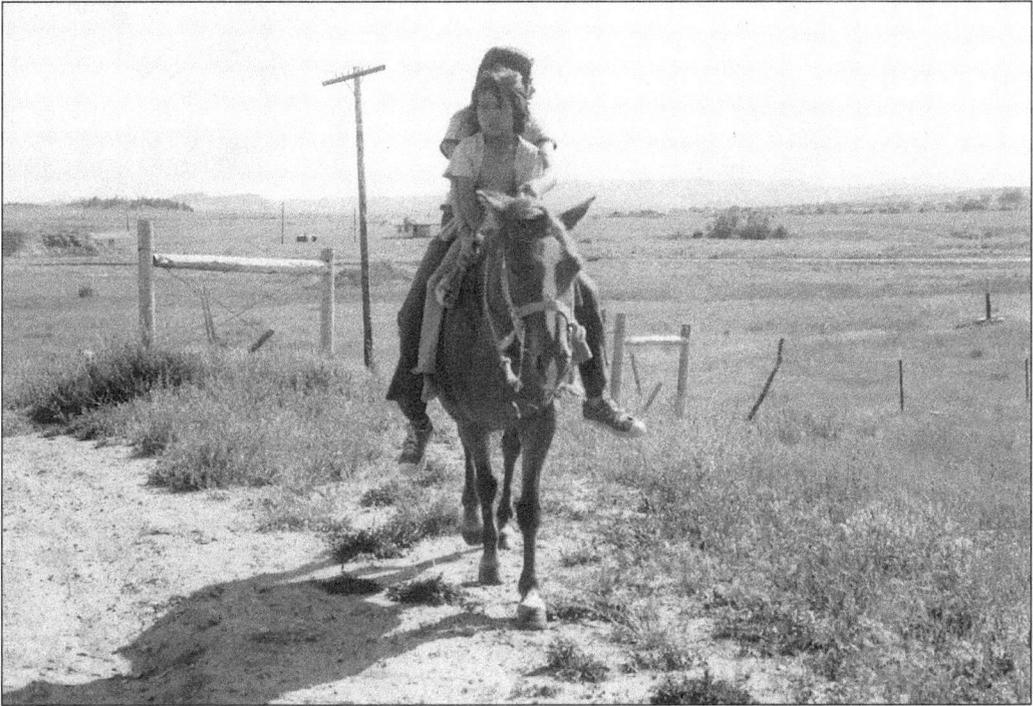

Cheyenne Children and their Horses. This was still another subject about which Sandoz became so familiar that one day she would draw from her experiences in watching Cheyenne youngsters like these when writing her novel, *The Horsecatcher*. In *Old Jules* (28), she described how Plains Indian horsemen would let "their ponies" lope "untiringly over the low swells, through chophills, and out into tiny, bunch-grassed valleys. . . ."

A Cave near the River. In a bluff not far from these pilings of the old bridge once leading to the Sandoz home is a cave. Its setting and associated legends contributed to the narrative of the tale, "Fly Speck Billy's Cave," appearing in Omar Barker's anthology, *Myths and Legends of the Old West*. The story concerns gold which was rumored to be hidden there after Billy's gang robbed the Black Hills stage.

The "River Place" Grounds with Indian Hill. In *Old Jules* (27), Sandoz mentions that after the Oglalas first greeted Jules, he visited their "broken circle of tepees set among the hackberry and box elders at the foot of Indian Hill." Today some of the same trees remain in this view of the hill atop which young Mari, as the Foreword to *Love Song to the Plains* notes, "hoped to see far places in the shimmering mirages, perhaps even Laramie Peak, as old-timers promised."

Celia's View from Indian Hill. This close-up of Mari's niece, Celia Ostrander, was taken from the hilltop, where—as the "Foreword" observes—"miles of the river and beyond" can be viewed. This scene also provides the sight in the background which Sandoz, in *Old Jules* (19), called the "silver ribbon of the Niobrara," in evoking how the river appears winding its way through the bluffs visible here on its far side.

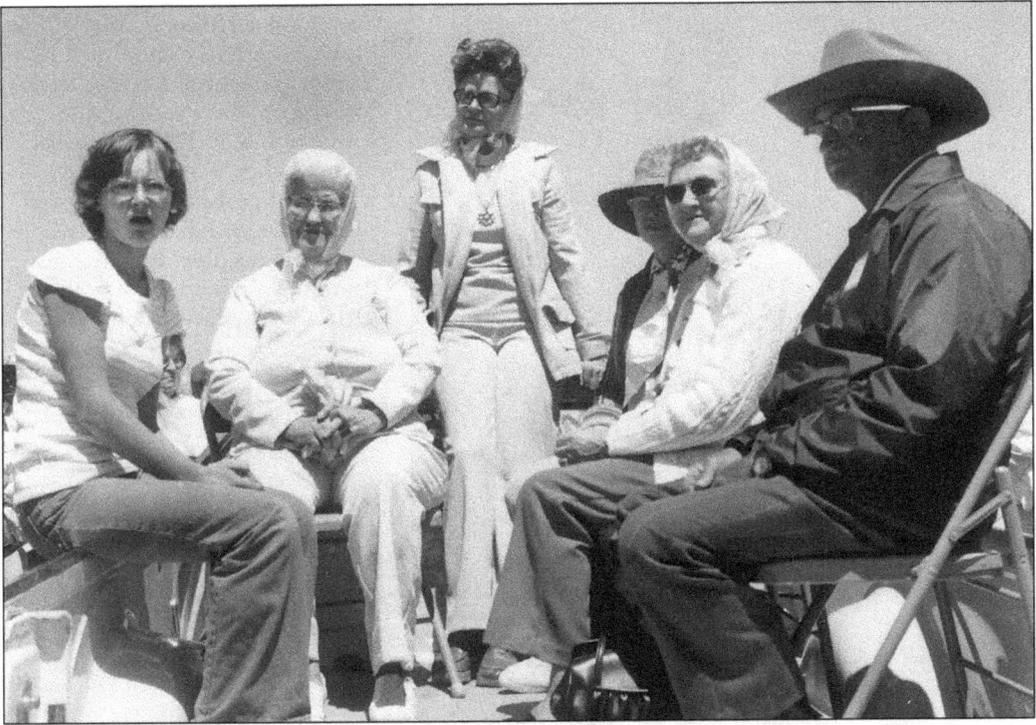

Some of Sandoz Family, 1976. On a tour of the River Place, these members of the Sandoz family shared recollections with a Chadron State workshop on Mari's writings. They are, from left to right: Myrtle Ostrander, Mari's great-niece; the late Blanche Sandoz, widow of Mari's youngest brother, Fritz; Celia Sandoz Ostrander, niece; Caroline Pifer, sister; the late Marie Sandoz, wife of the late James, who is seated beside her.

Thoughts of Crazy Horse. Sandoz mentions how, as a child, she liked the feeling of the "gravel, black from Indian signal fires," under her bare feet, as she climbed to the top of the hill. As a writer, she would think also of how young Curly (the Sioux nickname for Crazy Horse) likely sought the top of this well-known area landmark for his fasting and puberty dreaming.

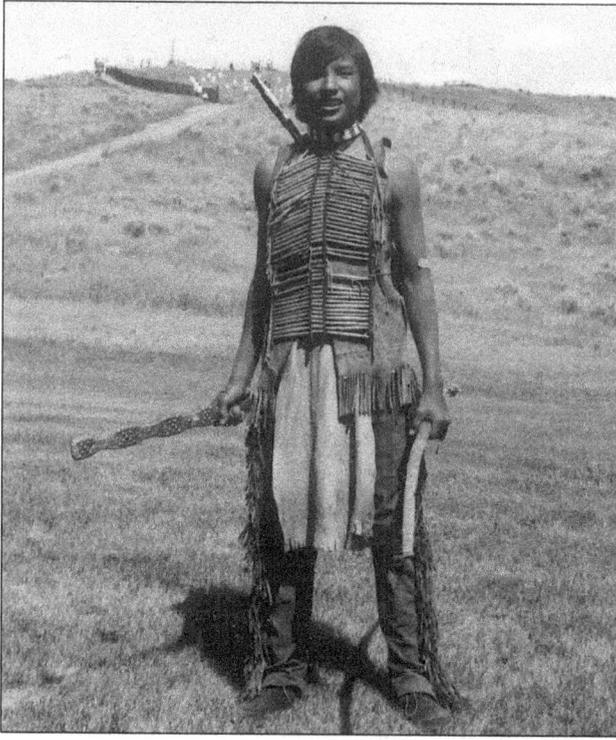

Solace on a Hilltop. *Crazy Horse* provides various examples of how Sandoz thought of a young leader like the one here seeking the solace of Indian Hill. One place occurs in her "Foreword" (*viii*), where she probes "the confusion" his heart must have felt there about the needless and grievous death of Conquering Bear, the Oglala's last peace chief.

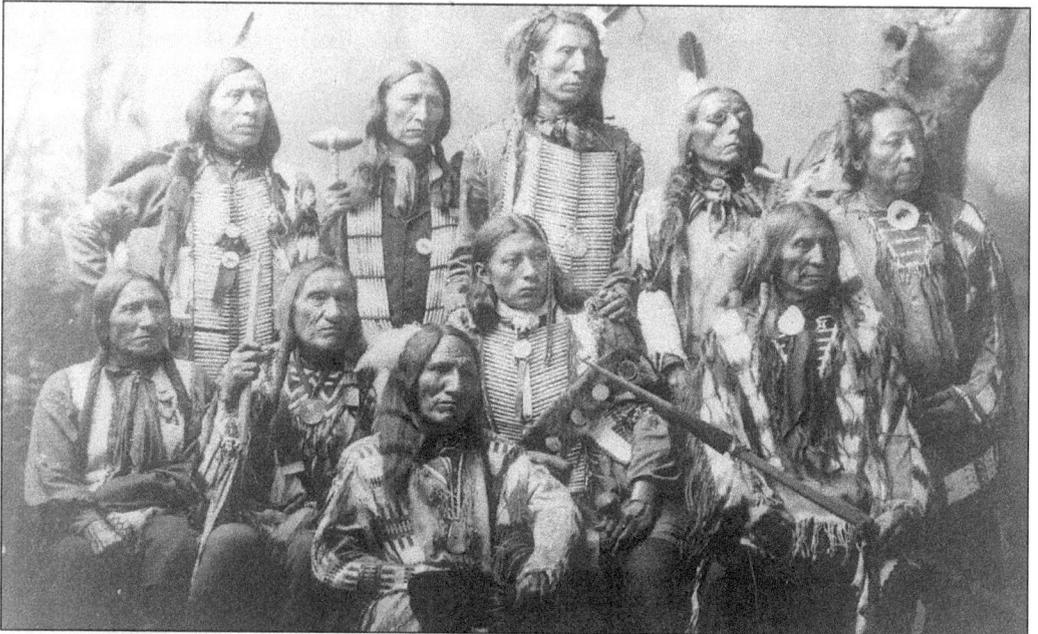

Conquering Bear, Bottom row, Extreme Right. The death of this revered leader, pictured with this Oglala delegation, set the Sioux on the warpath. Conquering Bear fell in a Brule Village through the careless and grievous actions of a young Army officer named Lt. John Grattan, just three years after the treaty-making of 1851, in which he was participating here. (Smithsonian Institution, Neg. #57,076; Courtesy South Dakota State Historical Society—State Archives.)

26

Old Jules's Vision on Arrival. Mari's father also had a vision upon arriving in the area in which he saw the "rudimentary mirages" associated with the Mirage Flats. As depicted in *Old Jules* (19), they symbolized for him a home like this of later tenants "close enough to the river for game and wood," and with "hard land" that was "black and fertile" for the "corn and fruit trees" he needed.

The Hayfields of Old Jules's Last Home. His vision included hayfields such as these too, which once were actually his at the Hill Place, and of the strong descendants that *Old Jules* (19) mentions who would "swing the hayfork and the hoe" in working them. Today Jules's great-grandson, Cash Ostrander, still oversees all the haying needed on the place.

Mari's Visions. Unlike those of her father, Mari's hilltop visions were more often linked to the region's past and the world of "Gone-Before-Ones" like Conquering Bear. When she was still the towhead in the orchard (*Cf. supra*, 18 top) and was called by her friend Bad Arm, "Short-Furred One" because of her haircut, she was treated by him to an imagined "ponyback" ride like this Sioux actually offers youngsters.

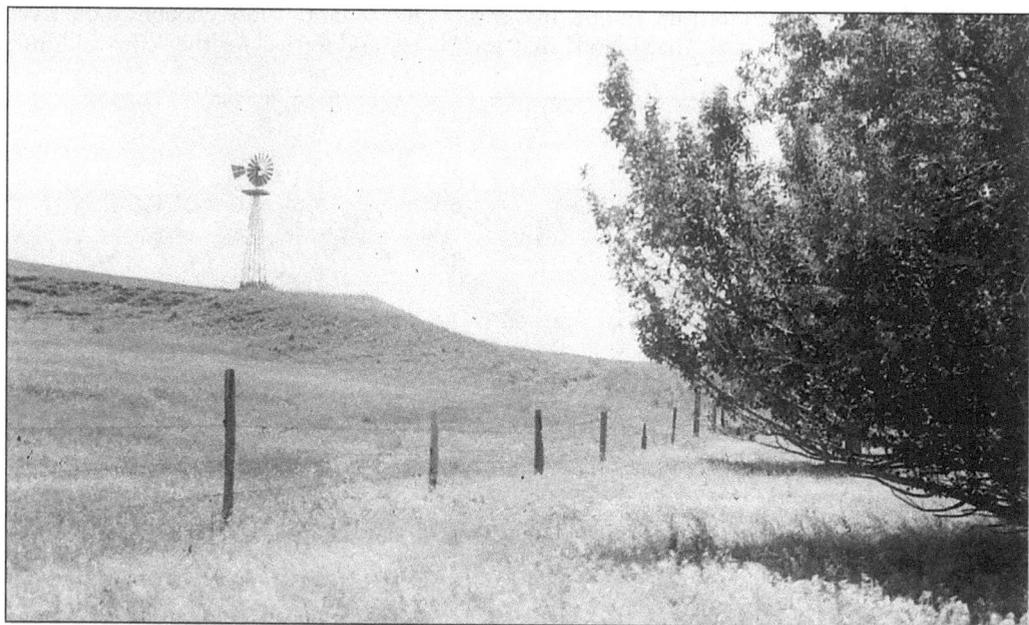

Bad Arm's Ride. The warrior from the Little Bighorn took Mari on his back up this slope to the bench of the hill where her home stood, with her "old country grandmother" screaming from just seeing them together. Yet when the ride that is described in *These Were the Sioux* (16) ended, Sandoz recalls that her "fingers" had "to be pried out of" the Oglala's "strong black braids"—an acknowledgment of the security that she, a tiny "white girl," felt in "clinging shamelessly" to them.

Modern-Day Oglala Children, Pine Ridge. Even then, as the account also notes (17), Mari was aware of something these Sioux youngsters' countenances reveal that they already know—the "amused and playful way" that elders like Bad Arm have with tykes of all races is a natural outgrowth of their feeling that any little one should be considered a "grandchild." Sandoz noted in *Hostiles and Friendlies* (39), that elders conveyed their feelings simply by addressing any child by this term.

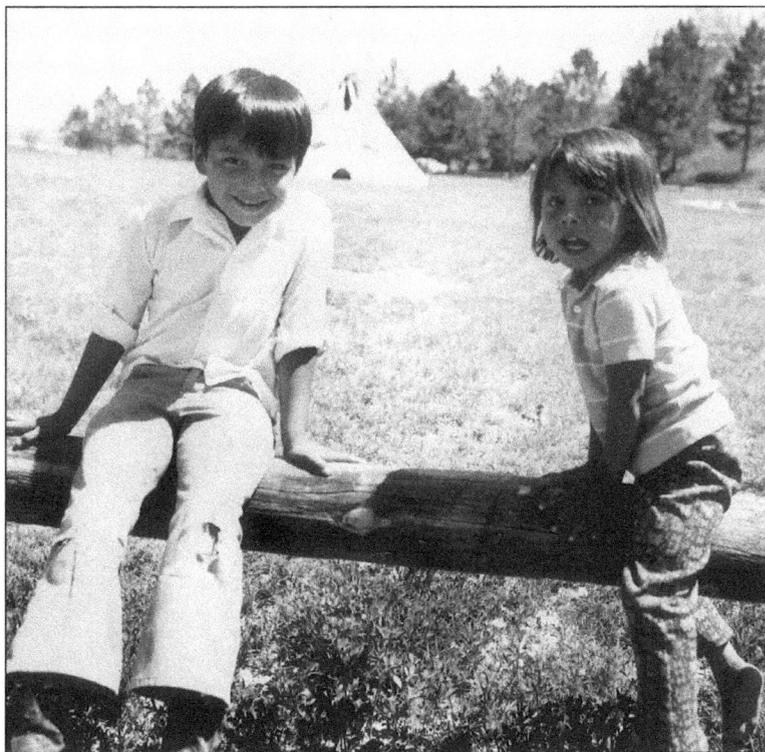

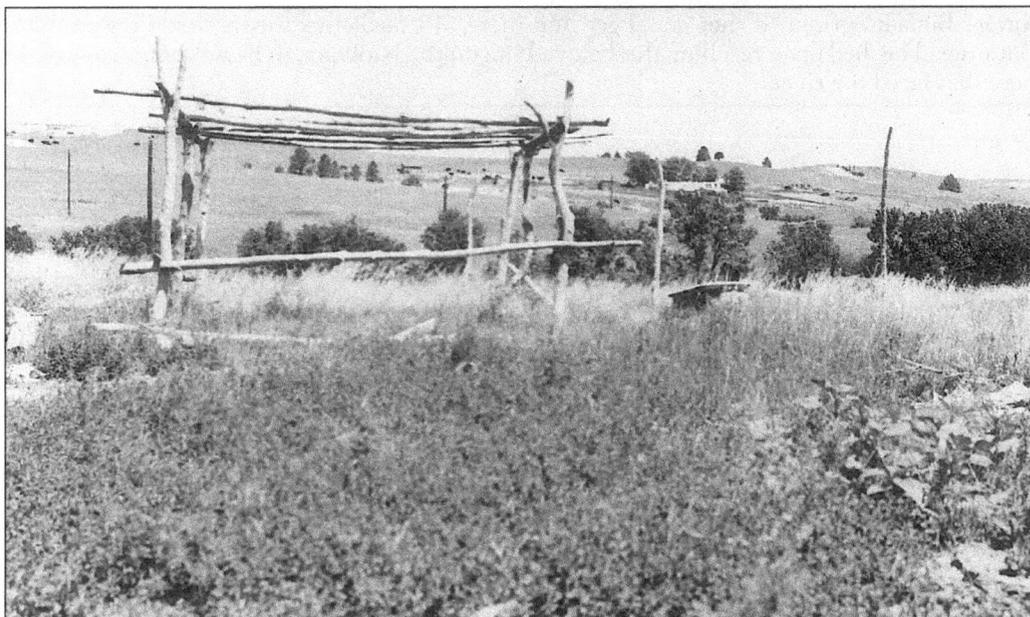

A Sioux Scaffold, Pine Ridge. This kind of scaffold often came to mind when, as a child, Sandoz looked at a certain place in the orchard that a Brule warrior on a visit from the Rosebud, South Dakota, agency, told her about. She recalled in *Hostiles and Friendlies* (85) how she had seen "an occasional old Sioux" go to the spot and pay homage there by smoking "a pipe in the evening sun."

The Old Dyehouse Cherry Tree. The Brule said the tree marked the place where his people erected the death scaffold for Conquering Bear. In *Love Song to the Plains* (179), Sandoz discloses that after rescuing "the wounded head chief," his men whipped "his travois horse" toward Buffalo Spring. "If they could get him there," its medicinal waters would restore him. But instead he died upon reaching this beloved site on the Niobrara, so he was put on a scaffold here that faced the river.

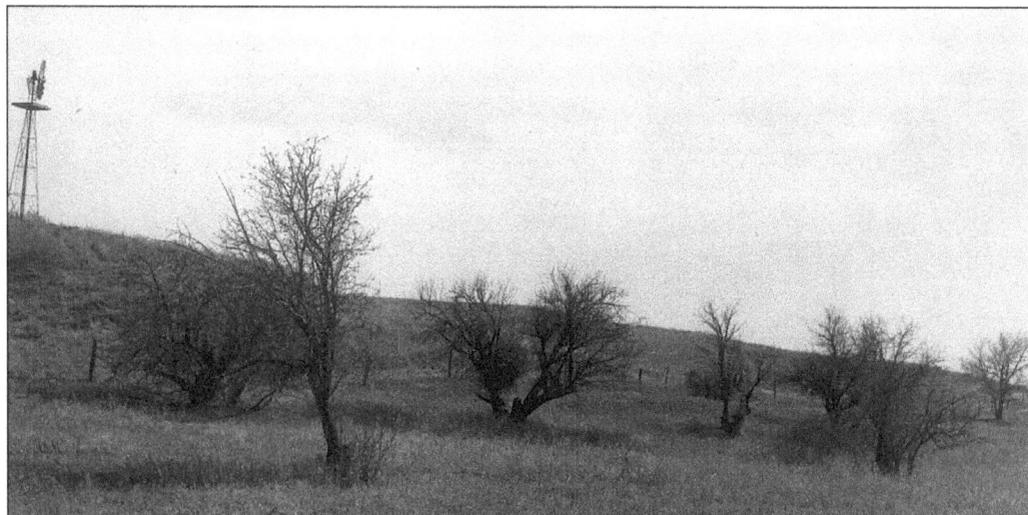

Wood-Gathering. When she was older and disliked having to be out gathering wood, Mari suddenly walked upon an old, wrinkled-faced Sioux in the orchard. He was "gravely dancing" on a "little knoll" some distance from her. In *Hostiles and Friendlies* (38–9), Sandoz depicts how she, feeling guilty about interrupting him while he honored the fallen chief, tried to creep away. But the visitor stopped her, and then called her back with "one word"—"granddaughter."

30

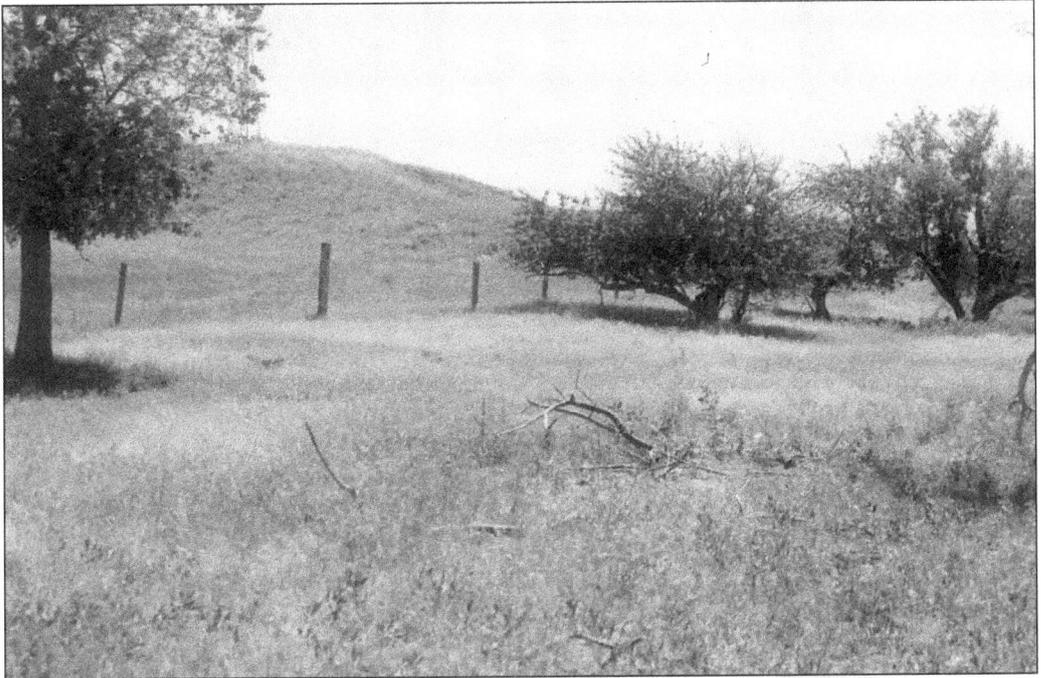

Lesson. Drawing pictures in the ground and using sign language, the ancient visitor told her a story about "the old woman who lived in the moon," then just rising, and of how a "storm. . . always followed" its "first waning." Considering the weather ahead, he wanted to show her, a child, how worthwhile her "task of woodbearing" was. (*Ibid.*)

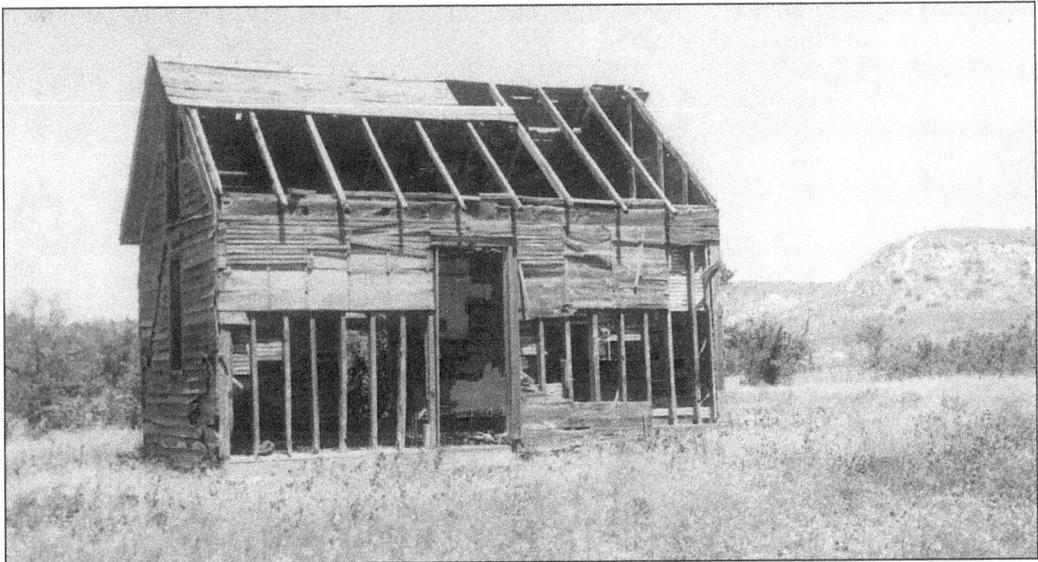

The Abandoned Home of Charley Sears. In "The Neighbor," a piece included in her posthumous collection, *Sandhill Sundays* (1970), Sandoz wrote of how, as a girl at the River Place, she could always count on her family's bachelor neighbor, Charley Sears. He lived here and was an interested friend, who, according to Sandoz in *Hostiles and Friendlies* (46), was always ready to give her the attention she craved or let her borrow from his "tall bookcase full of books."

31

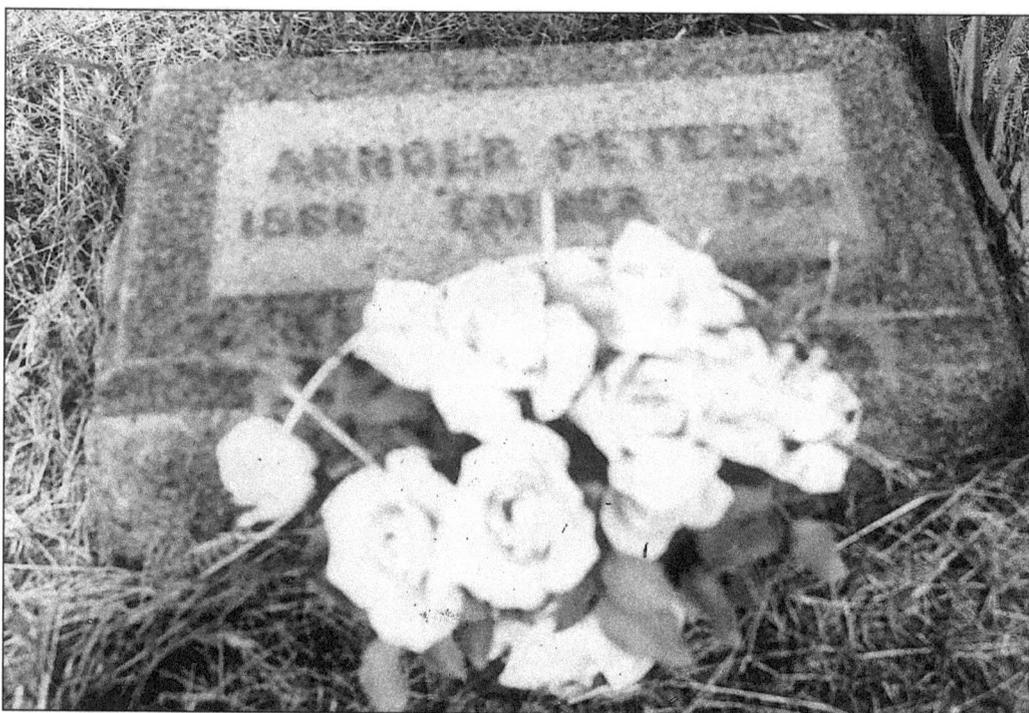

Arnold Peters's Grave. At the Sacred Heart Church Cemetery, this headstone of a Sandoz neighbor brings to mind the passage in *Old Jules* (198–9) where Mari's father contested some filings Peters made for pasturing purposes. As a result, Peters, a shrewd businessman, got revenge by acquiring control of a post office Jules had been operating from his home and then proceeded to move it to another location.

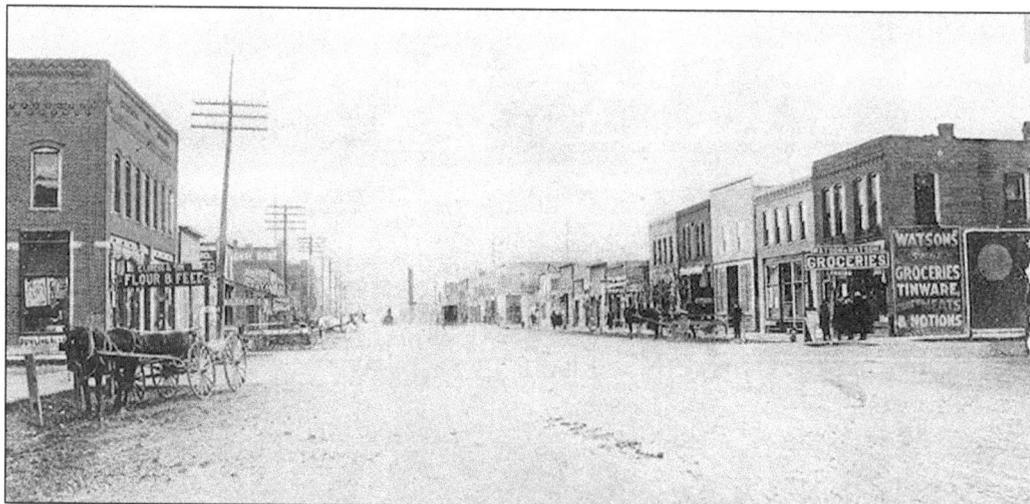

Alliance, Nebraska, 1890. This downtown street scene evokes Old Jules's turbulent career as a locator, as does the grave of Frank Koller, near the grave of Arnold Peters. Once more in *Old Jules* (245, 255 *ff.*), Sandoz provides the background on how Mari's father, after spending a month in the Rushville County Jail for allegedly shooting at Koller, went into the land office on this street and sought revenge in the early 1900s by contesting Koller's fraudulent filings on a pasture adjacent to the River Place. (Courtesy Knight Museum of the High Plains, Alliance.)

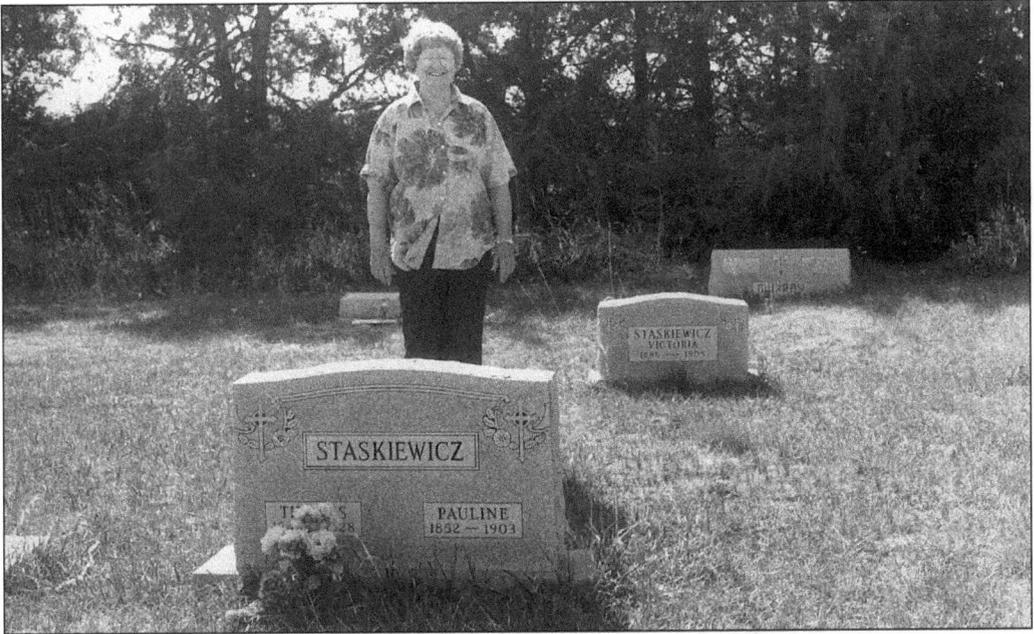

"The River Polak" and the Staskiewicz "Victorie" Romance. Caroline Pifer stands beside the Sacred Heart grave of Victoria Staskiewicz, a Polish girl. The story of Victoria's romance is recounted in both "River Polak," appearing in *Hostiles and Friendlies* (167 *ff.*), and in "Victorie," which was edited and published by Pifer under the same title in 1986. The posthumously-published collection also includes Sandoz's remaining unpublished stories.

Gatepost Pastime. Another childhood pastime Sandoz indulged in was to lean against the gatepost and imagine, while looking out at the River Place road, the lives of the strangers going past. Earlier the road had been an old Mormon trail, made first by Conestoga-style wagons, which left wider-than-standard tracks.

Road Scenes. While Mari watched phenomena around her, like the "wind," which she describes in *Sandhill Sundays* (125) as "singing in the red bunch grass," the horses or wagons that came rumbling across the nearby bridge from the Mirage Flats sometimes brought visitors up alongside the gatepost at the far right. Sometimes they were legends themselves—people with stories which would later become a part of her writings.

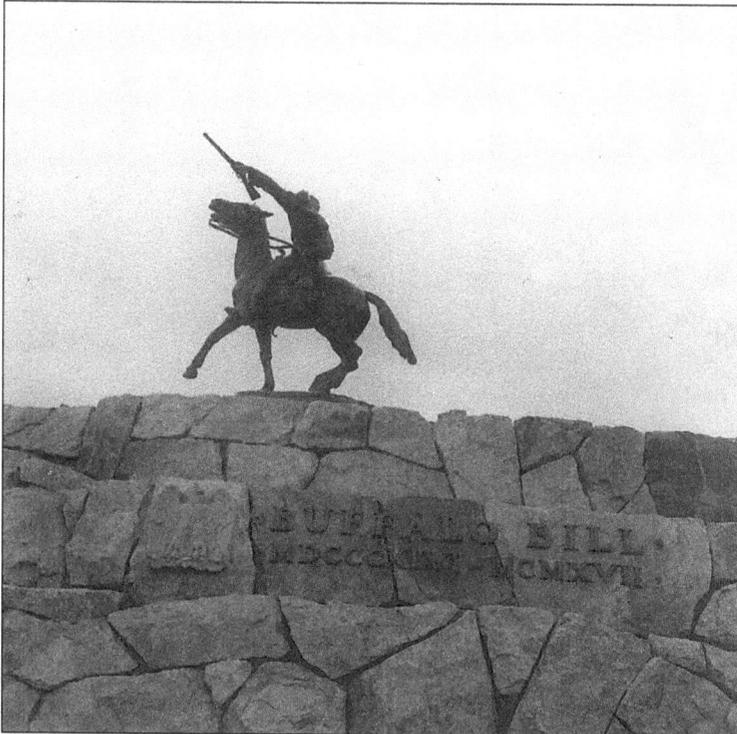

Buffalo Bill (William Cody). He was one such visitor. When he suddenly appeared at the River Place to hunt with her father, Mari was much more fascinated with his long yellow locks than with the fact that he brought along a rifle. It was of the sort he is shown gesturing with on this statue honoring him in Cody, the Wyoming town which bears his name.

Cody's Locks. However, the girl's fascination with the visitor and his shoulder-length hair was to turn into permanent mistrust when she tried to summon him to breakfast the next morning. Though he was already out hunting with her father, she found his wig with the handsome locks still on the bedpost. From then on, Sandoz's mistrust of Cody was such that in future writings she usually debunked him. (Courtesy Nebraska State Historical Society.)

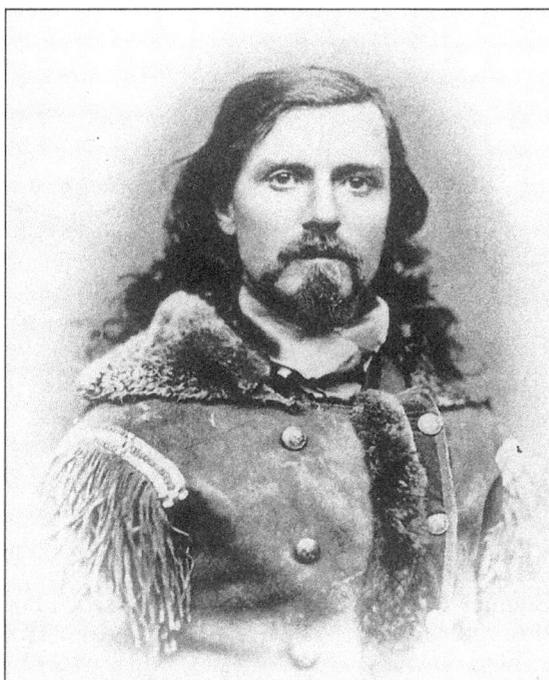

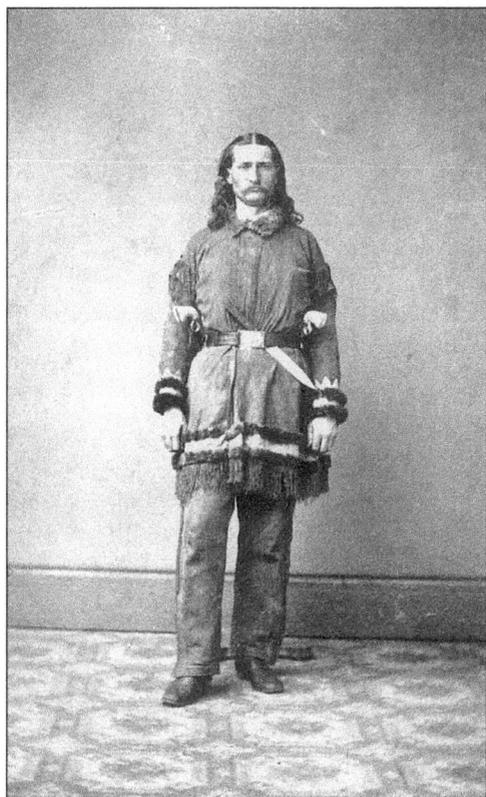

Wild Bill Hickok. Sandoz treated Hickok in a similar way. His story, like Cody's, had interested her from childhood. She began research on both men while still in the sandhills, later putting her findings into a number of her writings, particularly *Love Song to the Plains* (208 *ff.*). Among other Western idols she disliked and whose public images she also deflated, were those of Calamity Jane and General Philip Sheridan. (Courtesy Nebraska State Historical Society.)

Country Schoolhouse. This remodeled schoolhouse marks the site of the Peters School—the closest one to the River Place. Mari entered school at age ten with her brother Jules. According to him, they walked about a mile and a half to attend the school, which mainly served the children of its trustees—the neighbors whom Old Jules most often differed with, John and Arnold Peters. Sandoz in *Old Jules* (312–313) provides the dilemma in which Mari and Young Jules, despite their later friendships with various Peters children, were at first caught up.

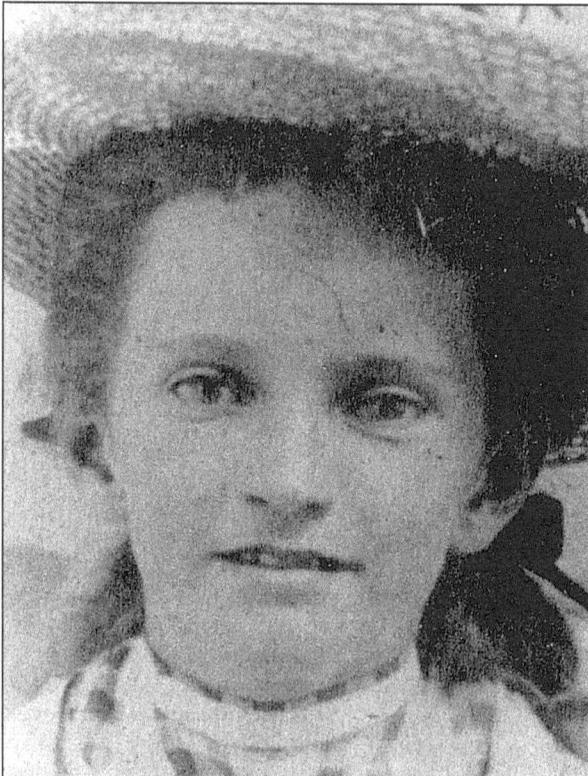

Schoolgirl and Author. Mari and Young Jules entered school speaking only their mother's dialect of Swiss-German, except for a few words of what Mari termed "hybrid English." Nevertheless, by 1908 Mari had mastered English enough to win third place in the *Omaha Daily News* children's story contest and to have her first composition, "The Broken Promise," appear there. (Courtesy Mari Sandoz Estate.)

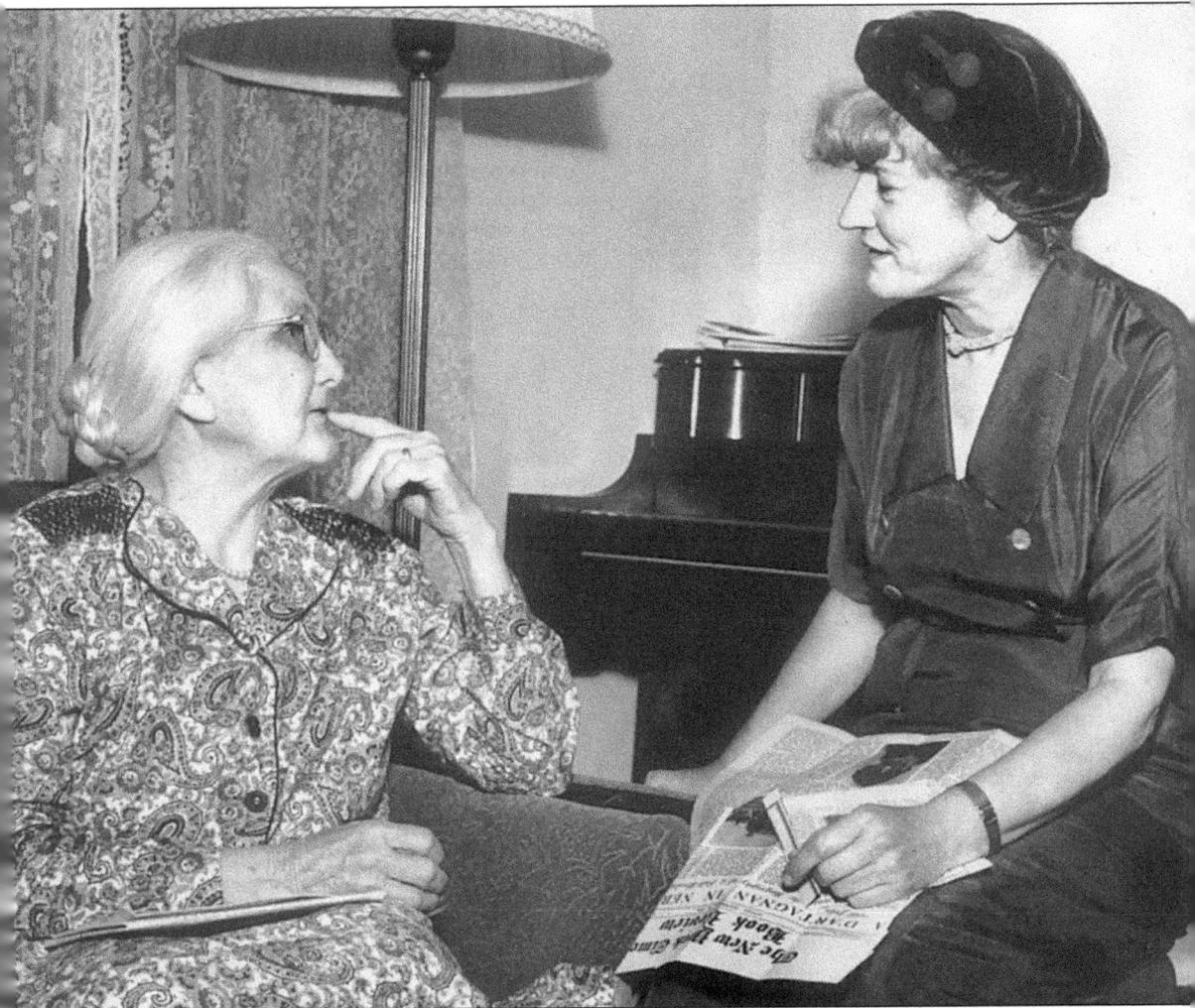

Mari and her Teacher, Sadie Lathrop, 1951. As a grown woman teaching creative writing at the summer writers' conference of the University of Wisconsin, Mari reminisced with Mrs. Lathrop, her favorite country school teacher. While teaching Mari for two years, Lathrop lent her books of fiction and encouraged her to develop her writing skills. Mari said that because of Lathrop's encouragement, she was able, despite Old Jules's strenuous objections to her writing aspirations, to maintain her hopes and to continue to secretly pursue such a goal. Mari also recalled how welcome Lathrop had made her and Young Jules feel at the school even though they really belonged to one in another district 5 miles away. Lathrop remembered how Mari used to sit on the schoolhouse steps and relate her stories to any listeners she could manage. Since Lathrop was frequently among them, Mari acknowledged that here again she had inspired her to put her stories down someday. (Courtesy Nebraska State Historical Society.)

Mae Peters Manion. Five years younger than Mari and a chum mentioned in *Old Jules*, the late Mae Manion was nevertheless Mari's third and fourth grade teacher at the Peters School, which bore her family's name. The daughter of John Peters, Mae Manion remained a friend to the Sandoz siblings throughout her life. She married at the Sacred Heart Catholic Church, with Mari in attendance at her 1912 wedding.

Sheridan County Court House. After Mari continued to cram what amounted to an eighth grade education into four-and-a-half years, she rode horseback all the way into Rushville, Nebraska, the county seat, and without telling anyone, took and passed an examination which entitled her to a certificate permitting her to teach in rural schools. This time, to her surprise, her father demonstrated pride in her accomplishment. Today, the nearby Sheridan County Historical Society Museum on Highway 20 at Nelson Avenue also shows pride in their small, but permanent Sandoz memorabilia displays.

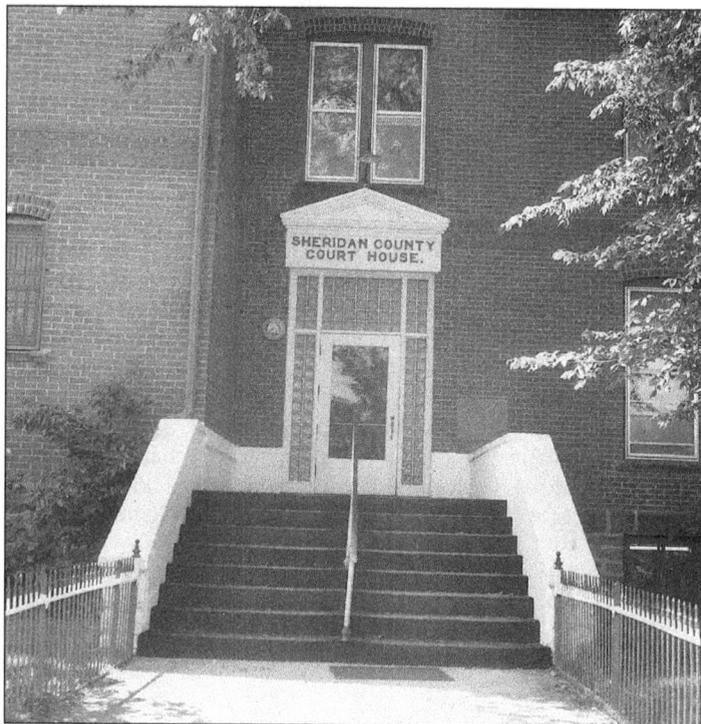

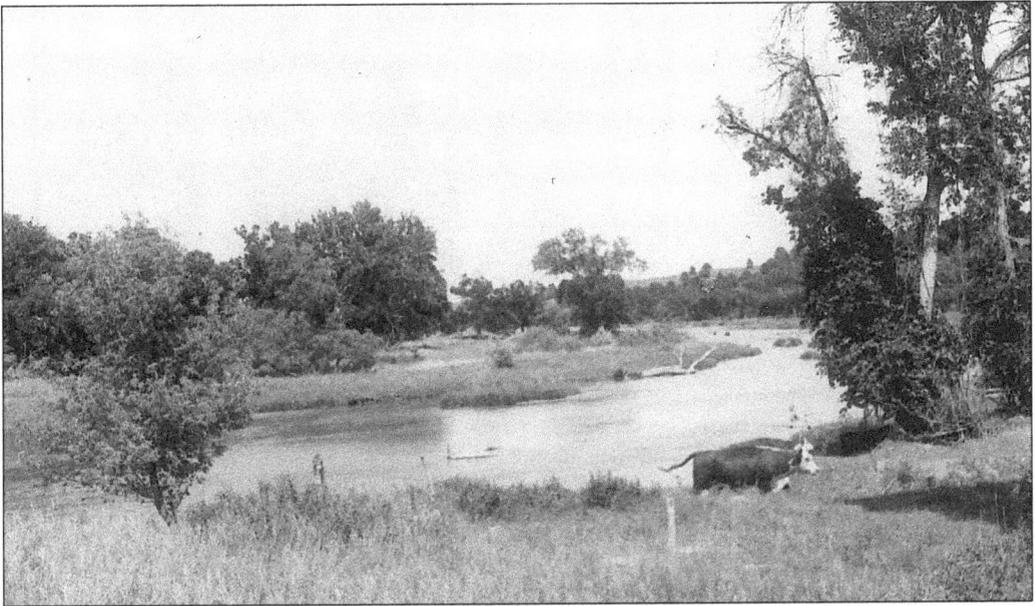

"Slogum House" Site. The area where the Niobrara River makes an oxbow is not far from the Swiss settlements Old Jules made along Pine Creek, but closer still to Smith Lake, which is further south. In selecting the oxbow as the setting for *Slogum House*, her second book and first novel, Mari again chose a landscape familiar to her since childhood. She patterned the Slogums, like the Schwartzes in *Old Jules*, after the Smith family of the area, who local people generally believed hired her uncle Emile Sandoz's killer.

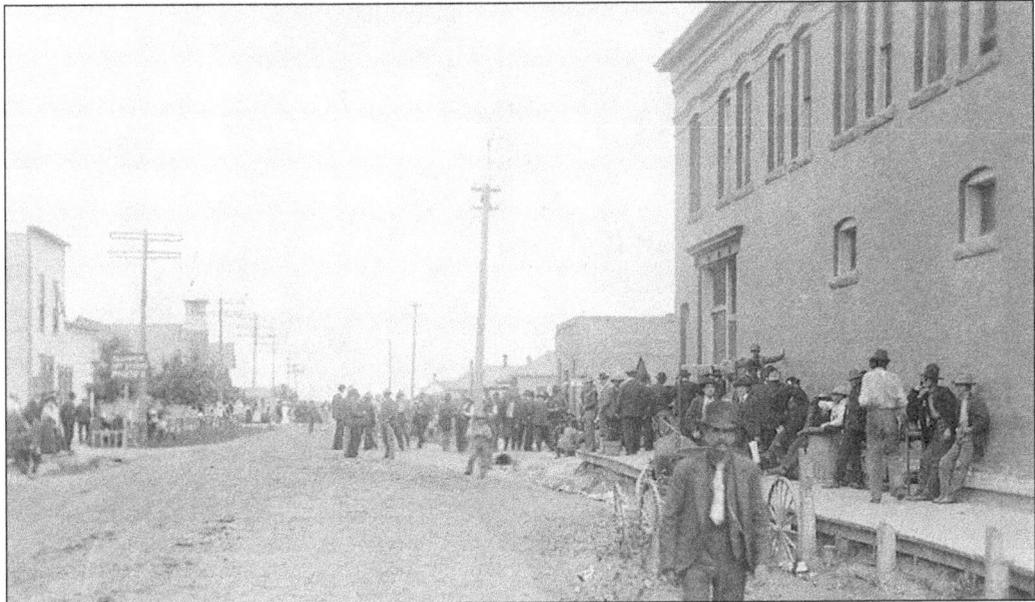

The 1904 Kinkaid Opening, Alliance. The crowd is gathered at the land office at the right, which Jules frequented. His brother's murder and quarrels with neighbors at the River Place had so disheartened him by the time of the 1904 passage of the Kinkaid Act, allowing homesteaders 640 acres of land for $14, that he filed on a Sandhills claim without telling his wife or family. (Courtesy Knight Museum of the High Plains, Alliance.)

Mari's Parents and the Sandhills Move. On hunts with Indian friends such as White Eye to places like Deer Hill described in *Old Jules* (28), Mari's father gained an intimate knowledge of the adjacent sandhills region. Its numerous lakes convinced him that it offered settlers grand opportunities. Again, Sandoz in *Old Jules* (328) supplies the story of how he finally shares his secret with Mary and his family: "Jules had kept his filing from Mary as long as he could, but it slipped out one evening when he was particularly pleased with his supper—quail, with potatoes, fried into golden sticks. . . . Mary threw up her knotted hands and rolled her faded blue eyes back. Now, at last, he had gone crazy. The children drew away into the shadows, their voices buzzing softly. Got to live in the sandhills where gray wolves lived, and the cattlemen, the rattlesnakes." (Courtesy Mari Sandoz Estate.)

Two

THE SANDHILLS: ADOLESCENCE, COUNTRY TEACHING, AND MARRIAGE: 1910–1923

New Sandhills Surroundings. The region that captivated Mari's father most lay about 22 miles away in the sandhills east of the River Place. It became a place for which Mari, from her adolescence onward, would know as deep an emotional identity as the one she would also have for the rest of her life with the Niobrara of her childhood. In *Love Song to the Plains*, Sandoz furnishes some of the best examples of the poetic style with which she produced images through language; the work displays, too, the extent to which she used her emotional identity with the sandhills to produce prose designed to make readers respond with the sense of recognition she intended them to experience. In her foreword to the book—which she initially named *Nebraska: Love Song to the Plains*, only to have her publishers insist on dropping the reference to the state—she affirmed employing special rhythm patterns to convey moods and landscapes "perhaps as abrupt as a cut bank or as vagrant as a dry-land whirlwind."

Old Rushville. However, with the 1910 move, Jules, unlike before, was neither the first white man nor settler with visions and plans to move into the region. In the late 1800s, Albert Modisett rode horseback into Rushville—the town after Hay Springs, closest to the River Place. Modisett then proceeded into the sandhills to found a ranch at the head of Deer Creek near where Jules often hunted.

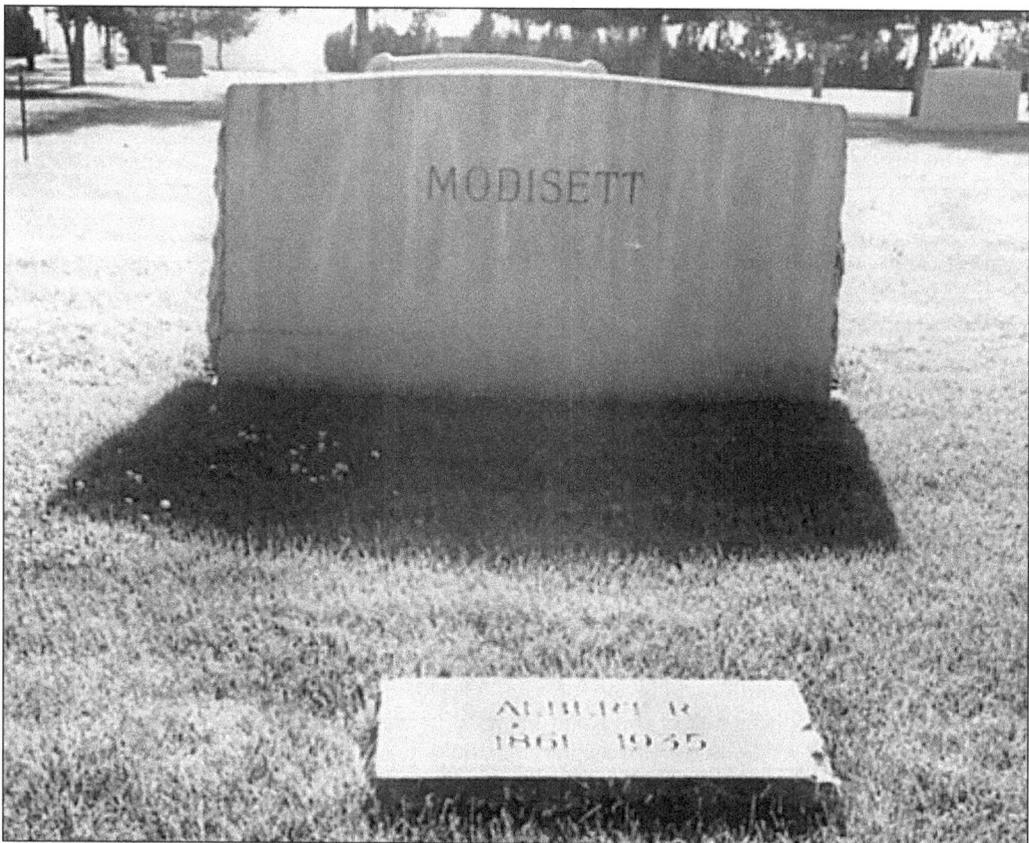

The Modisett Grave, Rushville. While Modisett figured among the most prominent leaders and ranchers of the area, he, unlike many of the sandhills cattlemen, took his fence lines down before the government intervened. Later, he took an interest in Mari and particularly in *Old Jules*, which mentions him, his family, and their twin windmills. Mari exchanged occasional letters and lunched with him in Lincoln and Omaha before his 1935 death.

The Modisett Club, Rushville. Thirty years Mari's senior, Modisett had been divorced by a wife who disliked the sandhills so much that she returned to West Virginia. Always civic-minded, he left most of his estate in trust for Rushville with bequests for many organizations such as this club for older men. On his property, he also dammed up the head of Deer Creek and left it for public use.

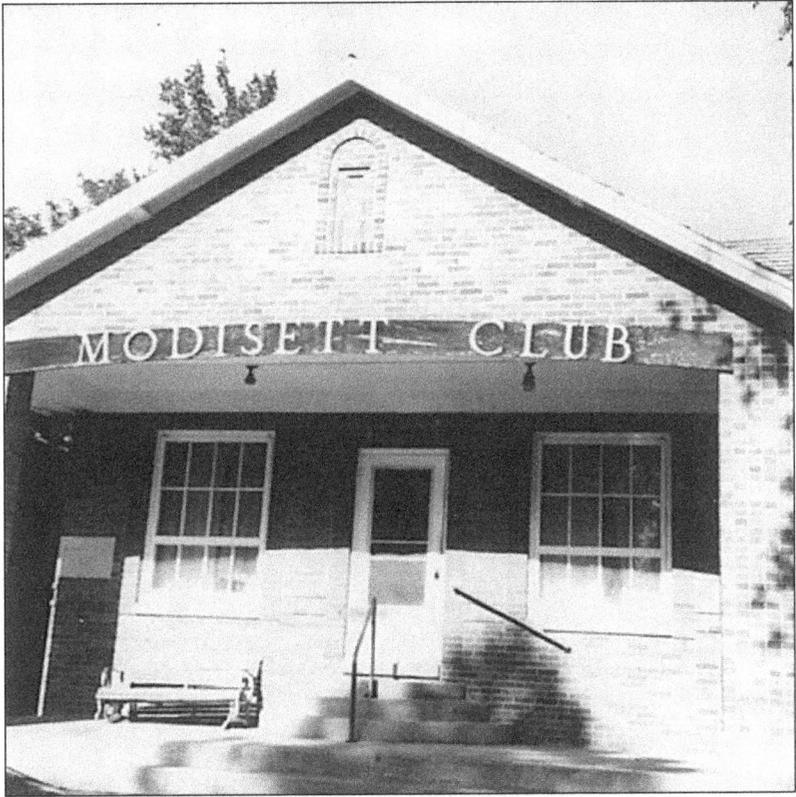

Snakebite Valley. After deciding to relocate, Old Jules first tried unsuccessfully to prove a claim in Snakebite Valley. Its location was a place on the other side of the sandhills, visible beyond these flowers pictured at his last home. Today the claim site is near the ranch outside Lakeside, once belonging to Pete Sandoz. In *Old Jules* (331), Mari enlists help from this cousin after her father's snakebite.

43

Blanche Sandoz, 1977. Blanche, the widow of Mari's youngest brother, Fritz, still lived at the ranch which they bought from Pete Sandoz years after the incident. Blanche told students about the ranching life she and Fritz experienced during most of their married life. Their place was adjacent to the claim her father-in-law abandoned after successfully surviving the bite from the rattler that occurred during Fritz's childhood.

Sandhills Lake. Following his marriage, James Sandoz built a home near the lake in this "wet-valley region," as Mari called this area of "hay flats. . . lying between the parallel sandhills." (*The Cattlemen*, 431.) Alice Elsberry, one of James's two children, grew up here but now lives with her husband, Virgil, on a ranch 27 miles outside Gordon. She has replaced Caroline Pifer as executrix of Mari Sandoz's literary estate.

James Sandoz on an "Old Jules Tour." James gave Pifer, who led this tour annually from 1967 until recently, pointers on how he and Mari—an occasion further recounted in *Old Jules* (350–7)—spent most of a summer alone together on the new claim. While the rest of the family remained at home on the River Place, they had only a rifle for protection. That stay was only the first of several; after the move they started guarding the River Place together.

Walgren Lake. About 4 miles south of Highway 20 and midway between Rushville and Hay Springs, Walgren is the first of the region's numerous lakes visible from the road. Sandoz wrote "Ossie and the Sea Monster," published posthumously, about it. The story concerns the dragon-like creature inhabiting it who fell in love with a small man from the sandhills. Sandoz mentioned the monster in several works—*Old Jules* (412 f.) and *Love Song to the Plains* (246–8) among them.

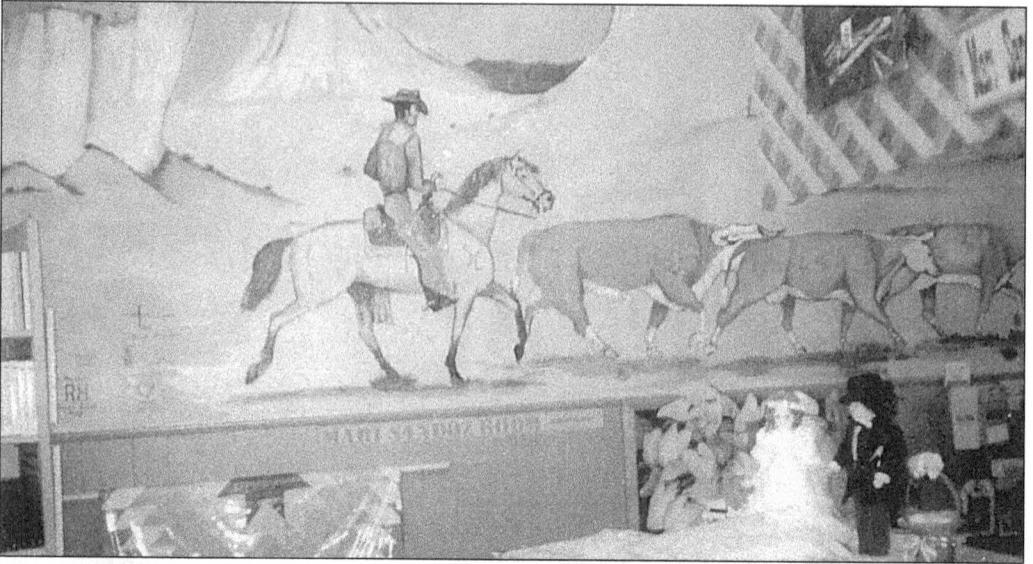

Mari Sandoz Room Mural, Gordon, Nebraska. Some 30 miles north of Sandoz's new home at "the Hill Place," this room with a mural at the Ad Pad, 117 North Main Street, serves as a good departure point for a visit to the author's last home in the sandhills and her grave there. The mural was executed by the late Verdell Pawnee Leggings, a Pine Ridge Lakota. The room is open every day except Sunday from 9–4, and has permanent displays of Sandoz memorabilia, including exhibits of photographs, clothing, and furniture. All of Sandoz's books are on sale as well as many publications about her. (Courtesy Mari Sandoz Room, Gordon.)

Caroline Pifer Beside a Wagon. At the time of this photo, the wagon was displayed in the backyard of Gordon's "Iyuko Upo" (or Rawhide) Trading Post. During Mari's childhood, this kind of wagon was a common mode of transportation for both settlers and the neighboring Oglala Sioux, who long patronized the post. As recounted in *Old Jules* (330-1), when Old Jules's rattlesnake bite occurred, Mari drove for help in such a wagon with him stricken beside her.

Crazy Horse and the Sandhills. In traveling from Gordon to the Hill Place, visitors of today follow what the Gordon Chamber of Commerce has designated "the Mari Sandoz Memorial Drive" on the sign advertising it near Highway 27. The road running south from Gordon to Ellsworth soon crosses the Niobrara River, and after entering the sandhills, seems to run like a ribbon through them. Looking at the hills, the Sioux leaders who once roamed the area come to mind, especially the one whose name, as Mari recalled in her *Crazy Horse* "Foreword" (*vii–viii*), "ran" through all the fireside talk of her childhood "like a painted strip of rawhide in a braided rope." He—Crazy Horse—was "the greatest of the fighting Oglalas."

Wagon-Wheel at Entrance of Road to Hill Place. Across from the state marker (*Cf. supra*, 9), this wheel marks the entrance to the country lane winding off Highway 27 and proceeding into the Hill Place. Ellsworth, Nebraska, lies some 17 miles to the south. The lake here reminds us that this area possesses one of the largest underground deposits of fresh water found west of the Mississippi River.

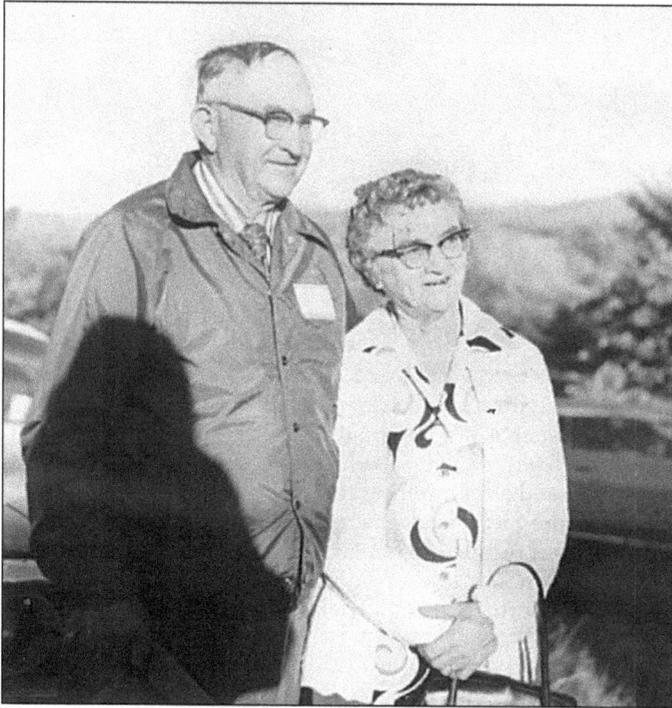

James and Marie Sandoz, 1976. Pictured at the Hill Place, they stand with the last orchard of Old Jules behind them. James was always considered his father's favorite; yet he, like his brothers, came to be the kind of cattleman Old Jules never was. Nevertheless, James shared with his father a deep interest in orchards, and with the exception of Flora, raised more fruit than any of their siblings did.

Marie Got James to Tell a Story. Once a Gordon teacher, Marie insisted that James tell about his and Fritz's experiences during the summer they were elected to sell the untended fruit then ripening over at the River Place. In recounting their experiences, James recalled how, since they disliked fixing meals, they would often forgo the task by climbing up a cherry tree to eat their fill of its fruit before going to bed.

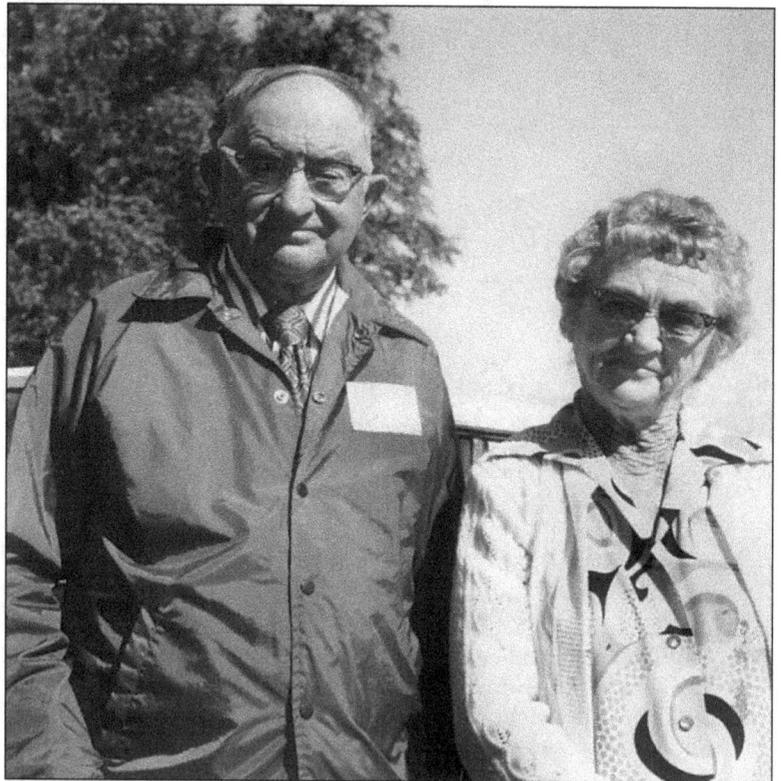

The Hill Place. Until the death of Flora, the house served as the last family home for Mari's siblings. Now it houses tenants who are not relatives, but it is still tended to by Cash Ostrander, the great-grandson of Old Jules. Mari's is the only grave located at the place from which scenes within her writings abound.

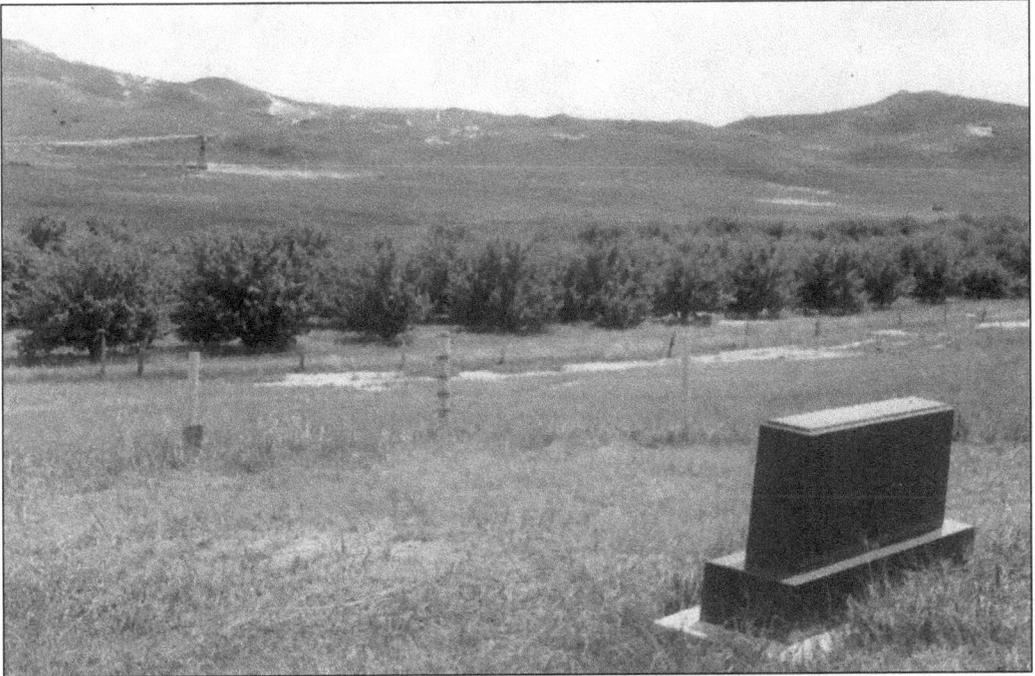

Mari Sandoz's Grave. From a site reminiscent of Indian Hill, Sandoz's monument looks out to the sandhill-lined valley of her Nebraska youth and to her father's last orchard—all scenery she loved and wrote about. After her death in New York on March 10, 1966, her siblings brought her home, as requested, for burial here.

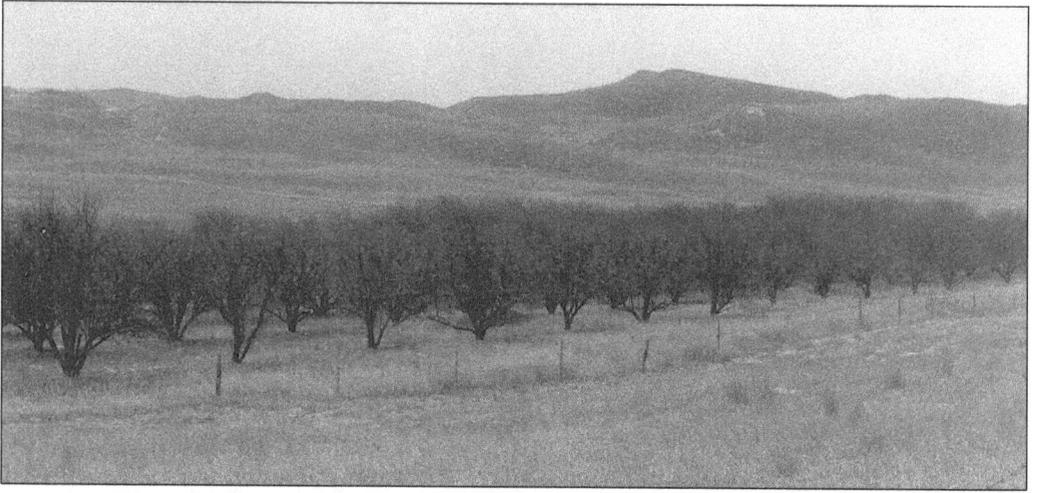

Another View of the Orchard. This view from the same hillside with the grave shows the space between the trees. Old Jules not only produced apples, plums, and peaches, he practiced truck farming by planting rows of peas between the fruit trees for the orchard's entire length. Besides furnishing produce, the arrangement prevented the soil from blowing away from the trees' roots.

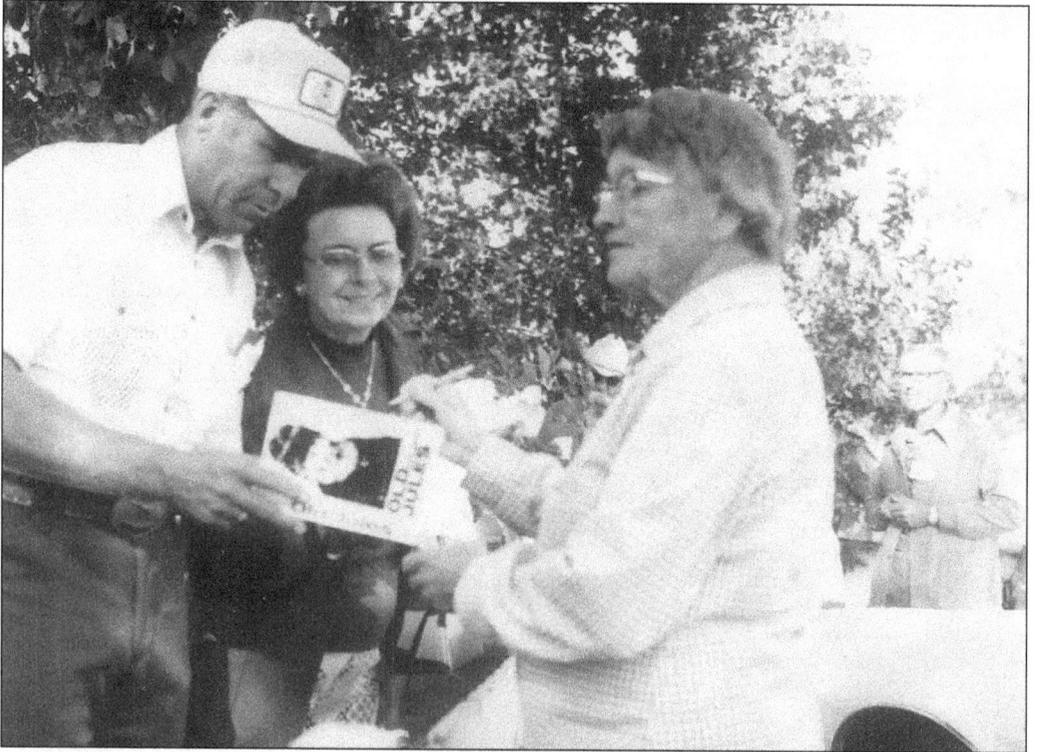

The Late Flora Sandoz (Kicken), 1976, Shows Guests "Old Jules." After her divorce from Boris Kicken, who was from a Dutch family that Old Jules located in the sandhills, Flora made her home at the Hill Place and single-handedly ran the fruit farm her father began. She often welcomed guests, like this couple, inside to see the library of Mari's books and other memorabilia concerning her life which she kept on display.

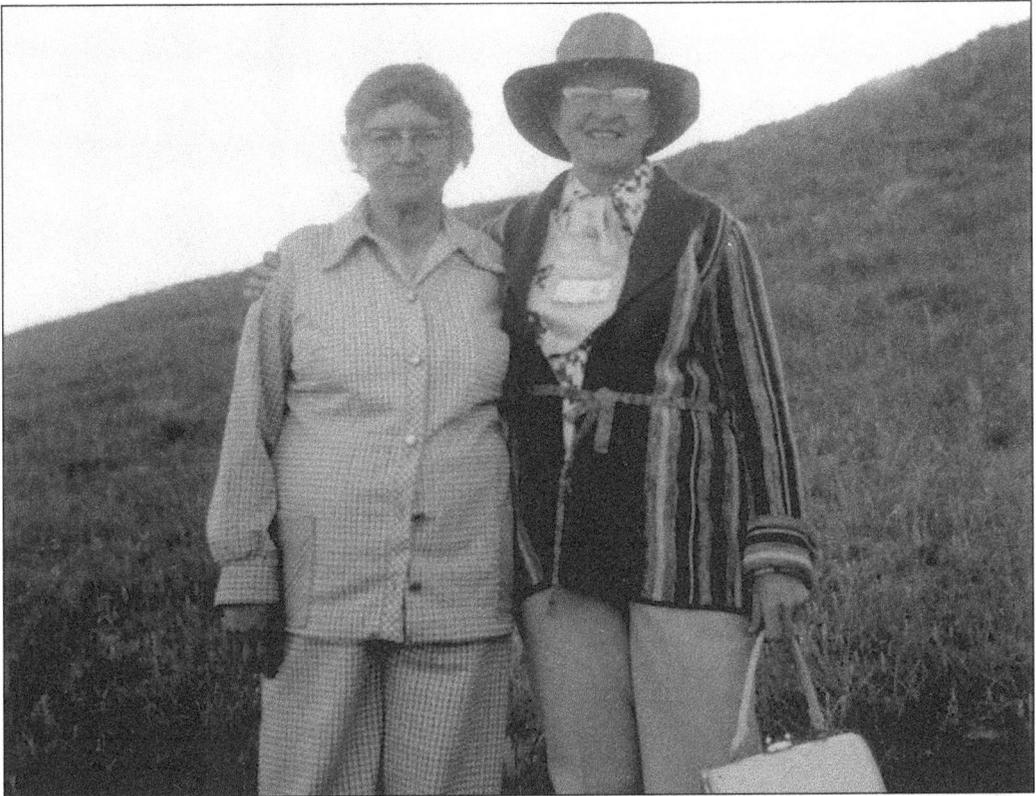

Flora and Caroline, 1976. Mari's only sisters talked about her life as they stood beside her hillside grave. In the year 2000, only Caroline remained of all the siblings. At the time of the photograph, students from the first Chadron State workshop on Sandoz offered by Dr. Richard Loosbrock, Professor of History, were gathered around the sisters, listening to their reflections.

Bunkhouse. This dwelling is next door to the family's last house. Once it served three of Mari's siblings—James, Fritz, and Caroline and their spouses—as their first residence after marriage. It is typical of quarters built for cowboys and ranch hands who neighbored and preceded the family in this area when the land, in its entirety, formed part of the Spade ranch, whose owners violently opposed homesteading.

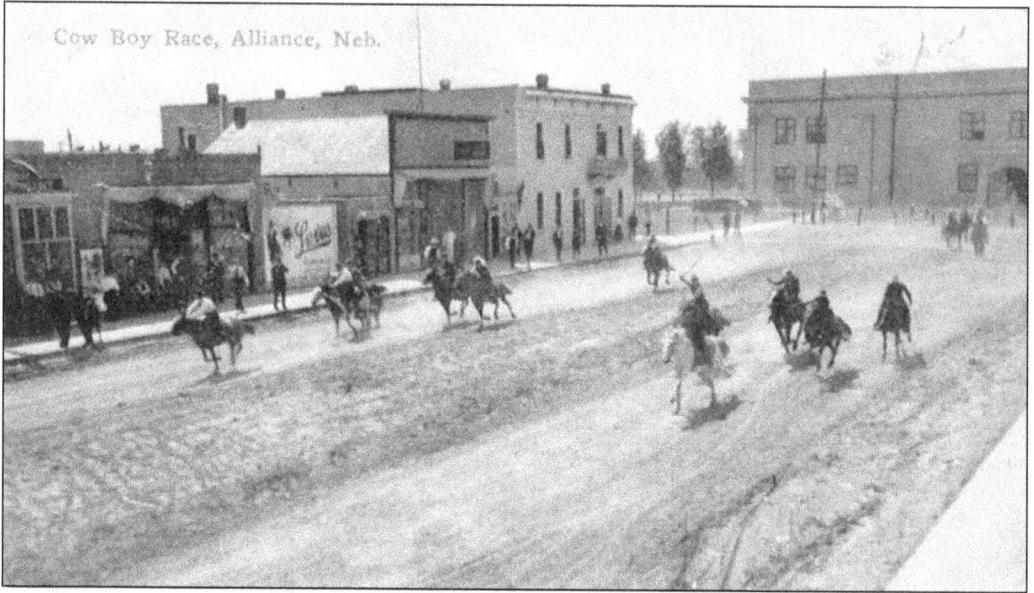

Cowboy Race, Alliance. These cowboys flying down the main street of Alliance around 1910 are pictured in the kind of race often held on July 4th, and are evidence of the kinds of sports and activities with which the children of Old Jules became well acquainted—after their move to the sandhills and on visits to this town, where their father conducted much of his business. Later most of them, as well as the offspring of homesteaders he located on claims in the sandhills, became the leading ranching families of the area. (Courtesy Knight Museum of the High Plains, Alliance.)

Blanche Sandoz, right, with Wayne Britt, left. At the time of this photograph, Wayne Britt, a distant relation of the Sandoz family through Old Jules's younger brothers, was helping Fritz's widow, Blanche, run the ranch she and Fritz owned near Lakeside. Wayne's forebears homesteaded a ranch at Pine Creek which is still in his family. They included the Pochons, other French-Swiss immigrants in the area, who are mentioned in *Old Jules* (162, 402, 413).

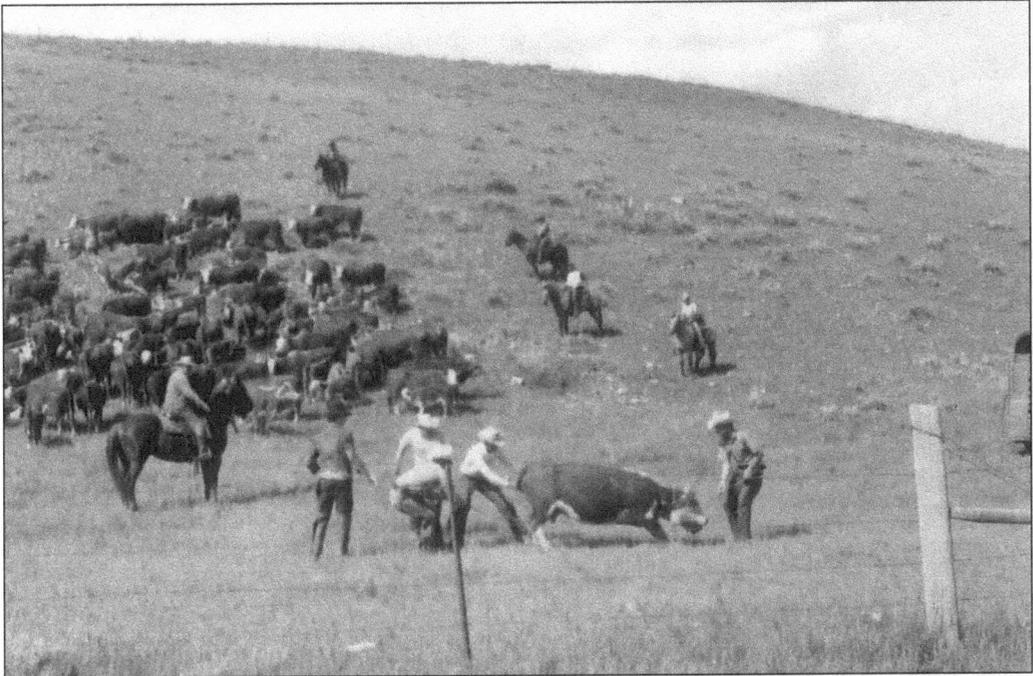

Modern-day Cattle Roundups. Such activities are familiar sights now in the sandhills, but in the days during Mari's adolescence, desperados on the payroll of the big ranching outfits like that of the neighboring Spade Ranch often roamed the range, threatening and inflicting trouble on the newly-arrived homesteaders. Mari noted in *Love Song to the Plains* (265) that her father sometimes had to protect his clients "with guns" against "the hired killers."

The Harington Sod House. Bob Olive was killed by Whit Ketchum in the dugout behind this sod house in 1887. Bob and Print Olive and their brothers were Texas outlaws of the day who figured among the worst troublemakers in the sandhills. In both *The Cattlemen* and *Love Song to the Plains*, Sandoz tells about the Olives' cold-blooded murders and how they scared settlers off homesteads. (Courtesy Nebraska State Historical Society.)

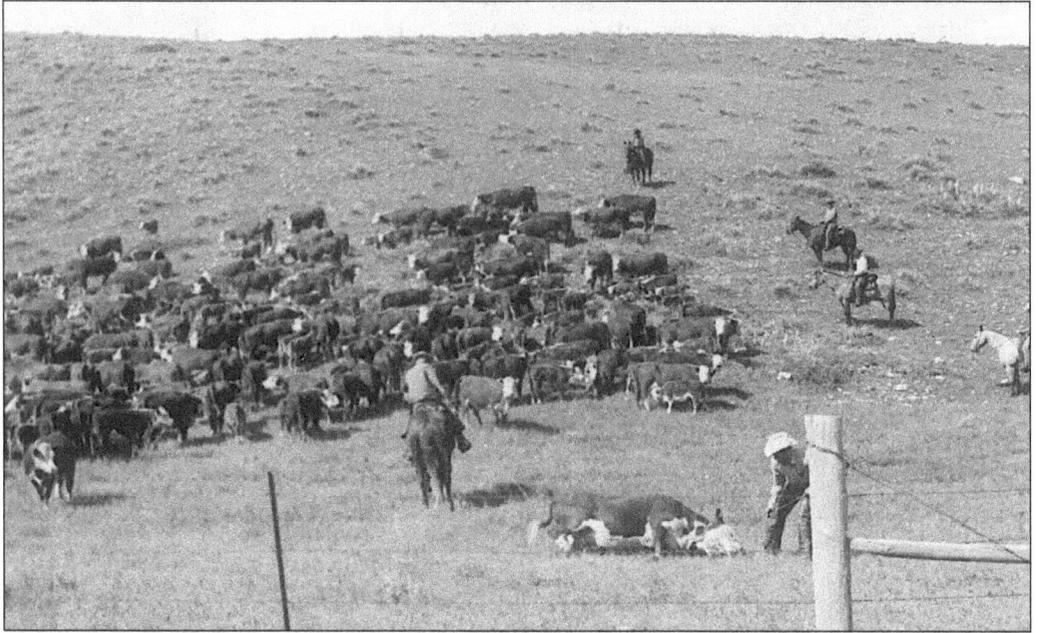

Today's Ranchers are a Different Breed. These days, with outlaws gone from the scene, the ranches of the area are often operated by families who are able to claim instead a long history of friendship and ties with Mari and all her siblings. Mari summed up her feelings in *The Cattlemen* (*xiv*): "The rancher is the encompassing, the continuous and enduring symbol of modern man on the Great Plains."

Ruth Davis Hooper, Lakeside, 1976. This rancher friend of Mari's was the daughter of William J. Davis of the Pine Creek area and was raised near the River Place. Her father, Bill, accompanied Jules on the big game hunt detailed in *Old Jules* (158–9), and he also helped to apprehend Emile's killer by riding in the posse which was promptly formed afterwards. Ruth enjoyed reunions with Mari in Lincoln and New York.

Hooper-Sandoz Ties. "Johnson" Hooper, Ruth's late husband, was among the ranchers possessing long-standing ties with the Sandoz family. Starting as homesteaders of Old Jules's days, the Hoopers lived in a sod house on the ranch where Ruth later raised her children. Her cattleman son, Nolan Hooper, served as a pallbearer for Mari. While writing *The Cattlemen*, Mari exchanged letters with Ruth's brother-in-law, Pat, one of which is included in Stauffer's *Letters'* edition (292–4).

Jules Alexander Sandoz, 1976. When Mari's brother died in 1980, he and his sister Caroline were occupied in writing his privately-published memoirs, *The Son of "Old Jules."* Unlike their father, he basically earned the bulk of his living as a rancher. Like Mari, he excelled in horseback riding and storytelling. Often his memories revealed an additional view on an experience that Mari had written about.

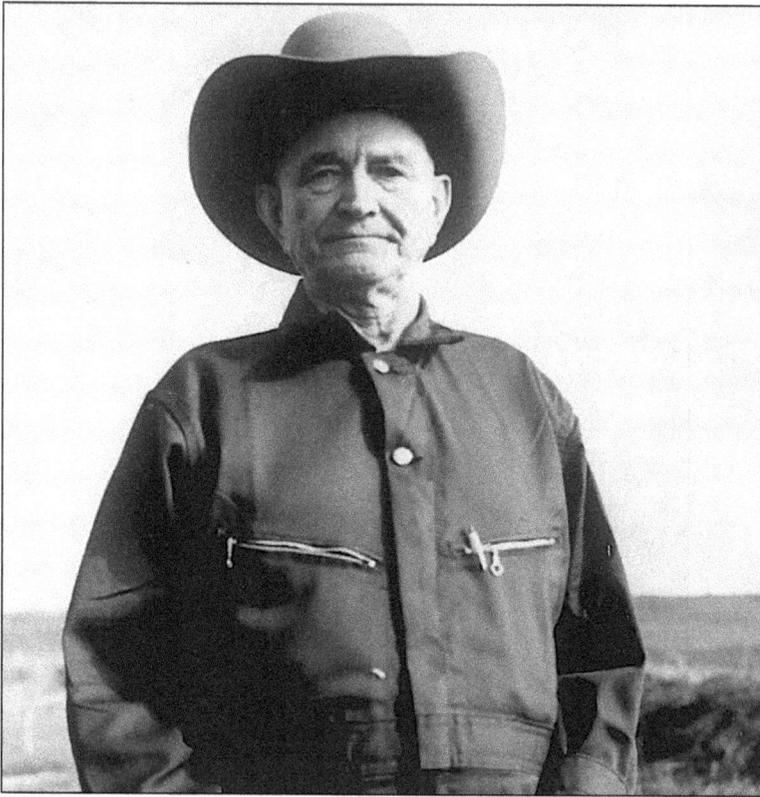

Brother Jules's Recollections. Among his remembrances of episodes related to Mari's works was the time in 1909, when he helped their father take some cows and the family's horses over to pasture them on the new claim. There they erected fences to contain them, but soon after leaving the animals to graze protected in their new surroundings, a Spade ranch herd rushed in and knocked the fences down.

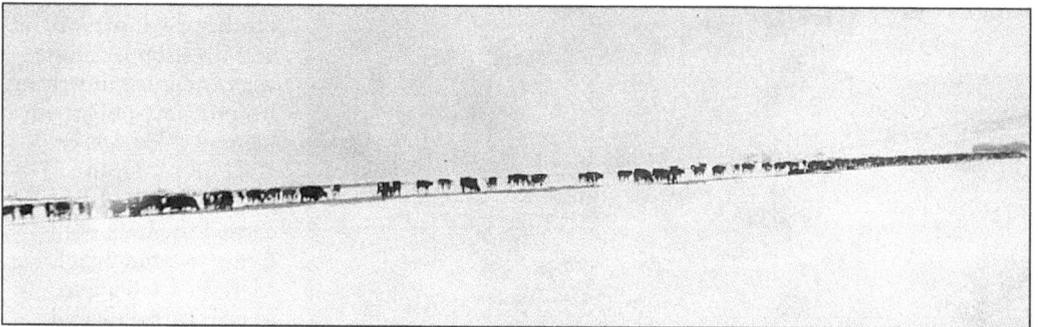

Brother Jules's Cattle in a Late May Blizzard, mid-1950s. Jules also spoke of the time recounted in *Old Jules* (361–4), when a blizzard caused the family's cattle to drift away, and their mother sent him and Mari out to locate them. Comparing their experience with his during this later blizzard, he emphasized how he protected his eyes from the sun glare that had caused Mari's left eye to go blind. (Photo by and Courtesy the late Jules A. Sandoz.)

Horses' Appeal. Sandoz expressed her love of horses and colts in *The Foal of Heaven*, an unpublished novel and the last of the titles that Caroline Pifer brought out for the Sandoz Family Corporation. Horseback riding, at which Mari excelled, was something she later missed from her sandhill days. However, once she became established, she enjoyed vacationing and riding at the ranch of the Van Fleets outside Boulder, Colorado.

Grouse (Center) in Flight at the Hill Place. This grouse has brown, red, and gray plumage, and is a Nebraska game bird related to the pheasant. Sandoz mentions grouse in various works, including *Old Jules* (*viii*, 20) and *Hostiles and Friendlies* (126). Grouse like the one in the center of this photo are frequently seen flying up from the hayfields at the Hill Place, one of which is seen here, or performing their mating dances nearby. Pheasants and prairie chickens also frequent the area.

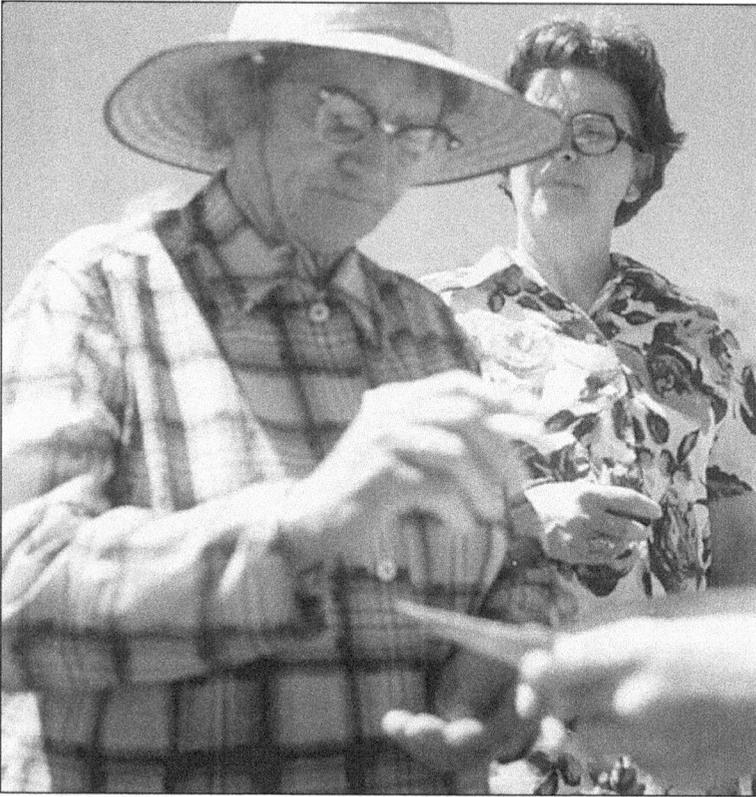

Flora Sandoz Identifying a Hill Place Wildflower. Flora was named—and well-named—by her sister Mari. Flora not only maintained her father's interest in orchards and extended his work in making their last home a recognized experiment station for the state, but was a trained botanist as well. After earning a botany degree from Minnesota, she also became an authority on Nebraska wildflowers, particularly those at the Hill Place. Maybelle Hooper, from Rushville, looks on.

"Martha of the Yellow Braids." At the entrance to the Hill Place off Highway 27, this sign indicates the area where Mari's best friend lived in the sandhills. Sandoz wrote an article about how inseparable she and this friend, Martha Fisher, were up until Martha's marriage at a young age. This story is now included in *Sandhill Sundays* (1970), the posthumously-published volume of Sandoz's recollections.

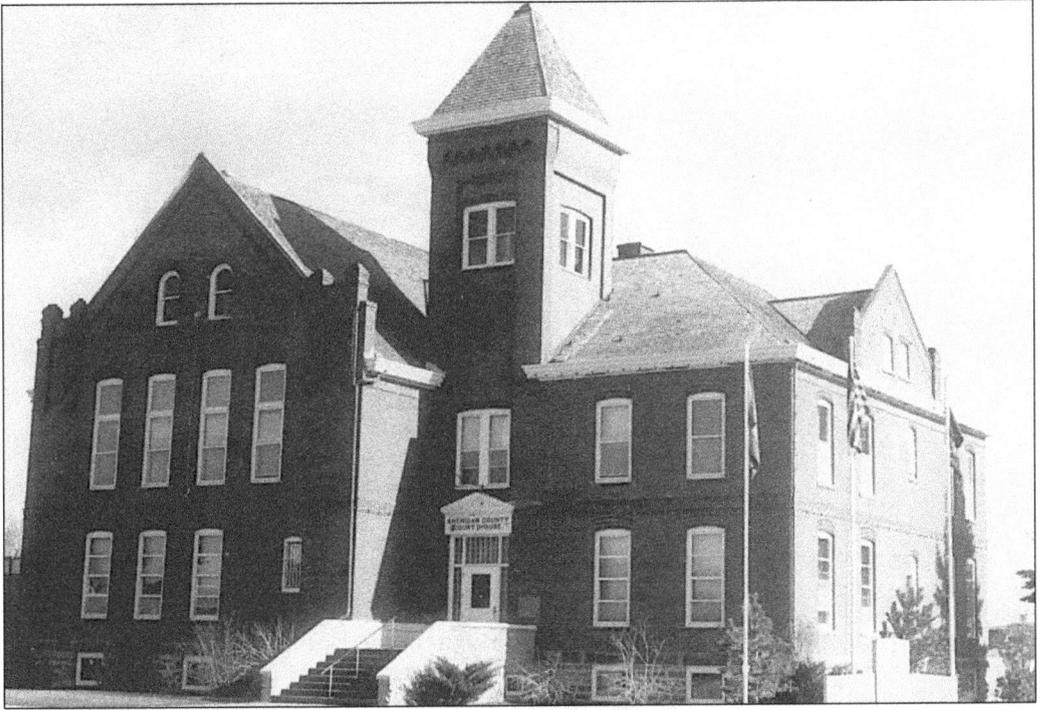

Another View of the Sheridan County Courthouse, Rushville. At age 17, after receiving here her license to teach in country schools, Sandoz began a seven-year teaching career. Most of the time, she taught in an area of the sandhills either near the Hill Place or in its general proximity. An exception occurred for one year when she went to Cheyenne County and taught at the Dalton School near Sidney.

Teaching at Home. With a starting salary of $40 for the entire term, Mari remained at home, and initially taught at the new school her father proudly established among these present-day buildings at the Hill Place. Later she taught close by at both the Strasburger and Hunzicker sod house schools.

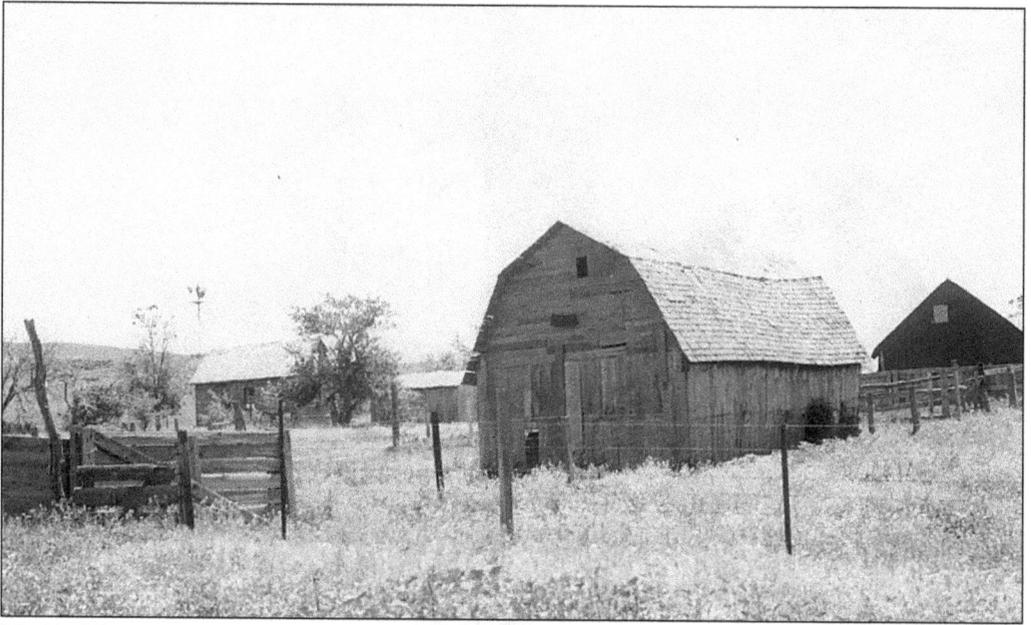

Mari's Classroom in a Barn. In her father's Neuchatel-style barn, a building similar to this one outside Rushville, Mari taught neighborhood children while Old Jules served the school as trustee. Sandhill barns, besides sometimes serving as schools, were often the scene of dances such as the memorable ones described in *Old Jules* (374, 385, 394 f.), which Sandoz's father—as was the custom—decided about giving.

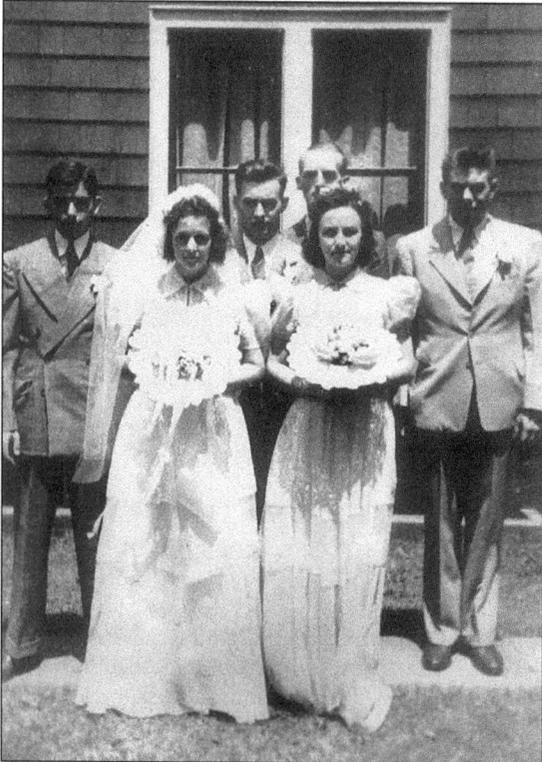

Marriage to Wray Macumber, 1914. When Mari was 18, she was married by a county judge in Rushville to Wray Macumber, a bachelor from Iowa, who started seeing her after he began homesteading a claim neighboring the Hill Place. Caroline believed Mari married to escape further domination by their father. Mari's female attendant was Wray's sister, her good friend Jennie Merrick. (Courtesy Nebraska State Historical Society.)

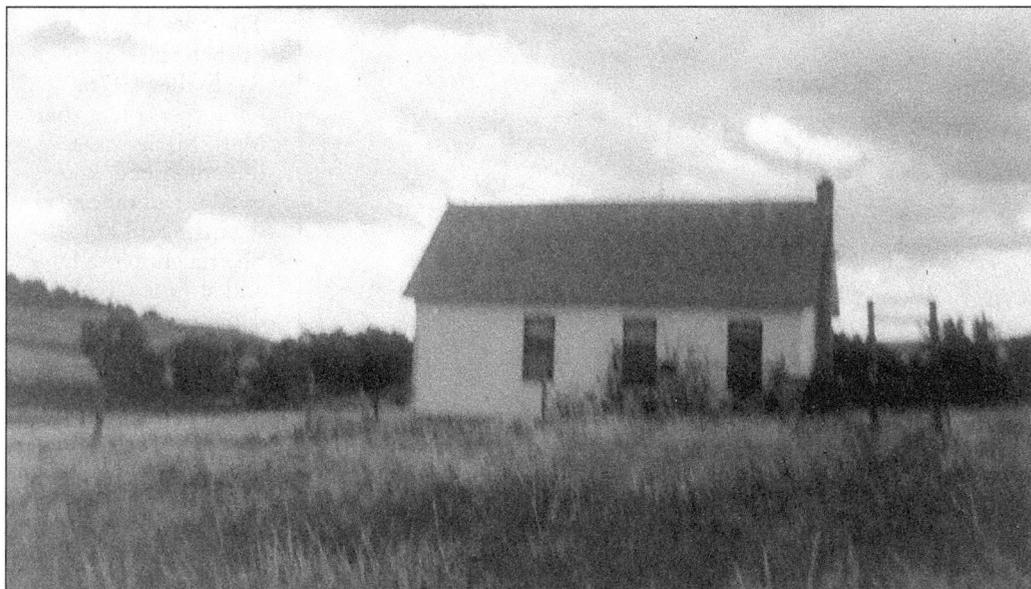

One-Room Sheridan County Schoolhouse. This Pine Creek school is typical of those in which Mari continued teaching for the next five years while she and Wray lived on his sandhills claim, and she was at the Strausburger and Spade Ranch schools. After tolerating an unhappy marriage, she gave up wedding bands forever. She got a divorce in 1919, while teaching in Pine Creek briefly, then she went to Lincoln to attend business college.

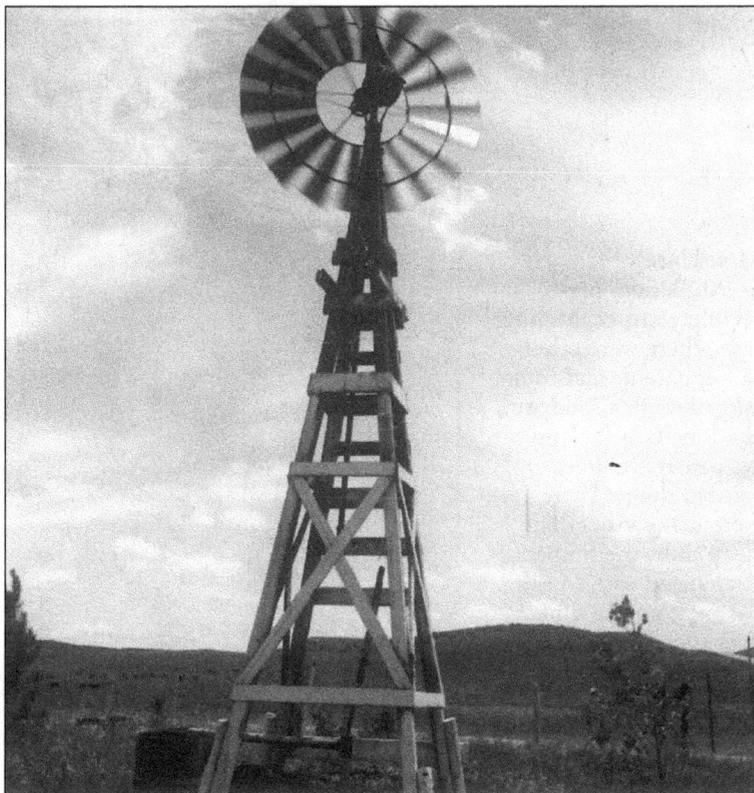

Windmills and Sandhills. The twin windmills on the Modisett ranch appear in more than one of Sandoz's writings. In *Old Jules* (328), she mentions herself and her father stopping at "one of the Modisett mills at the foot of Deer Hill" to water their horses. In "The Vine," which appears in *Hostiles and Friendlies* (122)—a story that Pifer claims is based on Mari's failed marriage—the husband fills the homestead's water barrels at the twin windmills.

The Late Marie Surber Hare of Rushville, 1976. Nine years older than Mari, Marie was a lifelong friend who lived on a homestead near the Hill Place. She taught close by and at Pine Creek. As depicted in *Old Jules* (346), besides sharing similar classroom experiences, she and her cowboy husband, George, attended many of the same dances and socials that Mari and Wray Macumber and the other Sandoz siblings did.

Mrs. Hare's Memories at 90. Besides her recollections of teaching days, there were others of her parents and their early days in a soddy on the Pine Creek claim on which Old Jules located them. There were many visits that her family, the Surbers, exchanged with Mari's, dating from the times that their fathers shared in their homeland of Switzerland, to the time her father Henri made the early orchard photo (Cf.*supra*, 18 top).

62

Fritz Sandoz's Tombstone.
His grave, with Blanche
now beside him, is located
in Rushville's Fairview
Cemetery. With the
exception of Mari, it is in
this same cemetery that
all the other deceased
siblings and their families,
and Caroline's husband
Robert, are also buried.
Like Mari, Fritz enjoyed
dancing—a fact echoed
in *Old Jules* (394), and in
Pifer's *Making of an Author*,
(V. 1, 28). After Mari's
divorce, Fritz took her to
various country dances
when she was in the area.
These included one their
great-uncle Paul held in
his barn with music by the
Kozals. *Sandhill Sundays*
(128) offers Mari's account of
such rural dances.

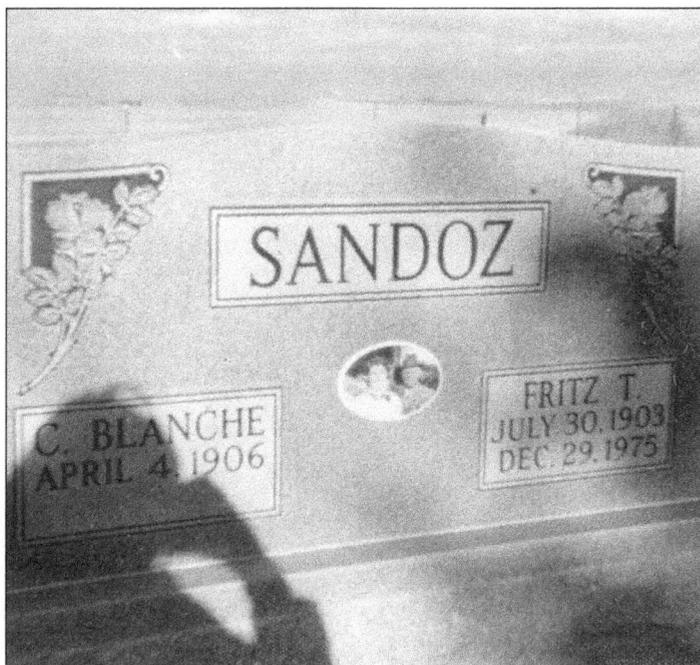

Aerial View of Sidney, Nebraska, and the Black Hills/Deadwood Trail. The trail appears in the grassy area to the left of the railroad. After her business courses, Mari taught for a year near a part of the trail while at the Dalton country school in Cheyenne County, a rural environment about 80 miles southwest of the Hill Place and approximately midway between Sidney and Bridgeport. The next spring she returned home. (Photo by and Courtesy Richard Loosbrock.)

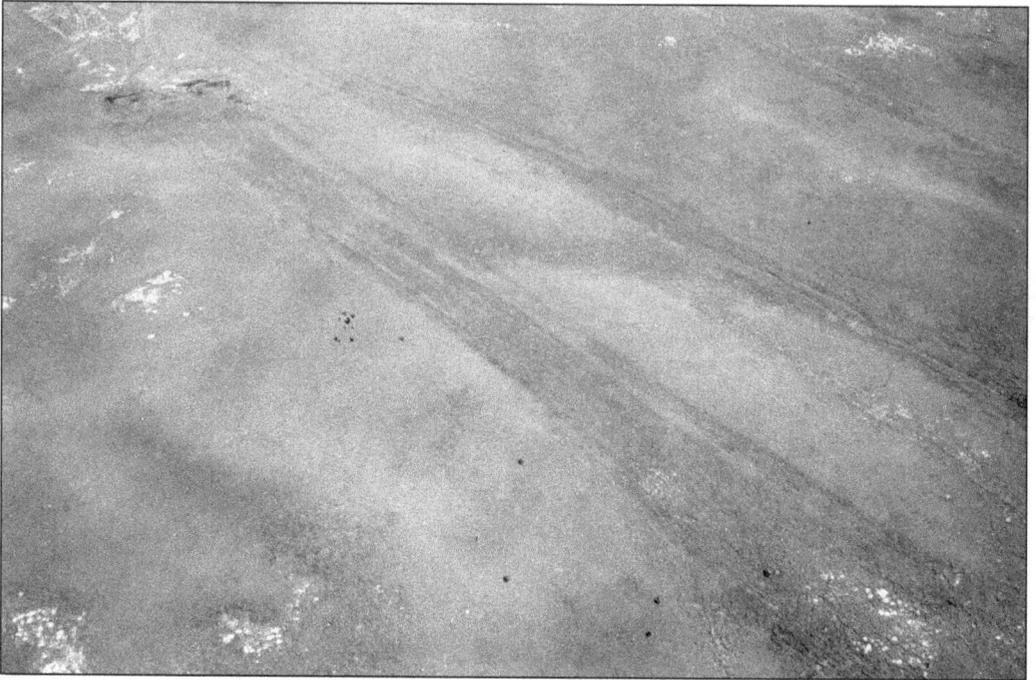

Aerial View of the Old Ruts of the Sidney-Deadwood Trail. This view is from the top of Deadwood Draw, just outside Sidney. Sandoz utilized her familiarity with this famous supply/ stage trail which runs through western Nebraska. She put its history and the characters like Calamity Jane and Sam Bass associated with it into her novel, *Miss Morissa* (1955). (Photo by and Courtesy Richard Loosbrock.)

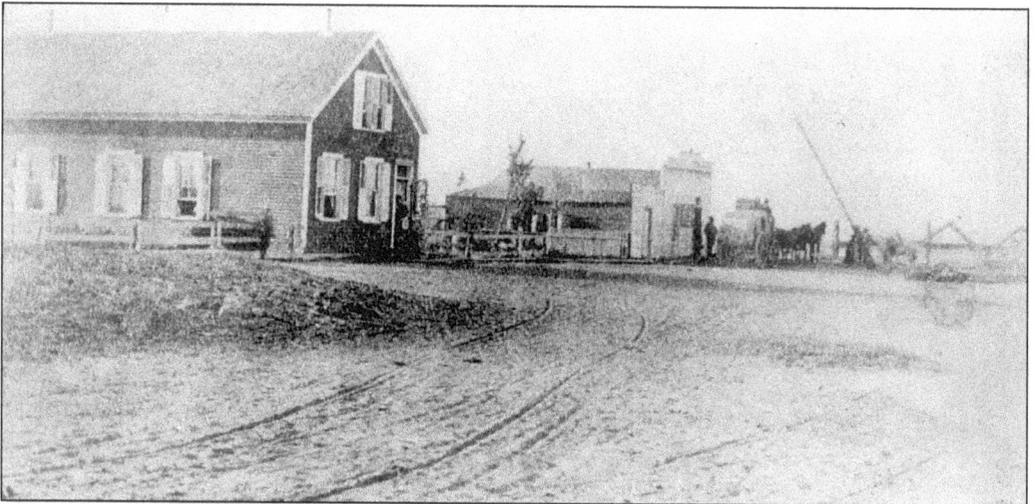

Camp Clarke and "Miss Morissa." The major part of the novel is set around 1876 at Camp Clarke, a now-vanished community, which was then some 3 miles west of modern-day Bridgeport, Nebraska. The narrative concerns a young woman physician, Morissa Kirk, who becomes involved in both gold strike conflicts and struggles between cattlemen and homesteaders through her location on the trail. (Photo from an 1876 photo by and Courtesy Richard Loosbrock.)

Loosbrock at the Clarke Bridge. Prof. Loosbrock, an historian-scholar of the old trail, stands beside the pilings of the Clarke bridge which once spanned the North Platte River. Morissa practiced medicine near the bridge—a place often guarded by the military in the days of frequent rumors of gold strikes. In the narrative involving her, the outlaw Fly Speck Billy makes another of his various appearances in Sandoz's writings. (Courtesy Richard Loosbrock.)

Fort Sidney. As revealed in *Miss Morissa* (173), after the protagonist marries Eddie Ellis at this fort, she finds reason to regret it, for she soon hears him speak sympathetically about finding "Doc" Middleton in the area. Until then, Morissa had been unaware that Eddie was on friendly terms with the Middleton gang—horse thieves who actually hung out in the same part of Nebraska in which Sandoz shows them in this novel. (Photo by and Courtesy Richard Loosbrock.)

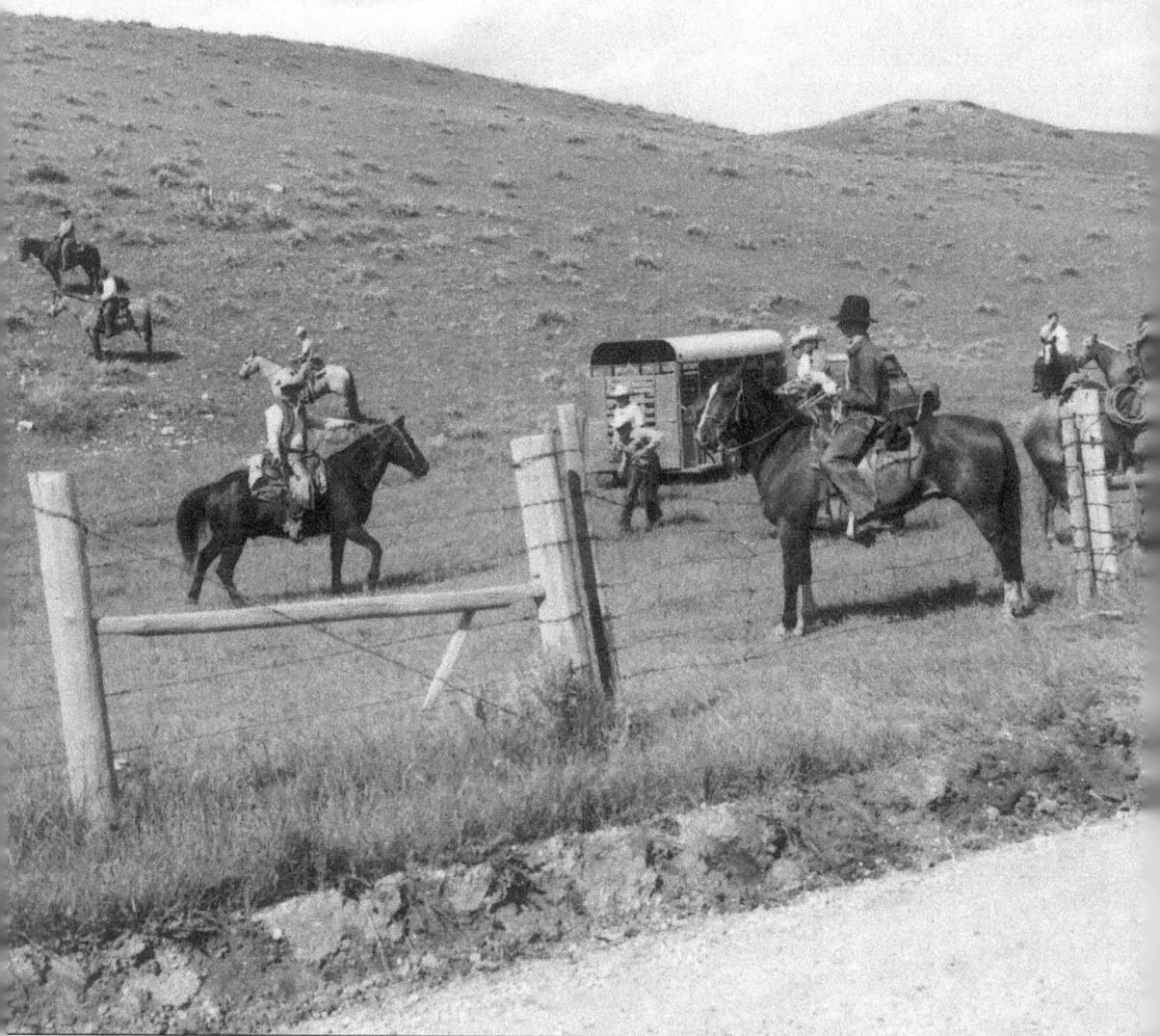

The Tom-Walker (1947). In the last half of this novel, when one of the main characters is on the train to the part of southeastern Wyoming bordering Nebraska to spend most of his life with horses and cattle, Sandoz uses again the Sidney-Bridgeport locale by setting the main scene of the train ride west there. However, in the prior part of the narrative—spanning three generations of a Midwestern family—she focuses on the time that the previous generation spent in an area to the east around Council Bluffs, Iowa. Of course, at that location the family is just across the river from Nebraska and its largest city of Omaha. Again, in connection with these regional settings, Sandoz's frequent references to places around Omaha illustrate the acquaintance she developed with this area during the days she spent in Lincoln. Such references also reveal the further artistry she demanded of herself in conveying accurately any setting she attempted.

66

Three

In and Out of Lincoln With Travel Inside and Beyond Nebraska: 1919–1940

Downtown Lincoln. This view of the city's business section *c.* 1910 shows the *Journal* building, home to a newspaper Mari later worked for, as well as a part of the University of Nebraska campus in the background. This view also furnishes a mental image of the sight which greeted Mari and her cousin, Rosalie Sandoz, some years later in September 1919, when they arrived in the cosmopolitan capital city from the sandhills. To reach Lincoln in the southeastern corner of Nebraska, they had traveled diagonally across the state for 400 miles. During this time—Mari's first Lincoln period occurring just before she spent her final year-and-a-half of teaching both in Sidney and again in the sandhills—she roomed with Rosalie in a boarding house which is no longer standing near the downtown. At first she took secretarial courses at the Lincoln Business College to gain enough office skills to eventually obtain jobs to support herself while achieving her goals of attending the University of Nebraska and pursuing a writing career. Later upon her return to Lincoln, she lived in a number of different places, renting cheap and unattractive quarters, including those at the Commercial Cafe in the business district with rooms for boarders. By June 1925, she had acquired a long-term residence in another dwelling now gone as well—the Boston home. (Courtesy Nebraska State Historical Society.)

Mari at the Boston House, 1226 J Street. South of the business district, the house two blocks from the capitol was so named because of her landlords, the Clyde Bostons. Mari lived here for over 13 years, occupying different single rooms from the various ones available over the years. From the porch, she watched the capitol's tower hoisted into place. (Courtesy the Estate of Mari Sandoz.)

The University of Nebraska, c. 1910. This overall view of the campus gives us an idea of the sights with which Sandoz became familiar some years later, when she was first able to enroll during the summer of 1922. Though she could attend only as an adult special in the Teachers College at the time, she was later allowed to take courses in the university's other colleges. In a letter of July 21, 1935, to Tyler Buchanan, a friend from her days in Lincoln who was then in New York City, Sandoz touched on her deep indebtedness to Dean Sealock for letting her into the university without high school credits. The letter, published January 6, 1971, appears in Pifer's *Gordon Journal Letters of Mari Sandoz* (Pt. 1, 57). (Courtesy the Nebraska State Historical Society.)

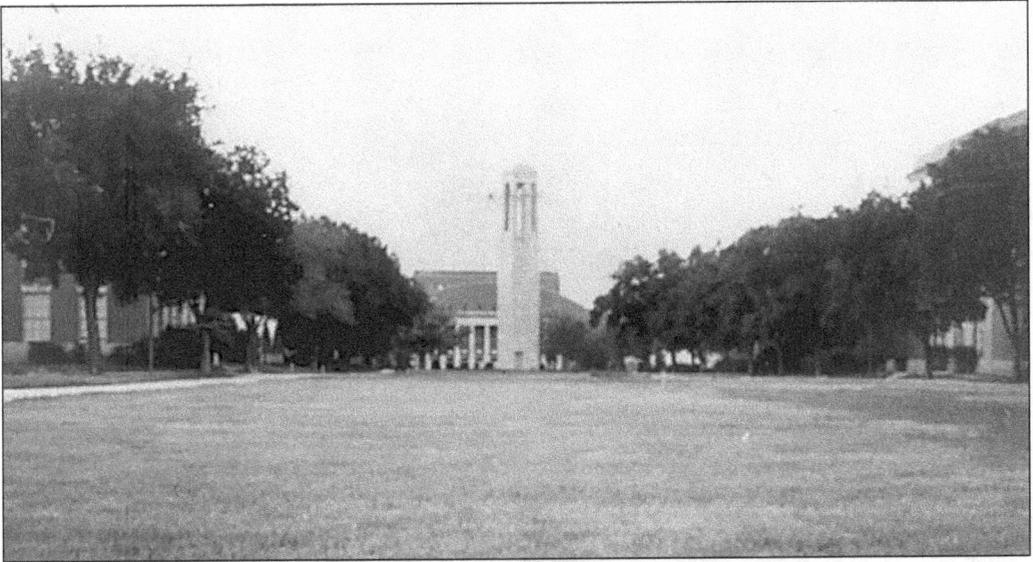

Part-Time Jobs/Part-Time Studies. Scurrying back and forth to the campus, Mari initially worked part-time at the Smith Dorsey Drug Company, and then elsewhere. Meanwhile, she continued to take courses at UNL, "browsing around," studying what interested her most—history, geography, philosophy, and especially English. Though she never got a bachelor's degree, she acquired a concentrated knowledge of her native region, which was her primary focus.

The Student Cafeteria. Housed within a predecessor of today's Nebraska Union shown here, it was the place Sandoz frequented the most during these lean years. Supporting herself with various part-time jobs, she headquartered in the old dining room, which has since been remodeled. Friends from those days claimed that she supplemented the snacks she managed to acquire with the free crackers and sugar available to the students on all the tables.

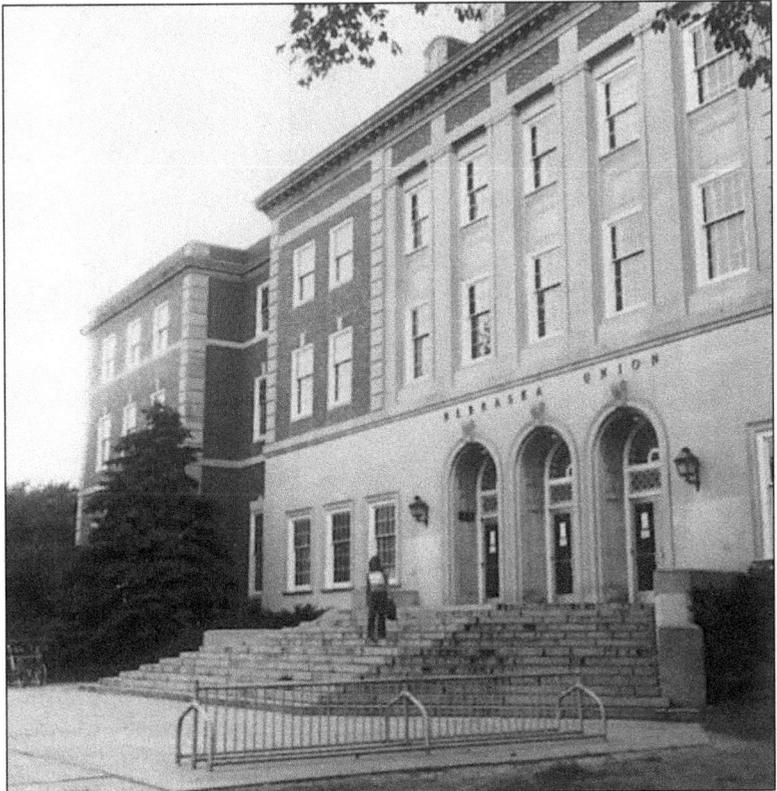

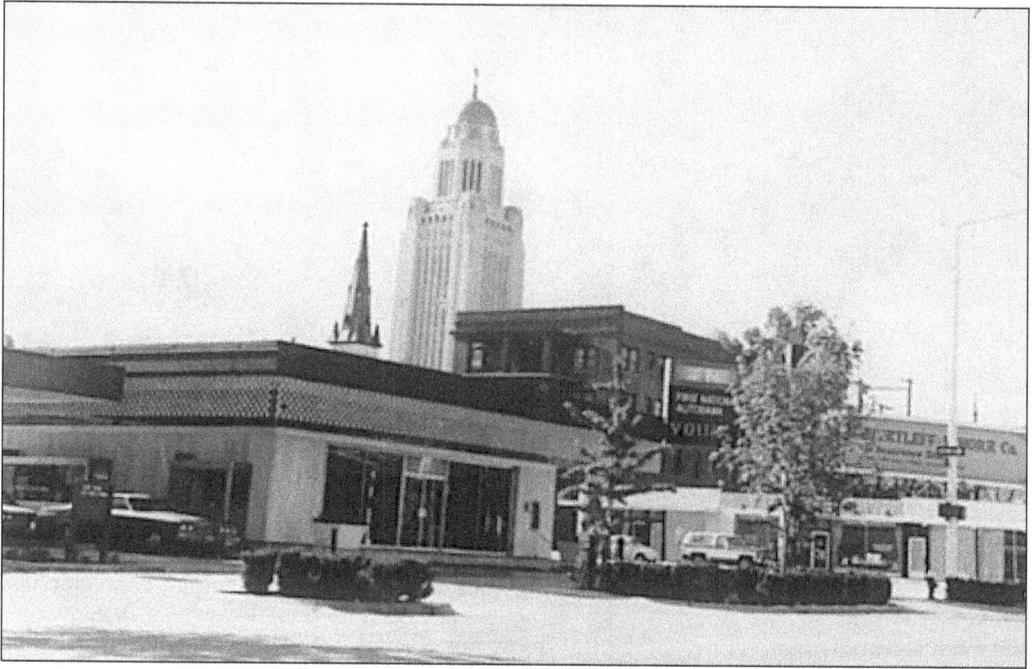

The Bygone Grand Hotel. Once located downtown in what is currently a parking lot, the hotel in those days provided a three-course lunch and a speaker for 25¢ for what they called their World Forum Luncheons. Mari's friend Dorothy Switzer noted that they made the most of this opportunity, both to eat and listen.

Melvin Van den Bark. In 1925, Mari took her first course in writing, short story composition, which was offered at night by this teacher who became the most influential of her career. As a result of the course, she was hired as an assistant to help the English and writing faculty as needed, and especially to assist Van den Bark with an extension short story writing course. (Courtesy Nebraska State Historical Society.)

Mamie J. Meredith. A young English teacher at UNL at the time, Meredith also inspired and encouraged (but never taught) Sandoz while she served as a teacher's assistant to the UNL English and writing faculty. They cemented a lifelong friendship and corresponded until Mari's death. (Courtesy Nebraska State Historical Society.)

L.C. Wimberly. As the founder of *Prairie Schooner*, Wimberly was another UNL English instructor who recognized Sandoz's writing abilities. He published "The Vine" as the lead story in the premiere issue (1927) of this now well-known and prestigious UNL literary journal. The magazine continued publishing Sandoz's work from time-to-time throughout her career. (Courtesy Nebraska State Historical Society.)

Disillusionment. In those days, as Mari frequented this area of the UNL campus, she received encouragement about her writings from a number of qualified people. However, she was simultaneously submitting her various pieces to well-known periodicals for publication. When she received many rejections, she became discouraged. A note in *Hostiles and Friendlies* (*xix*) explains that Mamie Meredith once reported witnessing her gathering and burning around 85 of her writings for which she had lost hope.

Louise Pound. This nationally recognized scholar and folklorist at UNL also taught Sandoz. She greatly encouraged and endorsed her both in class and at public literary gatherings. Moreover, Pound became a role model for Sandoz while she struggled to continue her UNL studies and become a writer. (Courtesy Nebraska State Historical Society.)

The Graves of Mari's Parents, Alliance, Nebraska. To reach this site, enter the middle gate of the city cemetery, and after 18 rows turn right at the Hunzicker headstone, then go past 20 more markers to find the Sandoz plot. Besides being the nearest town to the Hill Place with a hospital, and that being the place where Old Jules died in late 1928, Alliance was selected as his burial site and again as Mary's in 1938, for other reasons as well. Not only did the winter and sandhill roads of the time preclude a Hill Place burial, but the town had a history, too, of being the place where Jules not only took his locating business, but also sold produce. (Courtesy Knight Museum of the High Plains, Alliance.)

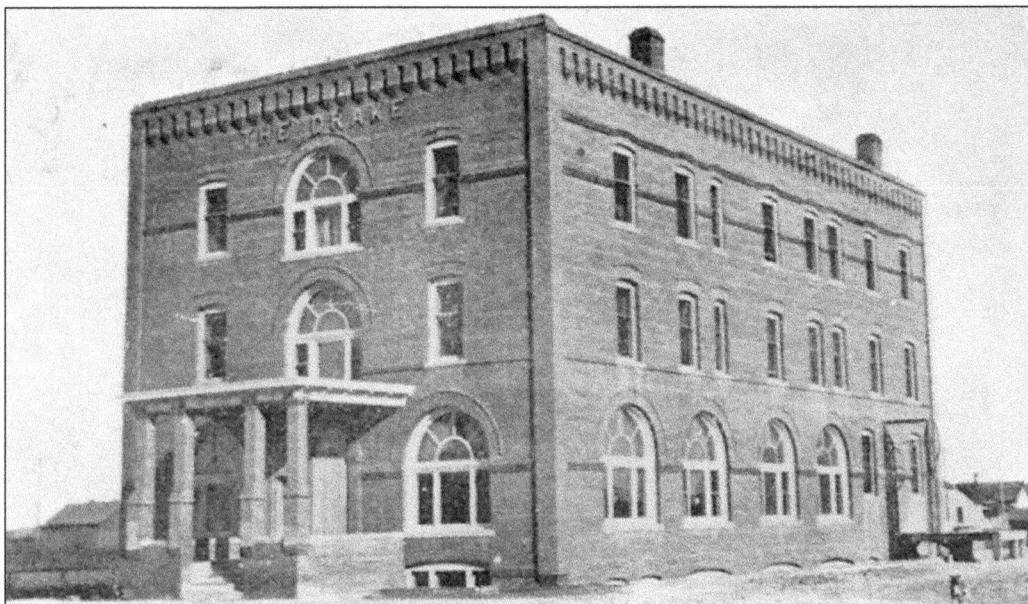

Drake Hotel, Alliance, c. 1913. In 1928, when Mari learned her father was dying, she took the train from Lincoln to be with him and her mother at the Alliance hospital, during which time she and Mary stayed at this hotel about nine blocks from the hospital. Before this last visit with her father, Mari had continued keeping her writing career from him. Nevertheless, she had still considered the fascinating story his life would make. Thus, when her father surprised her by suggesting from his deathbed that she write his biography, she could agree to it. (Courtesy Knight Museum of the High Plains, Alliance.)

73

Back on "J" Street in Lincoln. Following her father's death, Mari returned to her Boston quarters located on the same street as this residence at 1717 "J" Street, which gives an idea of her neighborhood and surroundings. By then (early 1929), she was making her first decent salary by working as an associate editor of *School Executives Magazine*, a Lincoln publication for school administrators, yet she soon quit her job. It was hard to give up her salary, but she knew she must for the sake of her writing career. There was the promised biography of her father that she needed to be writing. (Courtesy Nebraska State Historical Society.)

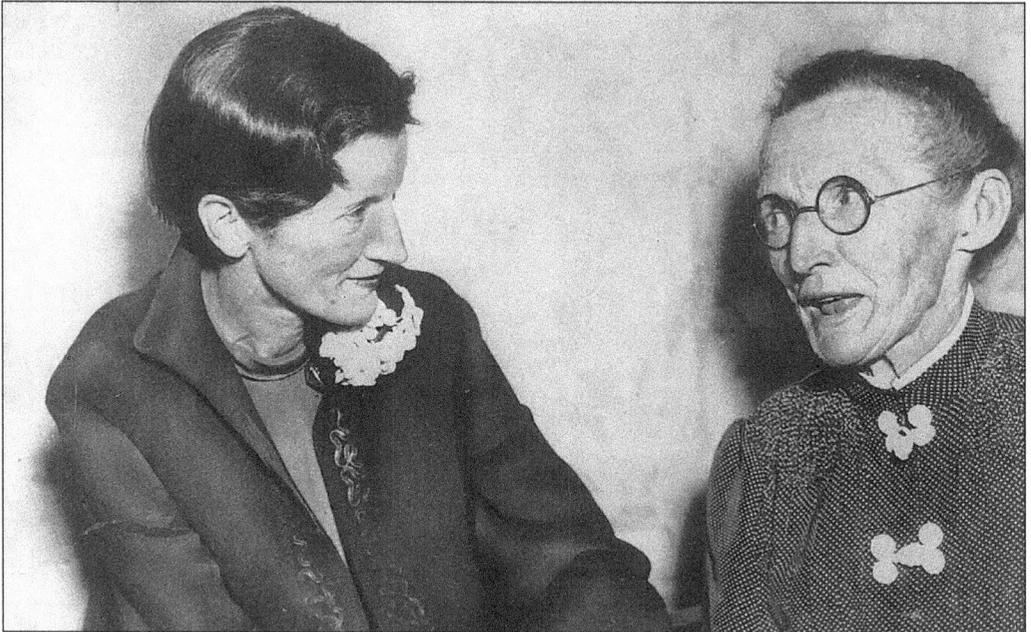

Mari Sandoz and her Mother. When she began writing *Old Jules*, Mari initially sought help from her mother. During 1930, she made several trips back to visit her at the Hill Place, trying in vain each time to obtain her assistance. Though Jules himself suggested that Mari write his story, Mary nevertheless hesitated in helping with the project. Not only did she consider such talk about her husband as bragging, she also frowned on Mari's hopes for a writing career. (Courtesy Nebraska State Historical Society.)

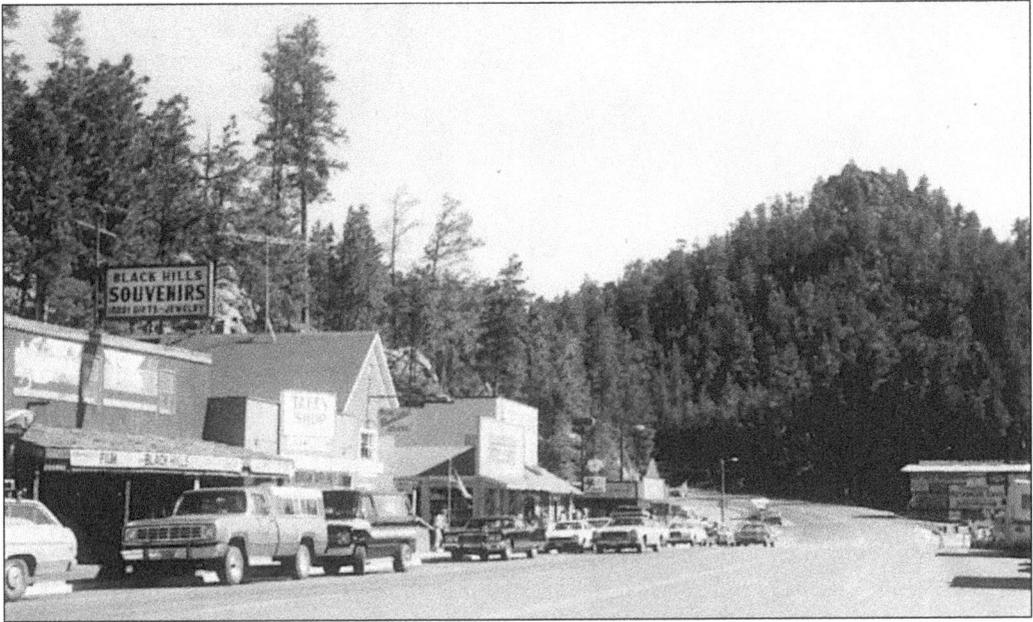

Black Hills Vacation. While Mari was trying to get her mother's help, she and Flora persuaded her to go with them during the summer of 1929 on a much-needed, three-day trip to this area of the neighboring Black Hills. When Jules had taken Mary to Hot Springs at the southern end of the Hills to marry her, Mary liked the scenery because it reminded her of her native Rudlingen, a village outside Schaffhausen.

The Result of the Black Hills Trip. Though Mari would return several times to the Black Hills, neither she nor her mother, much less Flora who drove the three of them up and back, enjoyed themselves this time. It was mainly because Mari continued to unsuccessfully persist in enlisting their mother's help. Later, however, Mary did relent and provide some assistance. Pifer's *Making of an Author* (V. 2, 44 *f*.) reviews the problems involved.

75

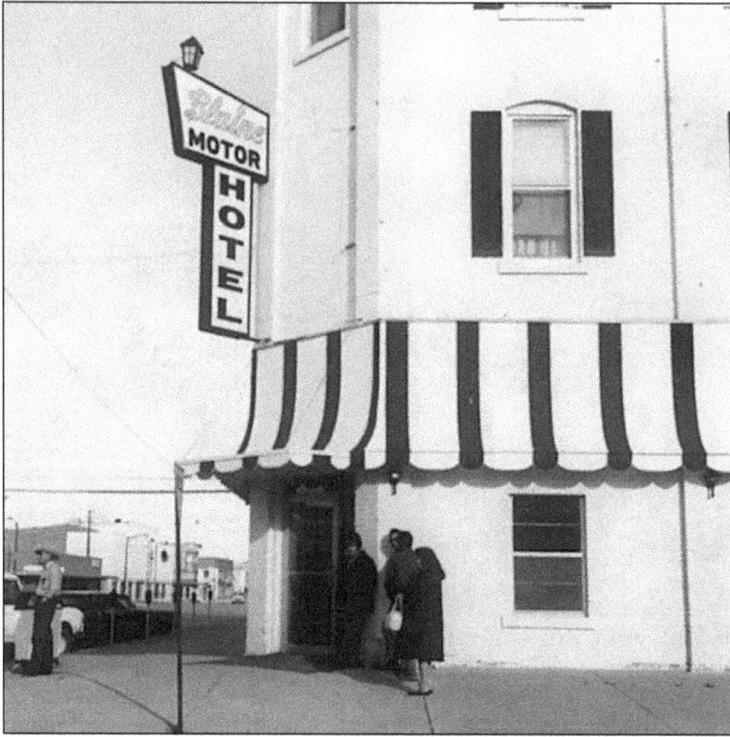

Blaine Hotel, Chadron, and the Chicago Horse Race. On visits to her home region while working on *Old Jules*, Mari began revisiting towns like Chadron. She looked into the thousand-mile horse race which left there in 1893 for Buffalo Bill's Wild West show at the Chicago World's Fair. It departed Chadron from this hotel, and in *Love Song to the Plains* (217), Sandoz reports that Doc Middleton, who had reformed by then, was a participant.

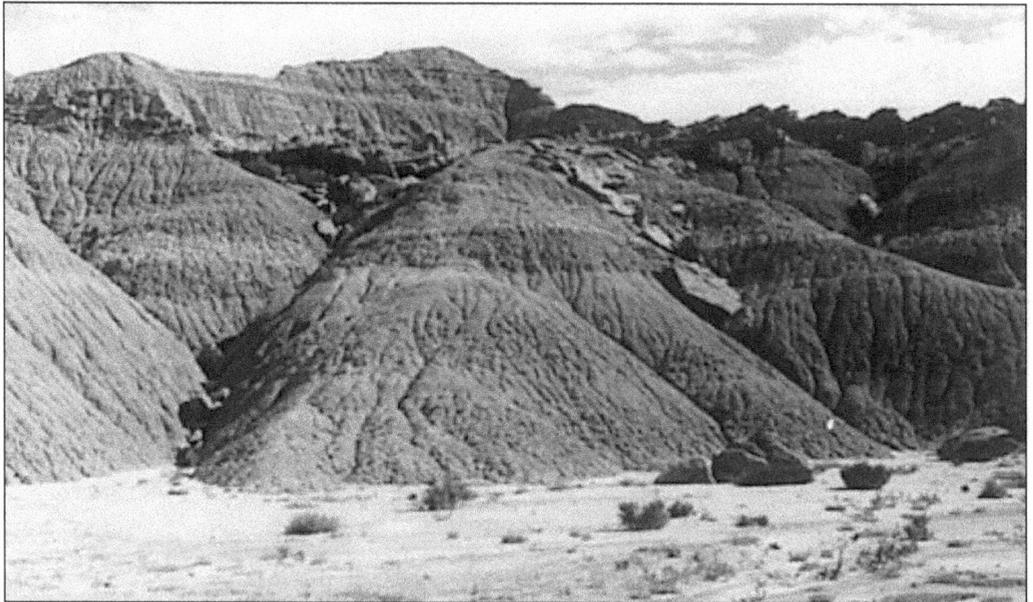

Toadstool Park. This geological park with unusual formations and moonscape surroundings is 17 miles north of Crawford, and is another area of her homeland Mari collected information about. To define the quintessential essence of Nebraska's ancient makeup, she cited in *Love Song to the Plains* (2), the park's rocks as proof of "the ages and the aeons" which "moved over the region, leaving the history of their moment behind in the Crinoidea of the great limestones."

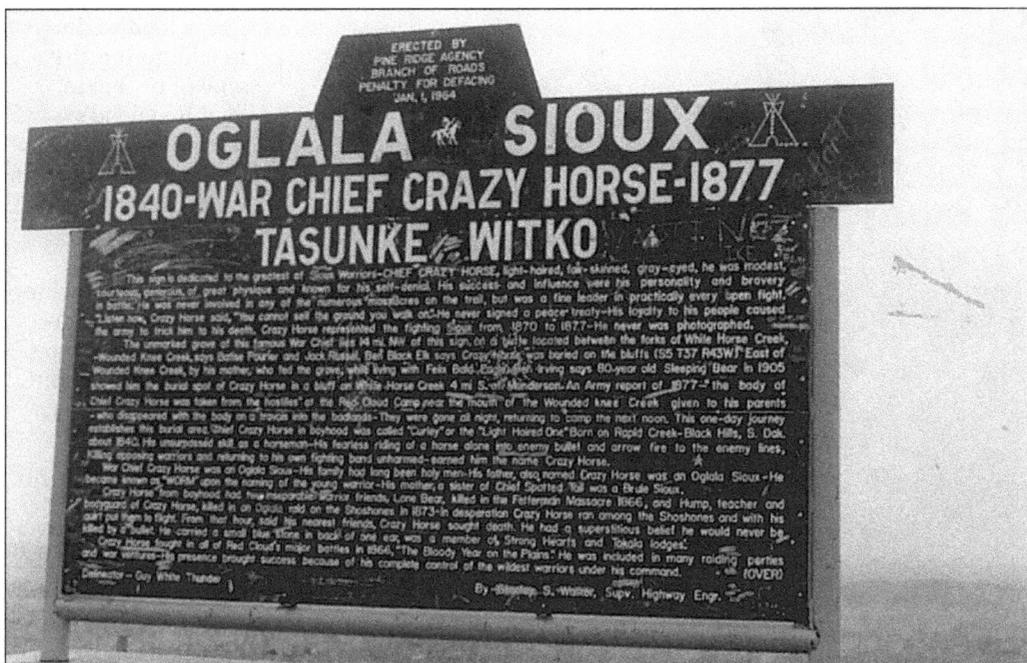

Marker Honoring Crazy Horse, 1840–1877, Pine Ridge Reservation. Five years before finishing *Old Jules*, Sandoz, in 1930 and 1931, made two research trips, both of which included this reservation. These trips also significantly influenced her direction and habits as a writer. The first was a 3,000-mile Model T jaunt through Nebraska, South Dakota, Wyoming, and Montana with another Crazy Horse student—a trip she described at length in a letter included in Pifer's *Making of an Author* (V. 3, 14 f.).

Typical Oglala Sioux Tepee. This tepee stands on the grounds of the Red Cloud Indian School below the hills of Pine Ridge, South Dakota, where Pifer remembered some of the later camping expeditions she shared with her sister. On Mari's initial trip here with Eleanor Hinman, she began making camp beside streams in the hills in this background, catching her own fish for meals.

Red Cloud's Kin. In addition to the symbol he makes, Paul Redcloud's resemblance to his "peace chief" ancestor is still discernible. One of the things that Sandoz and Hinman were looking into was, as Sandoz explained in a letter available in Pifer's *Making of an Author* (V. 2, 123), "the rumor that Crazy Horse was to have been made chief over even Red Cloud." For this reason, they conducted "many interviews" with elderly Indians, among them Red Cloud's daughter.

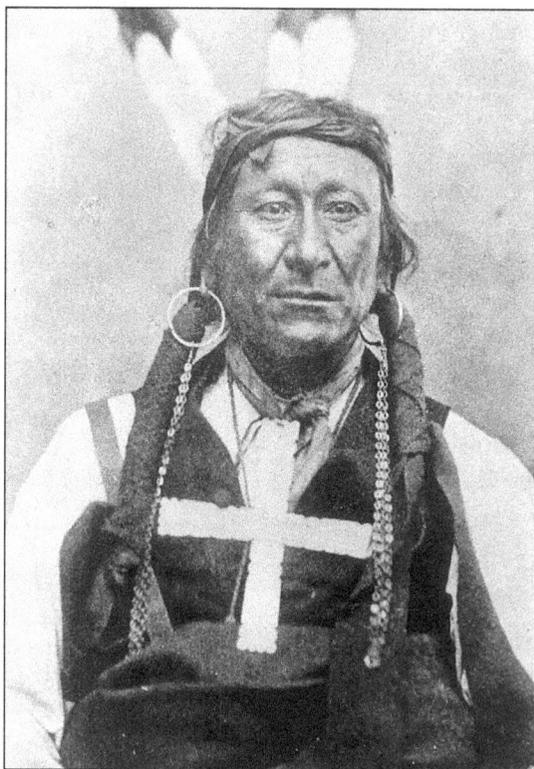

Young Man Afraid of His Horses. At first, Hinman was the one who intended to write the book on Crazy Horse, with Mari working on what became the small book on Young Man Afraid of His Horses entitled *The Great Council*. Mari grew up listening to her father talk about meeting this chief at a Rushville celebration, an event she included in *Old Jules* (66.) (Courtesy South Dakota State Historical Society—State Archives.)

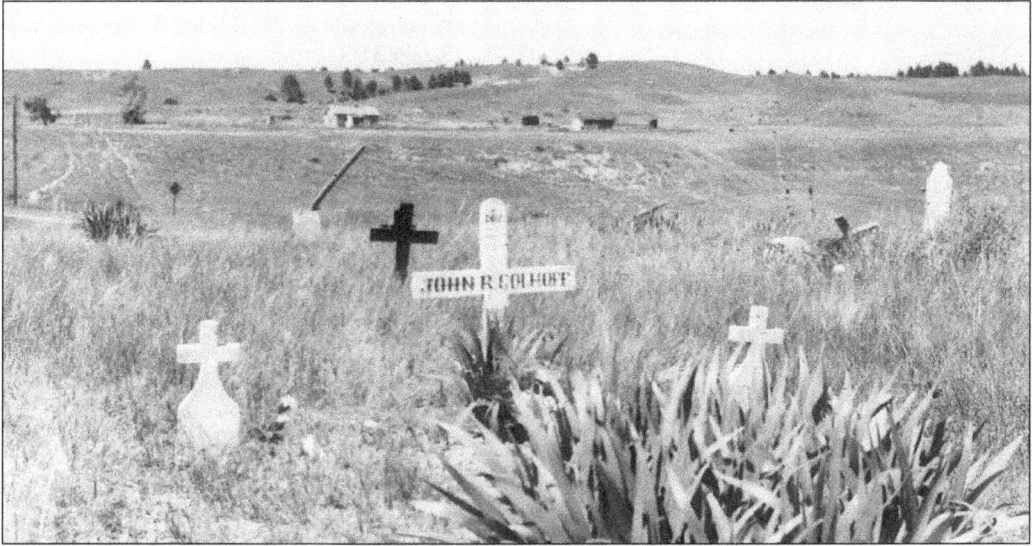

Grave of John Colhoff, Pine Ridge. As the son of George Colhoff who worked at the Red Cloud trader's store, this interpreter had the advantage of being raised around Sioux and Cheyenne who made history, as well as being of both Polish and Sioux extraction. In the 1930s, he served as the official Pine Ridge interpreter. He was among the people Mari met through Helen Blish, who had already begun researching Sioux pictographs.

1/34th Scale Model
© KORCZAK, Sc.

Scale Model of Korcyak Ziolkowski's Crazy Horse. Note the mountain carving in progress in the background, which shows the actual memorial that the family is completing in the Black Hills. Ruth Ziolkowski, the sculptor's widow, observes that the memorial to Crazy Horse is being erected there primarily because Lakota elders—contemporaries of Crazy Horse—requested Korcyak carve it to honor him. (Photo by Robb DeWall, Courtesy Ruth Ziolkowski, Crazy Horse Memorial.)

View of the Crazy Horse Memorial Area, 1992. Sandoz wrote about the lack of any known likeness of Crazy Horse in existence. Correspondence to and from Korcyak endorses Sandoz's respect for his work. In a letter to him furnished in Stauffer's edition of Sandoz's correspondence (195), Mari stressed her support of his project, noting how his "vast talent and understanding of the task" would enable him to do it.

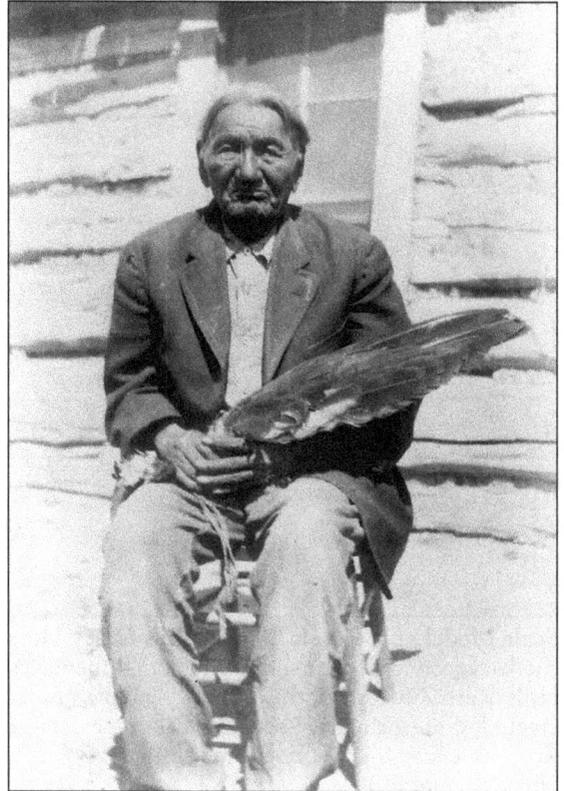

He Dog as an Old Man. On all Sandoz's trips, Colhoff assisted her in interviewing the aged warrior He Dog, the closest friend of Crazy Horse. Already in his mid-90s when they met, he was characterized by Sandoz in a letter published in Pifer's *Making of an Author* (V. 2, 120), as being "blind" and speaking "no English," though she stressed his "vivid memory." (Courtesy South Dakota State Historical Society—State Archives.)

St. Francis Mission and School. Sandoz and Hinman stopped here on the South Dakota Rosebud Reservation to see Fr. Eugene Buechel, then at work on his well-known dictionary of the Dakota languages. The priest was instrumental in establishing various programs, including the arts and crafts industry of the nearby Sioux Museum to help these Brule Sioux, once led by Spotted Tail, readjust to their 1878 removal from Nebraska.

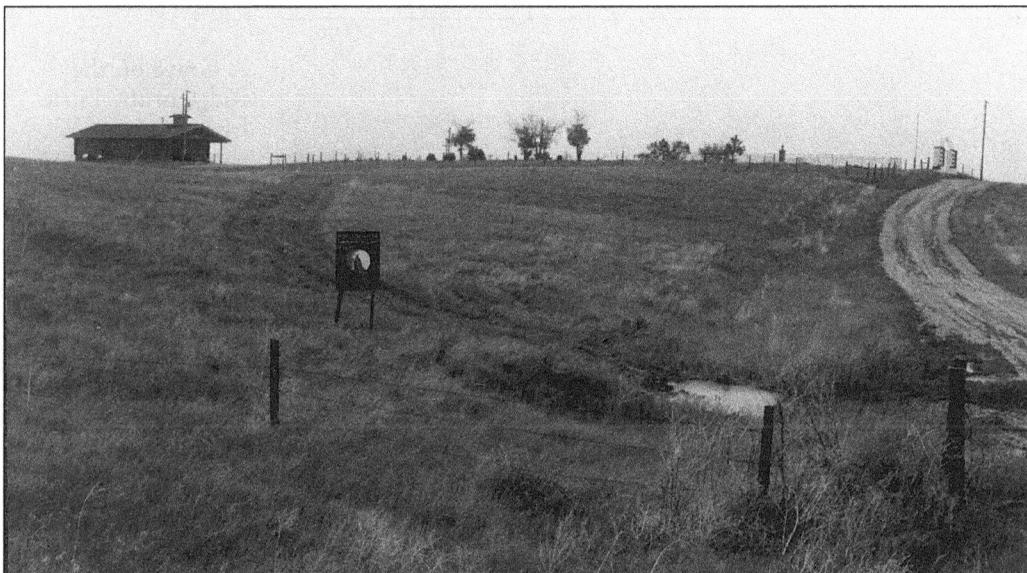

Wounded Knee. On a later trip, Mari saw the mournful hill where the Hotchkiss cannons of the Seventh Cavalry put the Minniconjou and Hunkpapa Sioux under Big Foot into the mass grave in the cemetery, visible here with the fence around it before the church. In *Old Jules* (131) Sandoz records her father's visit to the massacre scene and how "from a hill to the north," he lamented the sight before him.

81

The Bozeman Trail and The Big Horns, Near Sheridan, Wyoming. Sandoz saw this trail for the first time when she and Hinman stopped their jalopy in Sheridan "to interview some old-timers," as Sandoz noted in a letter Pifer included in *Making of an Author* (V.2, 120). Later, in connection with future books, Sandoz traveled more than once to its various parts, especially to that surrounding Ft. Phil Kearny. She also researched oil explorations along the trail.

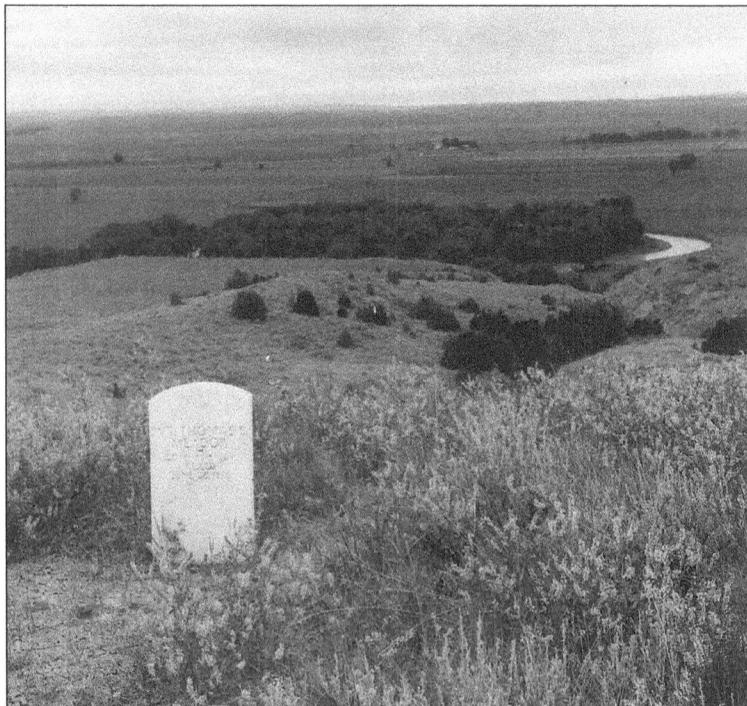

A Grave on the Ridge of the Little Bighorn. In a 1930 letter furnished by Pifer's *Making of an Author* (V.2, 124) regarding the end of the trip in Montana, Sandoz recorded: "We camped on the ridge along which Custer retreated, burned out our clutch band in Reno creek. . . ." Before the two turned back toward Nebraska, they also visited the nearby site of the Battle of the Rosebud to assess firsthand Crazy Horse's role in that encounter.

Mari Sandoz, Mid-1930s. She was now practically penniless from struggling to put her writing career first. She was using her maiden name again for her writings, resuming its use following her father's death. Since a birth certificate for her was never registered, she felt free to spell her first name now as Mari, a rendering closer to its pronunciation by her Swiss parents. (Courtesy Mari Sandoz Heritage Society.)

Newspaper Work. One of the several jobs by which Mari supported herself during these years of attempting to launch her writing career was as a proofreader for Lincoln's newspaper, the *Journal Star*, working at night and on weekends during 1931. By the time of this photo, though, the newspaper building had undergone extensive renovation and had changed a great deal from her days there.

Nebraska State Historical Society. In the fall of 1931, Mari took a job as a research assistant for the Nebraska State Historical Society. However, at that time the Society was not housed in the building pictured here, which is at its present location adjacent to the UNL campus.

Old Campus Headquarters. When Mari began working for the Society, it was housed in various places in Lincoln, including the basement of the Architecture Building on the UNL campus. Friends recalled seeing her there poring over newspapers from her region. Then, as time progressed she also came to work in another of the Society's offices—the state capitol's tower.

Addison E. Sheldon.
When Sandoz assisted
him, Sheldon was
superintendent of
the Nebraska State
Historical Society
and working on a
book about Red
Cloud. Earlier, he had
homesteaded in western
Nebraska, and for a time
had edited a Chadron
newspaper. He became
interested in Mari's
writing career and
made her his research
assistant. Sheldon
had known Old
Jules and encouraged
Mari in writing his
biography. (Courtesy
Nebraska State
Historical Society.)

**The 440-Foot Tower and the
Nebraska State Capitol.** When
Sandoz worked in the capitol's tower,
it was for Sheldon, whose office then
served as the Society's headquarters.
In 1935, she received word here
about winning the $5,000 *Atlantic*
non-fiction prize for *Old Jules*, and
with it, a contract for the book's
publication. Yet she hated having to
resign her position in order to prepare
the manuscript for publication.

The Cornhusker Hotel, Downtown Lincoln. With its air-conditioned coffee shop, the hotel offered a place which Mari, who liked being surrounded by activity, began to frequent while seeing *Old Jules* into print. After its publication, she continued to frequent the hotel, sometimes meeting friends there, but always ordering a soda or coffee while she worked on her next two books—both allegorical novels, *Slogum House* (1937) and *Capital City* (1939).

Cornhusker Reunion. Ruth Hooper (*Cf. supra*, 54 bottom) recalled a lively three-hour visit with Mari in a Cornhusker booth. Mari discussed *Slogum House* and its setting in the Oxbow of the Niobrara River near where Hooper was raised. In addition to $5,000 of Atlantic prize money, *Old Jules* brought Mari an additional $5,000 for being a book of the Month Club sale—money which enabled her to continue writing.

Favorite Lincoln Haunts. Other friends remembered seeing Sandoz at literary circle meetings at the all-night coffee shop of the downtown bus station. Once Caroline toured other favorite places and indulged in favorite pastimes—dining upstairs at Gold's, shopping at Miller and Paine's, and taking a trolley to the State Fair, with a ride there on a roller coaster and swimming afterwards at Capitol Beach. *Making of an Author* (V. 2, 47) provides Pifer's recollections of the tour.

The Capitol Viewed from the Center of Downtown Lincoln. The capitol itself caused controversy in connection with Sandoz's second novel, *Capital City*. The fact that Lincoln's response to its appearance in 1939 was negative grieved Sandoz. Yet despite her denial that this allegorical work, with its mention of "the high white tower" of its capitol, had anything to do with the local one, her critics insisted on thinking otherwise.

Another Look at the Capitol. While Mari stressed that the novel's setting was fictitious, many Lincolnites, including previous reviewers who had written admiringly of her other works, now censured, convinced that she was not only pointing a finger at local politics but at the new building as well. The completion of it during the Depression days of 1932 was a source of pride to them.

Farewell to the Capital City. The novel received such bad press and Lincoln's objection was so intense, that as a consequence, Sandoz moved to Denver in 1940. In future years, while she would return often to Lincoln for the many honors and the renewed praise that the city continuously bestowed upon her and her works, Sandoz was never to take up residence again in Nebraska's capital city.

Four

IN AND OUT OF NEBRASKA WITH "CRAZY HORSE": 1940–1942 AND "CHEYENNE AUTUMN": 1943–1953

"Crazy Horse" and Denver's Historical Holdings. With its extensive western collections at the Main Public Library and its wealth of historical archives, including museum exhibits like this one on Crazy Horse, Denver was a good location for Sandoz to work in. The exhibit here features a drawing of Crazy Horse that incorporates symbolism associated with the leader, as well as the sacred overtones his facelessness holds for the modern Sioux. In her new Denver setting, Sandoz could not only profit from the fine collections at her fingertips, but benefit from being practically adjacent to the sites important in the life of the Oglala leader, whom she was centering her attention on by 1940. Thus she could easily take her manuscript to pertinent locations as she liked. Besides these benefits, Denver actually shared more in common with her homeland than did Lincoln and even today, it still continues to be the more frequented center for trade and business for people from the sandhills area. For these reasons, Denver became and remained Sandoz's favorite city.

The Site of Fetterman, Wyoming, Adjacent to the Fort. The sites Sandoz investigated closely were those representing the heyday of Crazy Horse's victories in various encounters. More than once, she walked over these deserted grounds to reconstruct scenes or to remind us of events, as she does in the following sentence which actually appeared in her later *Cheyenne Autumn* (261). It tells of how Little Wolf's Cheyenne warriors rode in 1866, "with Red Cloud and the younger Sioux like Crazy Horse against the Bozeman forts."

Revisiting the Bozeman Trail. Sandoz gleaned close familiarity with this old route through eastern Wyoming and the Big Horns while particularly examining Crazy Horse's leadership in the Bozeman trail wars. For his story, as she noted in her "Foreword" to *Crazy Horse* (x), she tried to use "the simplest words possible, hoping by idiom and figures and the underlying rhythm pattern to say some of the things of the Indian for which there are no white-man words."

The Oglala Leader's Surrender at Ft. Robinson. Most of all, from Denver she took advantage of revisiting and refreshing her memory about landscapes like those she had heard the visiting Sioux talk about at the River Place. In May 1877, Crazy Horse and his band had come from the other side of the buttes in the background of this Ft. Robinson scene to surrender to a reservation life.

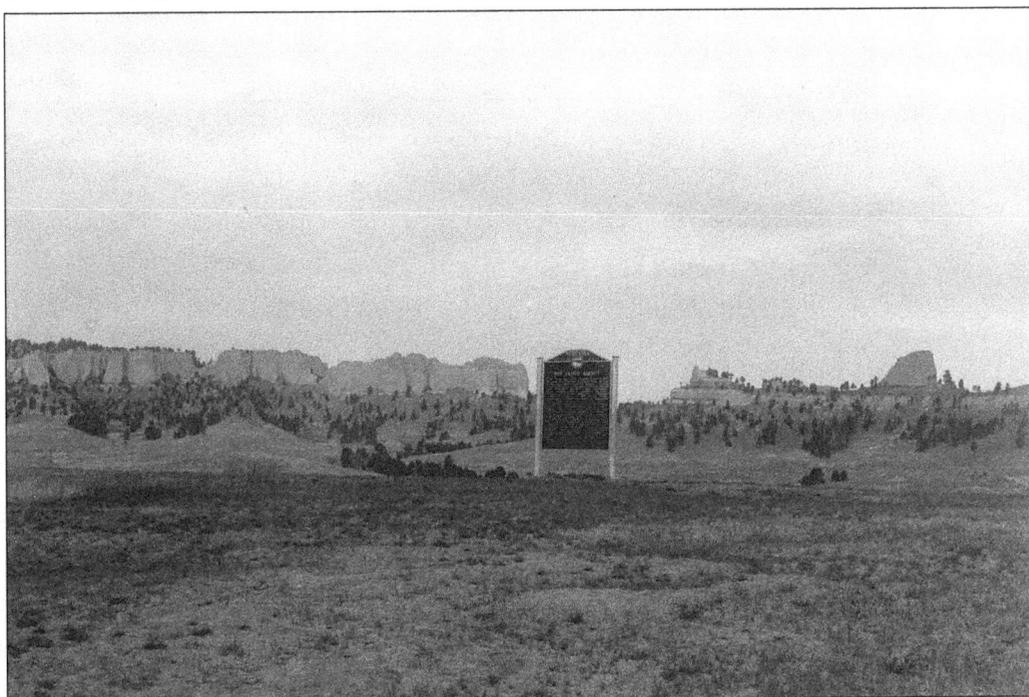

More about Crazy Horse's Surrender. He came in to make peace on May 6, 1877, at the Old Red Cloud Agency. Its headquarters stood at the marker in the center of this picture. He arrived via one of the canyons from his summer camp 5 miles north of the post of Little Cottonwood Creek. His understanding was that in making peace, his people would obtain the reservation he was promised.

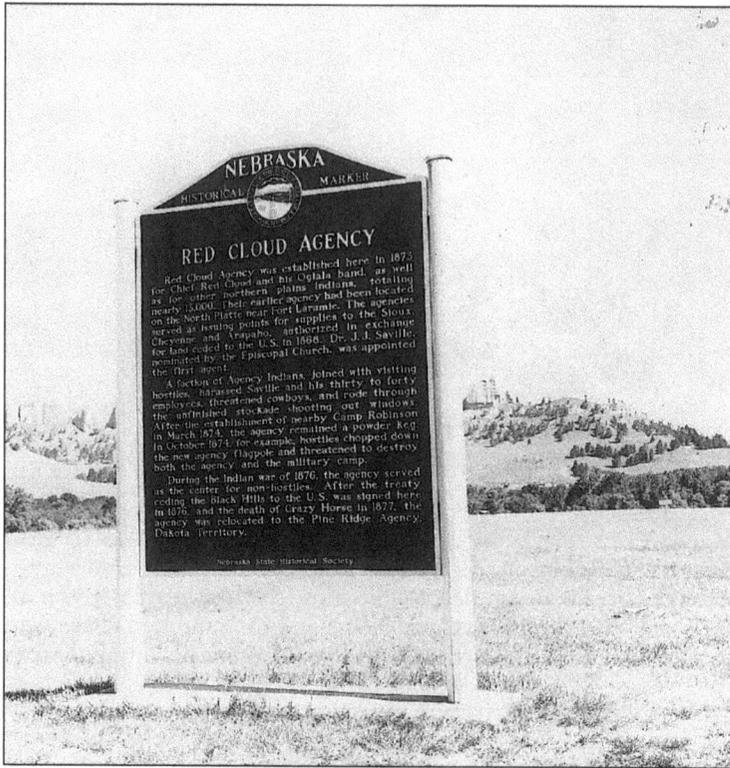

The Site of the Red Cloud Agency, 1873–1879. A reservation here, just outside Ft. Robinson where Red Cloud was already the leader, was not what Crazy Horse had in mind. Nor was the land north of Hay Springs, which is called the "Chosen Land of Crazy Horse." It was the reservation that he was promised up in the Tongue River Country—a story the Sandoz biography relates best.

Restored Log Guard House and Adjutant's Office, Fort Robinson. The restored guardhouse into which an effort was made to put Crazy Horse after a misunderstanding, is in the foreground. The adjutant's office, where he died, is beyond it. Touch the Clouds and Crazy Horse's father were present at his death, but He Dog saw him receive the wound and was with him for most of his last evening.

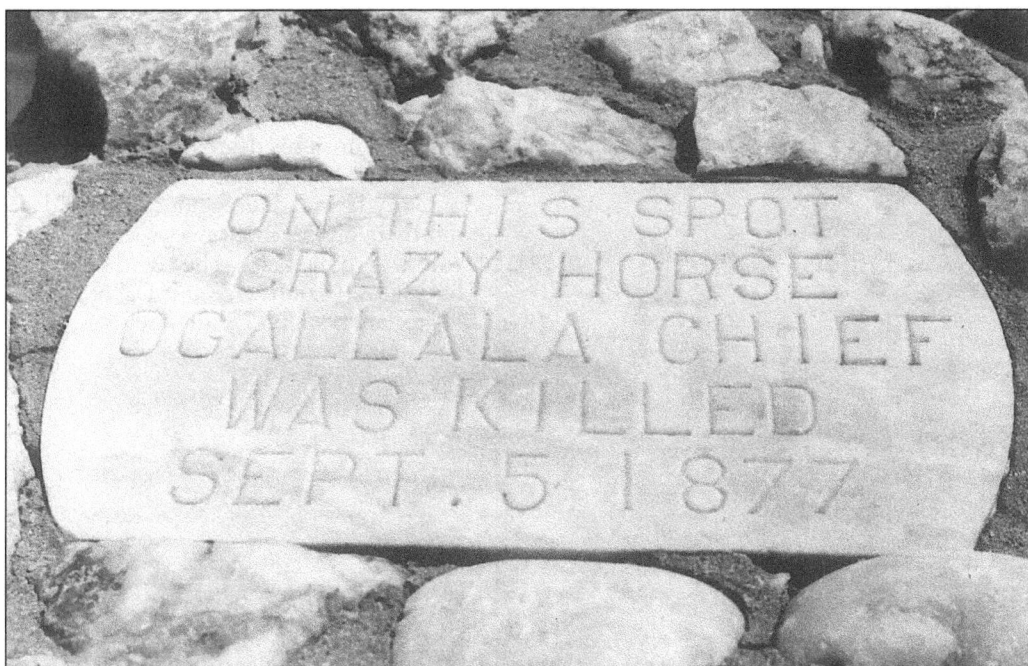

Plaque About Crazy Horse's Death. The plaque with the date of September 5, 1877, faces the parade grounds. When Crazy Horse saw the cells inside the guardhouse, he drew a knife and attempted to free himself, but as he struggled to do so, he was bayoneted in the kidney by one of the guards and mortally wounded.

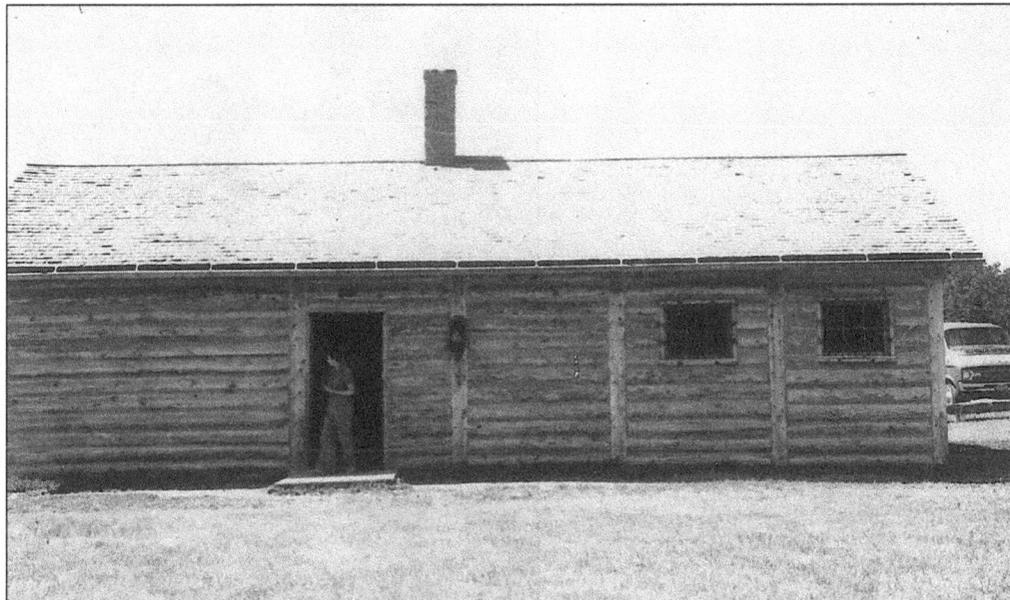

Death in the Adjutant's Office. When another attempt was made to put the gravely wounded warrior into the guardhouse, the Indians who had gathered and were observing the trouble seemed extremely close to outbreak. Therefore, the officer in charge agreed to the suggestion of the attending physician, Dr. Valentine McGillycuddy, and took him next door to the adjutant's office. He died there shortly before midnight.

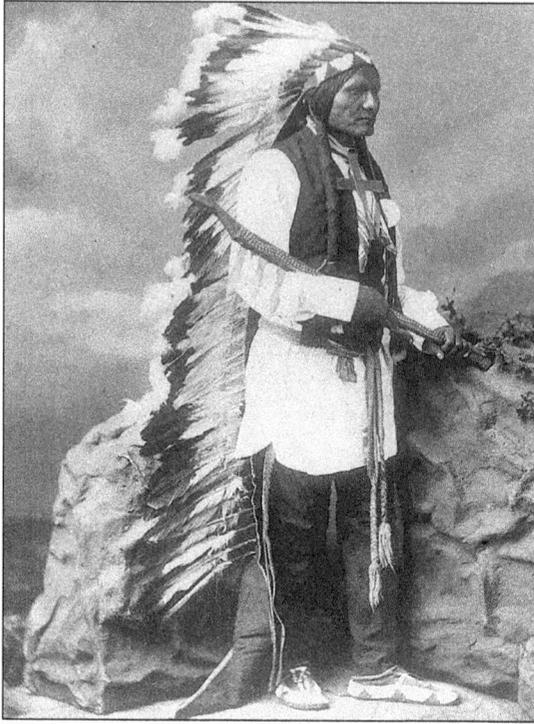

He Dog's Remembrances. He Dog was Red Cloud's nephew, a son of one of his sisters. He had grown up with Crazy Horse and was his best friend from boyhood until his death. To reconstruct the events surrounding the complexities of Crazy Horse's life, Sandoz depended mostly upon her interviews with He Dog, who was to die before she could write the biography. (Courtesy South Dakota State Historical Society—State Archives.)

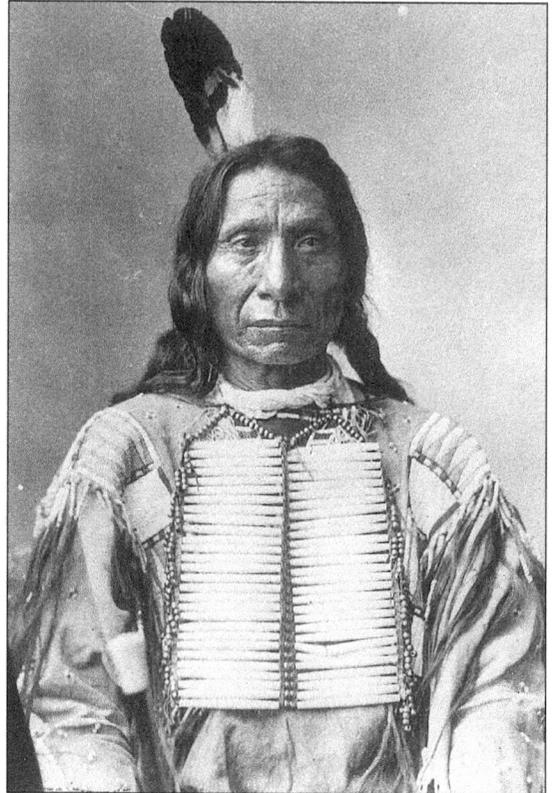

Red Cloud, 1880. In *Crazy Horse*, Sandoz provided her most revealing portrait of Red Cloud, who also appears in some of her other writings. She portrays his complex nature with dimension, rather than making him simply a lesser part of Crazy Horse's story. Red Cloud was a formidable warrior in his earlier days, but after leading the Bozeman trail wars, he turned to diplomatic battles. (Photo by Charles M. Bell; Courtesy National Anthropological Archives, Smithsonian Institution, #52,836.)

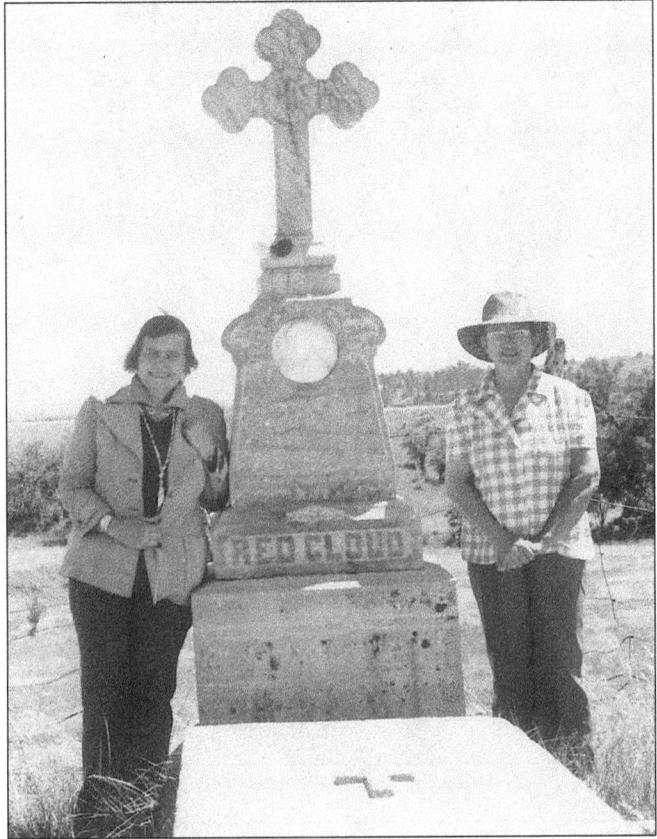

Red Cloud's Grave, Holy Rosary Cemetery, Pine Ridge. Sandoz became interested in this chief's life while helping Addison Sheldon research him. Though frequently painting Red Cloud as a wily peace chief, she still maintained admiration for him. She selected him, with Crazy Horse and Sitting Bull the Good, as the three great Oglala chiefs. Caroline Pifer is pictured at the right of Red Cloud's tombstone with LaVerne Clark at its left.

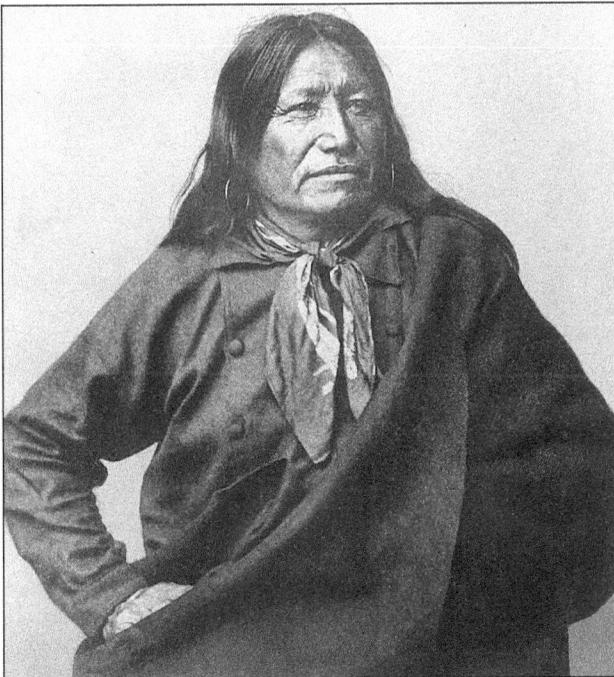

Spotted Tail. This leader of the Brules, who was influential in coercing Crazy Horse to surrender in 1877, was another of the peace chiefs whose story contributed a part to the Crazy Horse saga. In *Crazy Horse* and various other works, Sandoz contributed meaningful portraits of Spotted Tail. Like Red Cloud, he had an agency named for him. Sometimes the agency's business took him to Washington, D.C. (Photo by Alexander Gardner; Courtesy National Anthropological Archives, Smithsonian Institution, #3118.)

Modern-Day Descendant of Spotted Tail. The late Louise Janis Amiotte lived in Pine Ridge after her marriage, but she grew up near White Clay, Nebraska. It was there that she enjoyed a childhood in a small community closer to Beaver Valley and the old Spotted Tail Agency of her ancestor. She was also related to Nick Janis, an influential trader for the American Fur Company, whose story contributed to Sandoz's *The Beaver Men*.

Baptiste Garnier ("Little Bat") and his family, Fort Robinson. Sandoz wrote about her father's friendship with this half-breed French-Sioux scout and interpreter, "Little Bat," in *Old Jules* (46.) He is pictured here third from the left. In *Crazy Horse*, Sandoz considered what Garnier told Jules about Crazy Horse's time at the fort, along with what archival records like Ricker's interview with "Little Bat's" sister provided. (Courtesy Nebraska State Historical Society.)

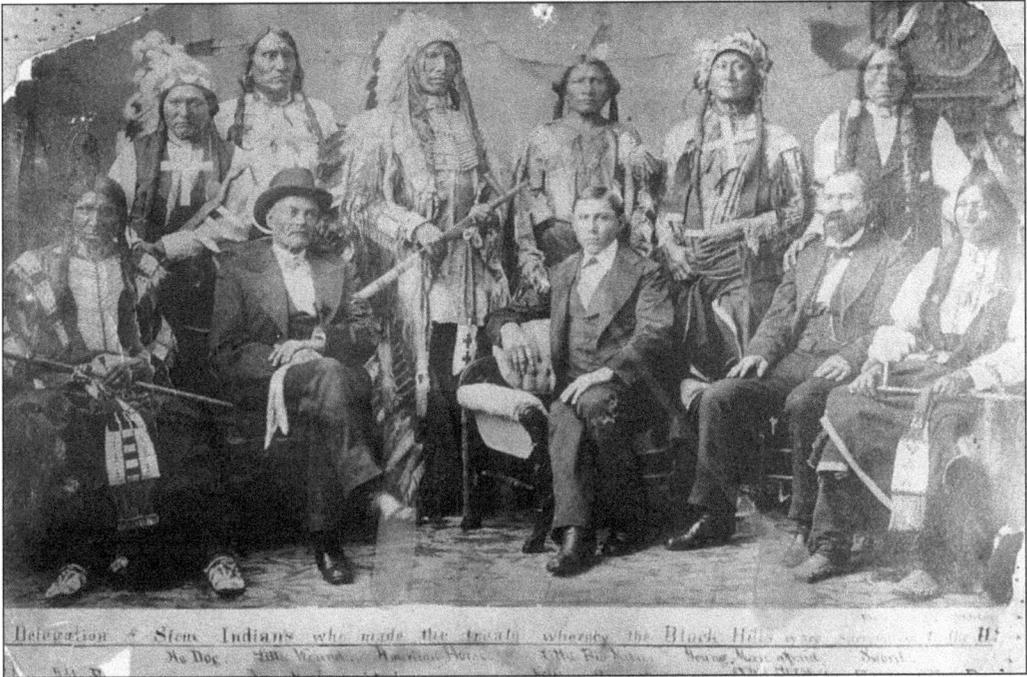

Billy Garnett. Seated in the center of the bottom row, this famous interpreter, whose mother was Sioux, had married Nick Janis's daughter—who was also half Sioux. He befriended Jules at Fort Robinson. Mari supplemented what she learned about him from her father with archival research. Also in this picture, note He Dog (top row, extreme left) and Young Man Afraid (top row, second from right.) (Courtesy South Dakota State Historical Society—State Archives.)

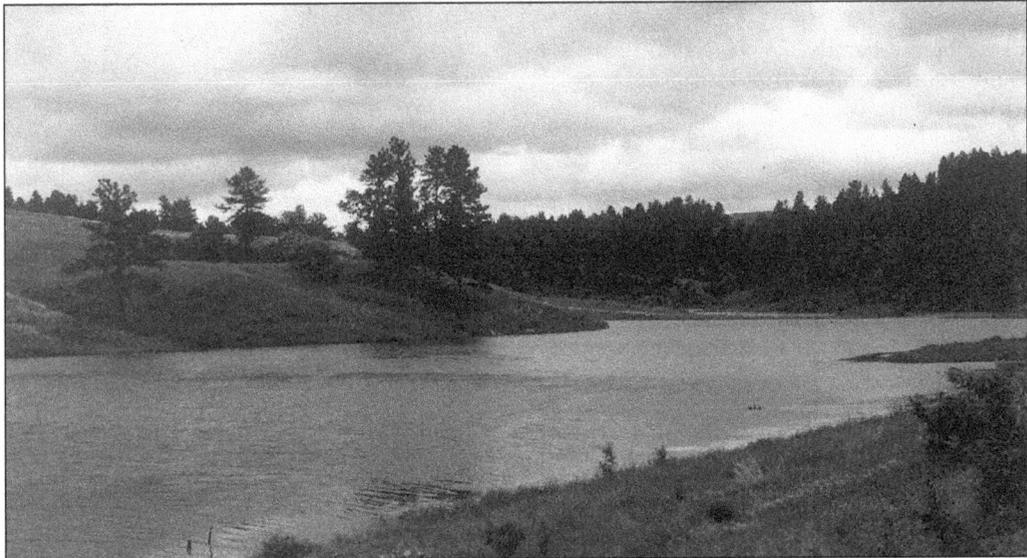

Sandoz Campsites. Beside streams like this one in the hills near Rosebud and at the place noted earlier near Pine Ridge, Sandoz continued her habit of camping out while gathering accounts about Crazy Horse from these elderly Sioux: Red Feather, brother of Crazy Horse's first wife, Black Shawl; Little Killer, brother of a Sioux who married Crazy Horse's sister; Short Bull, He Dog's younger brother; and White Calf, a scout.

Judge Eli S. Ricker. The valuable collection of documents that Sandoz repeatedly utilized within her Indian works had been assembled by Ricker, a native of Dawes County, Nebraska, who was employed by the Bureau of Indian Affairs for ten years. His collection covered the period from 1814 to 1936, and included interviews—especially those of 1906–7, with Plains Indians who were intimately connected with Crazy Horse's history. (Courtesy Nebraska State Historical Society.)

Crazy Horse Family. Sandoz corresponded with a Eugene W. Horse and agreed that Sitting Bull, the Oglala, was his ancestor, but she did not take up his possible links with Crazy Horse, as a letter in Stauffer's *Letters*, (294–5), demonstrates. However, this Horse family from Chadron— members of the same line—believe they are descendants. Pictured are: Bob Horse Sr., possibly a great-great-great-great grandson; Bob's mother, Bertha; his son, Bob Jr.; and his grandson, Michael.

What's My Line? While Sandoz agreed about Michael's descent from Sitting Bull and that his family's name means "Mystical" Horse, she might have balked about his possible descent from Crazy Horse, since she always depicted that leader as losing his only child when his and Black Shawl's daughter died. Michael's family also lacks their female ancestor's name, and there was a second wife who married another husband who took Crazy Horse's name—not an unusual Sioux practice. *Crazy Horse* (356–69, 428) and a letter in Stauffer's *Letters* (273) supply additional information about the complications involved in tracing descent from the revered chief. (For more on Michael's French ancestors, *cf. infra*, 124, top.)

Mari Sandoz, Creative Writing Teacher, 1951. During the summer of 1938, Sandoz embarked on an enjoyable, rewarding means of supporting herself—teaching at university writers' conferences. Beginning with Iowa, where Melvin van den Bark studied, her association with such programs lasted through 1956, and included appointments at Colorado, Indiana, and Wisconsin, with the latter engagements extending from 1947 to 1956. (Photo by Harold Hone, Courtesy Mari Sandoz Heritage Society.)

99

Wallace Stegner.
Like Sandoz, Stegner utilized some of his rural Nebraska childhood experiences in his writings. He was among the various distinguished writers who served with her at the Iowa and Wisconsin conferences. Beginning with Iowa and continuing through later summers at Wisconsin, Sandoz formed a lasting friendship with him and his wife. He particularly admired *Crazy Horse* and reviewed it on at least one occasion.

Little Fingernail's Picture History. The presence of a pictorial history at the American Natural History Museum in New York containing this sketch and many others was a chief consideration in Sandoz's decision to take up residence in New York. The sketches were recorded in a ledger found on the body of Little Fingernail, tribal historian of the Cheyennes on their flight north. (Negative #32,1323, Courtesy American Museum of Natural History.)

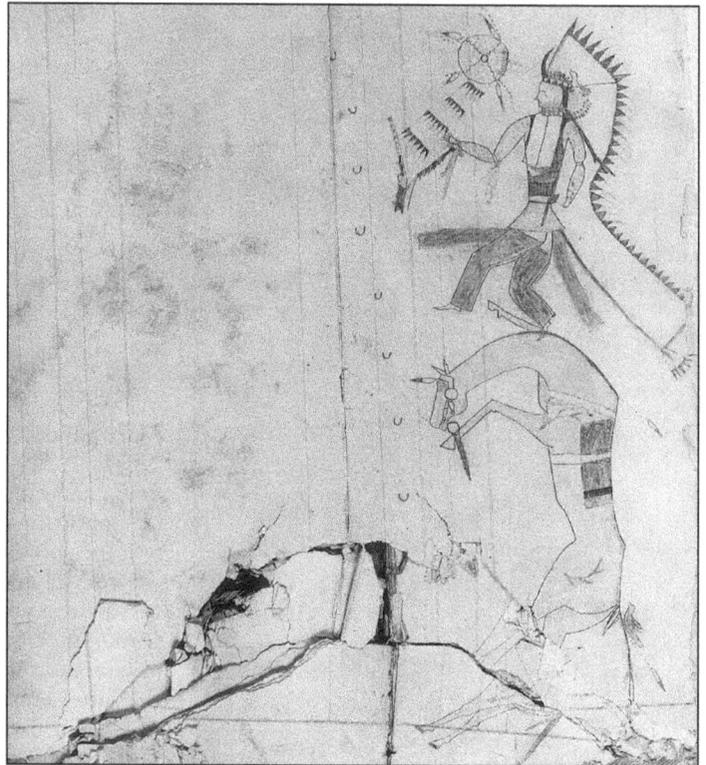

100

Replica of Last New York Apartment. At this sandhills replica of Sandoz's last Greenwich Village place (422 Hudson Street), visitors stepped inside and were transported from their Nebraska surroundings into the quarters which Sandoz described in her article, "Outpost in New York," published in *Sandhill Sundays* (139–52). Sandoz moved to New York in 1943, ready to write *Cheyenne Autumn*, convinced that she would profit from being near her publishers. Note the map of Indian sites she kept on the upper center of the wall.

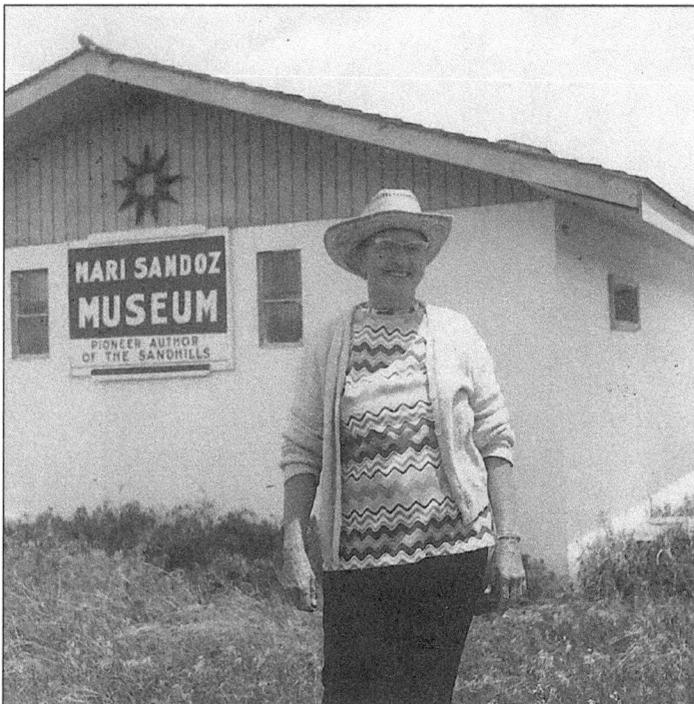

Former Sandhills Museum. Caroline Pifer was photographed beside the Mari Sandoz Museum at the entrance to the Pifer ranch. It was formerly located beside Highway 27 from Gordon, a spot not far from the bridge over the Niobrara crossed en route to the Hill Place. Besides containing the New York furnishings, the museum featured other memorabilia related to the author's life. Unfortunately, vandalism proved to be the catalyst for its closure in the mid-1980s.

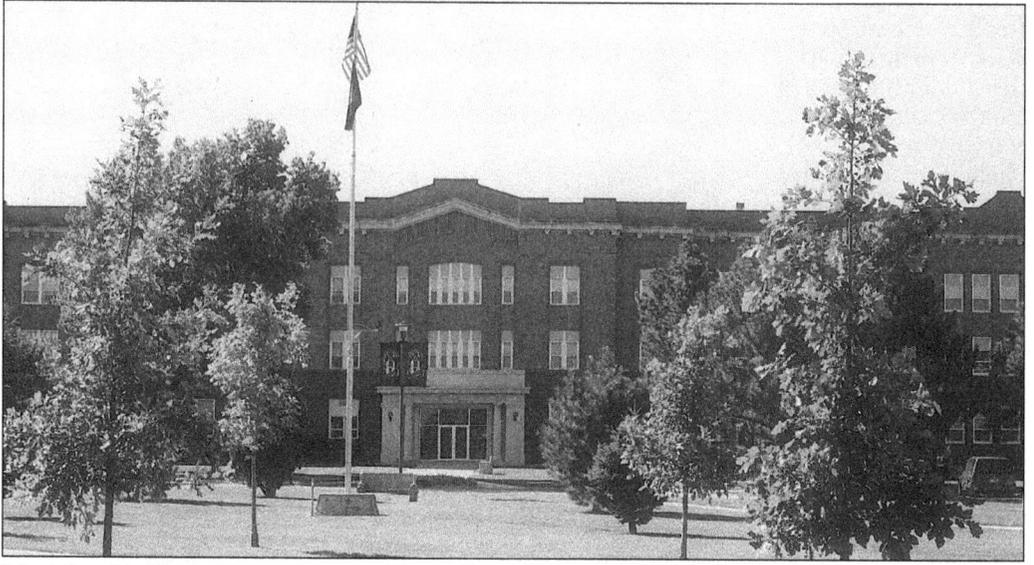

Mari Sandoz High Plains Center. The disbanded museum's holdings became part of both the Gordon Sandoz Room and the center soon to open here at Chadron State College, the nearest college to Sandoz's region. Besides providing a library and research center for students of the American West, the center will serve in numerous other ways relating to the dreams Mari Sandoz had for her native region. (Courtesy Mari Sandoz Heritage Society.)

Another Sketch from Little Fingernail's History. Sandoz was always intrigued by the role of tribal historians in Plains Indian societies and frequently mentioned their records in some of her writings besides *Cheyenne Autumn*. Always attracted to Little Fingernail's story, she was also captivated by the idea that he was the nephew of her childhood River Place friend, Old Cheyenne Woman. (Negative #32,1324, Courtesy American Museum of Natural History.)

Elk Tooth Dress. Had she been born earlier, Mari's friend, Old Cheyenne Woman, would probably have enjoyed wearing this kind of elk tooth dress, since female relatives of prominent Plains leaders often wore them. (*Cf. girl, supra,* 21 bottom.) Instead, she was among those taken in rags from the last hole of the Hat Creek bluffs above Ft. Robinson, and her stories of the Cheyenne's flight were Sandoz's principal source for *Cheyenne Autumn.*

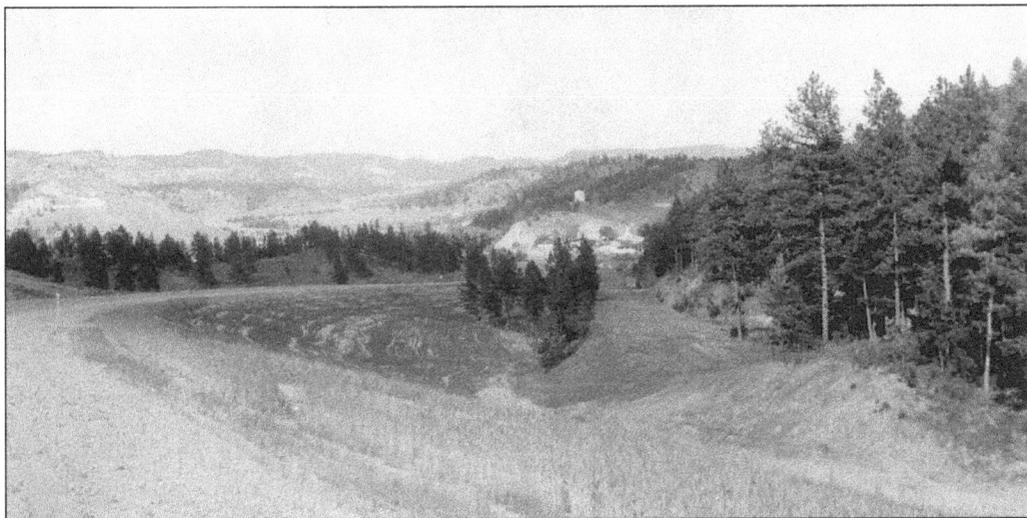

Entering the Promised Reservation, Lame Deer. Old Cheyenne Woman did not enjoy life here. In *Cheyenne Autumn* (*viii*), Sandoz informs us that she died "a pauper and alone, in a little white-man town." Sandoz never divulged her name, but in letters she did mention that she was an aunt (probably a great-aunt) of Little Wolf's daughter, Julia Wild Hog, thus making the chief perhaps her brother or nephew. She also referred to a Lydia Wild Hog whose fate resembled Cheyenne Woman's. For more details, see her correspondence in Stauffer's *Letters* (260, 440–1).

Marguerite Young. Author of the novel, *Miss MacIntosh, My Darling* and other works, Young came from the Midwest and knew some of the same people as Sandoz at Iowa, having also taught creative writing courses on an assistantship there. Young lived near Sandoz in Greenwich Village and was her intimate friend. A good source on Sandoz's New York period, she stressed her dedication to her work and her willingness to help young writers.

Ruth Stephan. This poet and novelist was the former editor of *The Tiger's Eye*, an avant-garde literary magazine in the Village. She had grown up in Chicago and was another of the mutual friends of Sandoz and Young with whom they sometimes socialized. Stephan also emphasized Sandoz's absorption in her work and admired her encyclopedic knowledge. Her granddaughter, Mari Dart, was named for Sandoz.

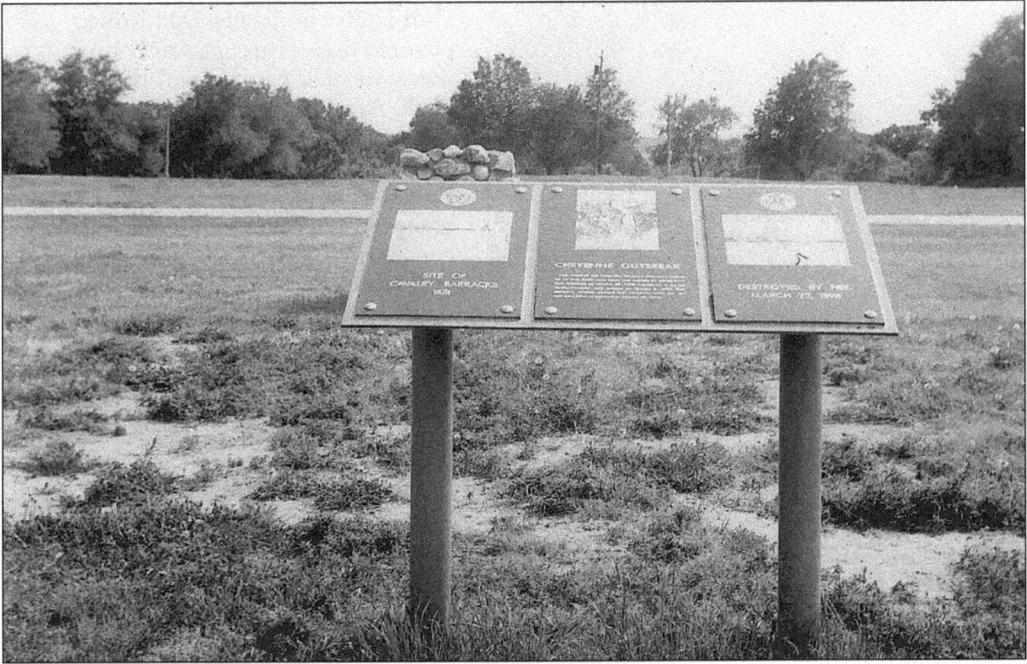

Site of Old Ft. Robinson Barracks. These markers indicate the location of where the members of Dull Knife's band were imprisoned. Following their capture on Chadron Creek in October 1878, they remained here until escaping in January 1879. Though living and writing *Cheyenne Autumn* in New York, Sandoz continued to return to her native land in order to check on the manuscript's different settings and other details first-hand.

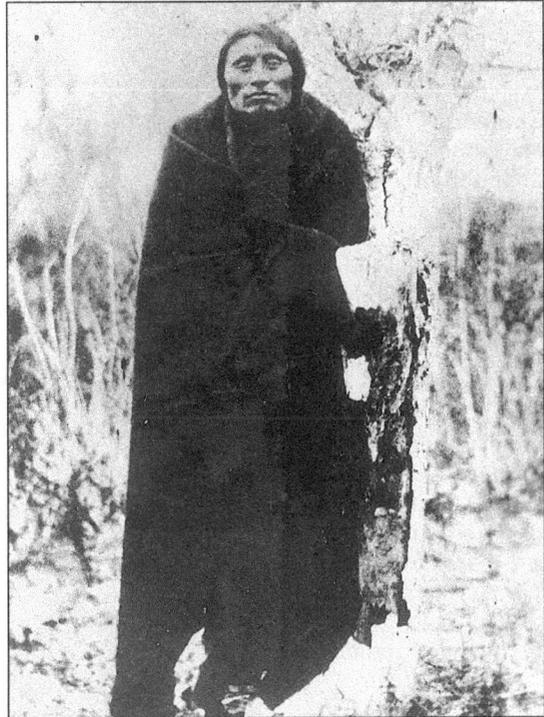

Chief Little Wolf. Along with Dull Knife's band, Little Wolf's Northern Cheyenne left Oklahoma on the 1,500-mile flight back to their former homeland; however, unlike Dull Knife's group, they evaded capture until March 1879. Little Wolf is pictured here just after his Montana surrender. Disagreeing about routes, the chiefs separated while heading north from Nebraska's White Tail Creek near the Platte River. (U.S. National Archives, Neg. #111-SC-83159; Courtesy South Dakota State Historical Society—State Archives.)

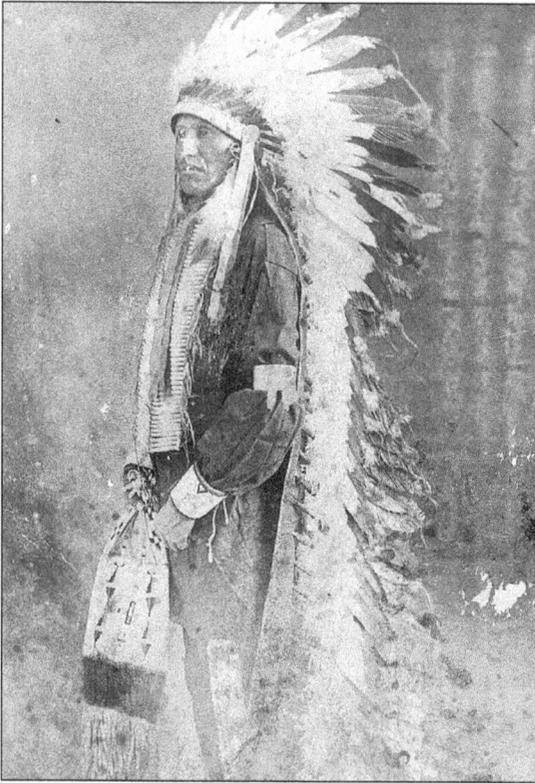

Dull Knife. Ironically, Dull Knife, pictured here wearing a war bonnet, was more of a "peace chief" than Little Wolf. After their bands separated, his group was captured at Chadron Creek, and its members were taken to Ft. Robinson as prisoners. Until then, they had expected to find refuge among Sioux compatriots under Red Cloud, unaware of their relocation. Yet even as prisoners, they refused to return to Oklahoma. (Courtesy South Dakota State Historical Society—State Archives.)

Cheyenne Outbreak Marker. Near Ft. Robinson, the marker repeats the story Sandoz's *Cheyenne Autumn* relates of how, after the imprisonment of the Dull Knife band in the post's barracks, Captain Henry W. Wessels, the commanding officer, attempted to starve them into submission. As a result, they broke out of their quarters after dark on January 9, 1879, and attempted to resume the flight to their Yellowstone homeland.

NEBRASKA HISTORICAL MARKER

THE CHEYENNE OUTBREAK

On September 9, 1878, after a year of suffering on an Oklahoma reservation, some 300 Northern Cheyenne Indians began a trek back to their homeland. Dull Knife's band of 149 Indians were captured and taken to Fort Robinson. For months they refused to return to their hated reservation.

Captain Wessels, Commanding Officer at Fort Robinson, imprisoned the Indians in a log barracks and attempted to starve them into submission. Using the few weapons they had smuggled into the building, the younger warriors began the Cheyenne Outbreak about 9:00 p.m., January 9, 1879. After a desperate running battle on the snow-covered parade ground, the Indians managed to follow the banks of the White River, scale the cliffs and escape.

Unable to find horses, the Cheyenne eluded pursuing troops for 12 days by heading northwest through the rough terrain of the Pine Ridge. Soldiers discovered their hiding place on Antelope Creek January 22, but the Indians refused to surrender. During the outbreak, 64 Cheyenne and 11 soldiers were killed. More than 70 were recaptured and several escaped. The number of casualties made the Cheyenne Outbreak one of the major conflicts of the Indian Wars.

Crawford Historical Society

White River Buttes and Cliffs. Following a desperate battle on the snow-covered parade grounds, the Cheyennes headed for the White River buttes and cliffs visible in the distance, and they basically escaped into them. As Sandoz notes in *Cheyenne Autumn* (193), "At Robinson it was truly the iron-hard winter that comes after the swift storms of the Cheyenne autumn."

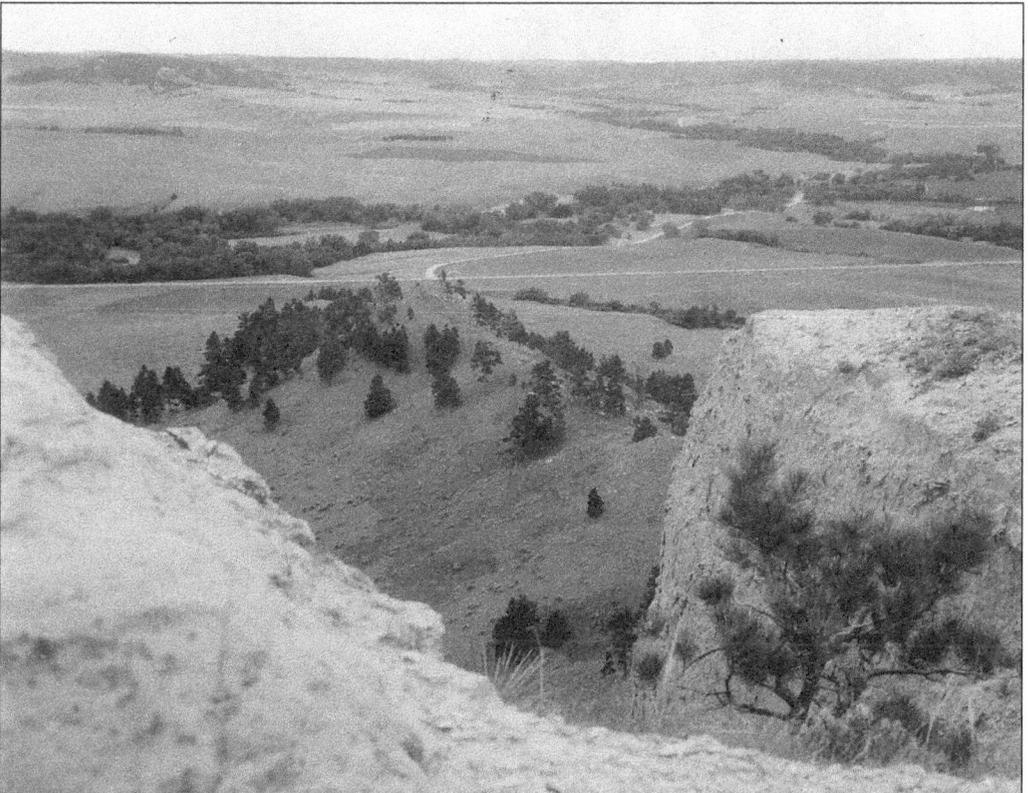

View from the Buttes Above Fort Robinson. According to a jeep guide at the fort, authorities now believe that following their winter outbreak, the Dull Knife band fled up into these cliffs through the crevasse shown here. Caroline Pifer recalled accompanying her sister to this locale and staying in a motel in nearby Crawford, Nebraska, for several days while Mari walked all over the area.

107

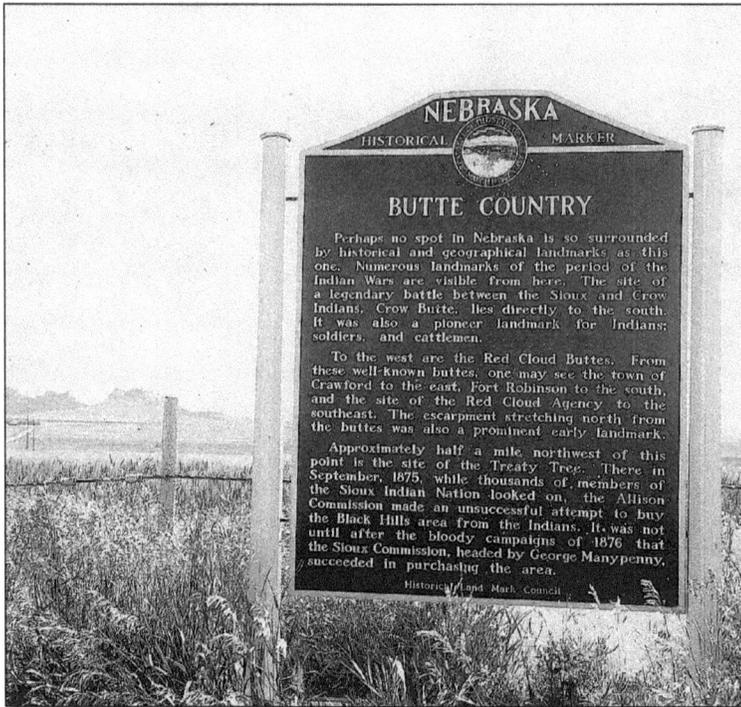

The Butte Country, Crawford. Upon seeing Crow Butte in the distance, *Old Jules* readers may recall how Sandoz's description of this landmark identifies it with the Cheyenne outbreak. As Jules is traveling back home, his wagon moves "past the dark morning face of Crow Butte. . . where the people of Dull Knife staved off ultimate tragedy at the hands of the white men a few days longer." (55.)

The marker text reads:

NEBRASKA HISTORICAL MARKER

BUTTE COUNTRY

Perhaps no spot in Nebraska is so surrounded by historical and geographical landmarks as this one. Numerous landmarks of the period of the Indian Wars are visible from here. The site of a legendary battle between the Sioux and Crow Indians, Crow Butte, lies directly to the south. It was also a pioneer landmark for Indians, soldiers, and cattlemen.

To the west are the Red Cloud Buttes. From these well-known buttes, one may see the town of Crawford to the east, Fort Robinson to the south, and the site of the Red Cloud Agency to the southeast. The escarpment stretching north from the buttes was also a prominent early landmark.

Approximately half a mile northwest of this point is the site of the Treaty Tree. There in September, 1875, while thousands of members of the Sioux Indian Nation looked on, the Allison Commission made an unsuccessful attempt to buy the Black Hills area from the Indians. It was not until after the bloody campaigns of 1876 that the Sioux Commission, headed by George Manypenny, succeeded in purchasing the area.

Historical Land Mark Council.

In the Crawford Area. Searching through countryside like this while working on *Cheyenne Autumn*, Sandoz tried ceaselessly to identify the exact flight path Dull Knife's band took and the various sites to which they fled along Warbonnet Creek. That stream is marked here by the line of trees running beside it and across the center of this view.

Vance Nelson. A distant relative of the Sandoz family, Nelson is also a former curator at Ft. Robinson and a past president of the Mari Sandoz Heritage Society. In 1977, he led a tour from the fort's buttes, before which he stands, to the region at his right, called Warbonnet Trail. The tour followed the escape route of Dull Knife's band.

The Area of Hat Creek Bluffs in the Distance. The tour ended in this remote area of the Hat Creek bluffs above Harrison in the northwestern-most corner of Nebraska. An unforgettable scene in *Cheyenne Autumn* (233) captures the way the Cheyennes hid themselves in a washout of this creek, now popularly called Warbonnet, and dug a hole at some 30 feet above its bed, forming breastworks around it, for their last stand.

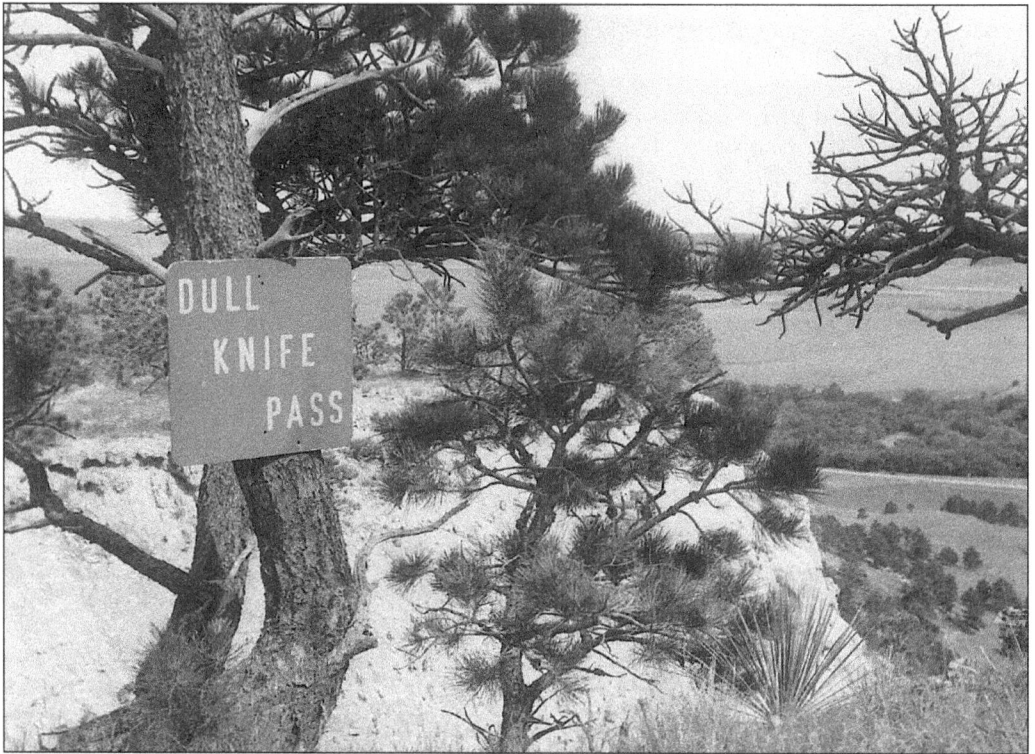

Dull Knife Pass. On returning to the fort at this pass along the escape route, one remembers the Cheyennes not returning—especially Little Fingernail. In *Cheyenne Autumn* (237), Sandoz reveals how he fell "face down" with his "canvas-covered book" when the "two Springfield bullets" went through it, striking him and leaving the tears still visible in the reproductions of sketches included earlier. (See *supra*, 100 bottom; 102 bottom.)

The Site of Fort Phil Kearny. During her ten-week 1947 fall research trip, Sandoz traveled to old outposts like Fort Phil Kearny in eastern Wyoming, familiarizing herself with earlier Cheyenne conflicts. Once more she observed how Dull Knife's earliest efforts in seeking peace at this fort resulted in his having to endure, as she noted in *Cheyenne Autumn* (261), the lashes which came in response from the "pony quirts" of his Sioux allies.

110

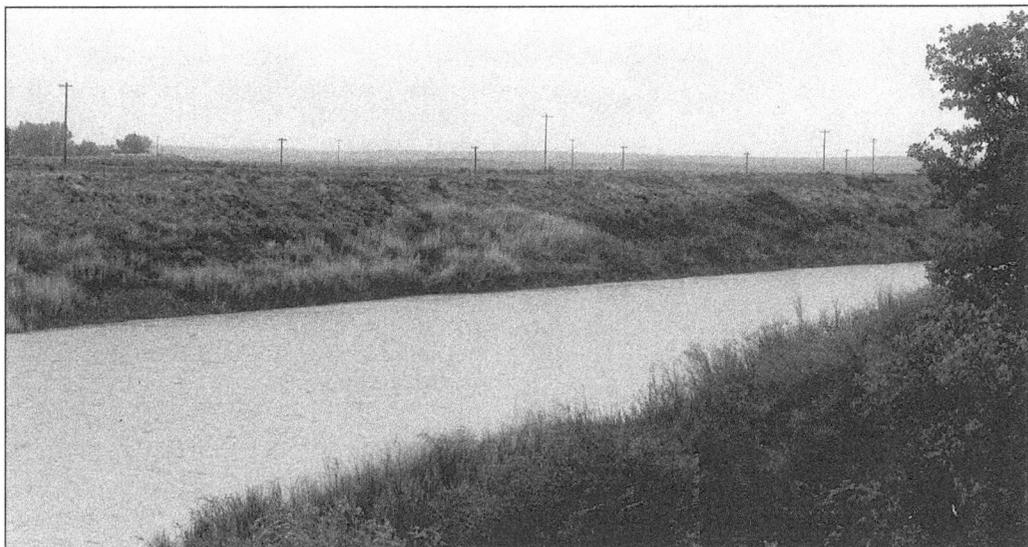

The Banks Along the North Platte Behind Old Ft. Fetterman. Sandoz reviewed this area for *Cheyenne Autumn*. She wrote (261) of how Little Wolf's warriors aided Red Cloud and Crazy Horse in December 1866, in successfully attacking both Bozeman trail forts—Kearny and Fetterman, and of how Little Wolf set fire to Kearny afterwards, then watched it burn. Yet, as she shows elsewhere, Ft. Fetterman came back strong. Col. MacKenzie's cavalry left it in 1876 to destroy Dull Knife's Powder River Village.

Caroline Beside Lost Chokecherry Lake in Sandoz Country. An unusually enjoyable part of the 1947 research came when Sandoz, aided by various siblings, finally located the 1878–9 winter hideout in which Little Wolf's followers, after parting from Dull Knife's band, took cover during the coldest months. The place—one the military never found—was located on property owned by her brother Jules, and was near Caroline's ranch as well.

111

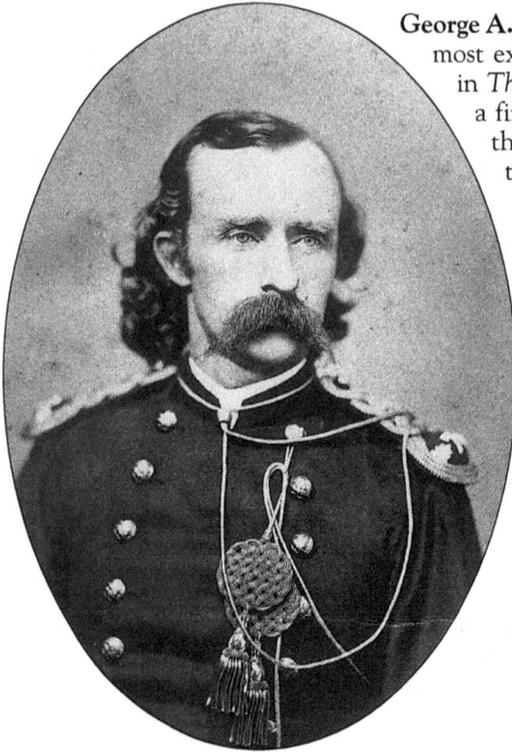

George A. Custer. Never his admirer, Sandoz provided her most extended exposé of Custer's controversial career in *The Battle of The Little Bighorn*, her last work and a first in suggesting that he sought the presidency through attempting such an encounter. Moreover, throughout *Cheyenne Autumn*, Sandoz probed the fate of Yellow Swallow, reputedly Custer's son by the Cheyenne, Monahsetah. Stauffer's *Letters* (228–9, 234, 260, *n1*, 300) supplies annotated correspondence with additional information about both the boy and his mother. (Courtesy Little Bighorn Battlefield National Monument.)

Johnny Wooden Legs. In his last years, this modern-day Cheyenne leader spoke admiringly of Sandoz and her 1949 research visit to Lame Deer and of their talks at several ceremonial events. He was in the movie *Cheyenne Autumn*, a film version of her work, which she disliked immensely because she considered its script inferior. She had spent five weeks on the reservation in order to absorb the sights and sounds which she wanted her writing to convey.

112

Five

A Nebraska Ending: Later Writings About the State With Its Reciprocal Recognition

Memorial to Sitting Bull, the Hunkpapa. Facing the Missouri River, this bust is located near the entrance of the Standing Rocks Sioux Reservation outside Mobridge, South Dakota. The monument faces the old buffalo range across the water that this leader hoped to restore through the Ghost Dance. Sandoz published an article, later appearing in the collection *Hostiles and Friendlies*, about how this chief was frequently confused with another Sitting Bull into one man possessing conflicting traits and motivations. Answering a query from Virginia Faulkner, editor of the collection, Sandoz provided statements Faulkner included (87) about how she came to write the piece: "For years I tried to explain this to researchers and historians, but it always required long letters to cite the endless documents that proved two men instead of one. When I discovered the presentation rifle in the Museum of the American Indian (here she is making reference to the gun given the Oglala chief discussed below), I finally blew up, wrote the salient points into an article, and had it published where outdoor men would see it in *Blue Book*."

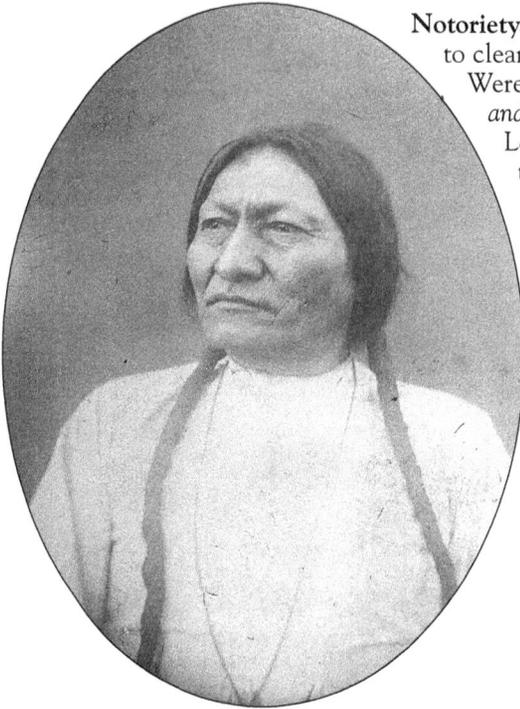

Notoriety. By 1949, Sandoz had contributed her efforts to clearing up prior confusion with the piece, "There Were Two Sitting Bulls," later published in *Hostiles and Friendlies*, but under the new title, "The Lost Sitting Bull." In it, she retraces how, through participation at the Little Bighorn and notoriety from touring with the Buffalo Bill show, the career of the Hunkpapa here contrasted markedly with that of the Oglala chief's. (Courtesy South Dakota State Historical Society—State Archives.)

The Hunkpapa's Death. The front of the bust commemorates the life of this Sitting Bull who was shot on December 15, 1890, by Lt. Bullhead, an Indian agency policeman, who feared he had treacherous intentions although he, like the Oglala chief, seen in the next photo, was a worthy leader and a visionary besides. The Hunkpapa's death so alarmed Big Foot and his followers that it caused their flight to Wounded Knee.

114

Sitting Bull, the Oglala. This is the courageous chief to whom President Grant presented a rifle for preventing the massacre of some whites at Red Cloud—an action later confused and attributed to the Hunkpapa. The Oglala leader is pictured here in the bottom row, extreme left, of an 1875 Sioux delegation. Also pictured are Red Cloud (right, standing), Spotted Tail (right, seated), and Swift Bear (center, seated). (Courtesy Nebraska State Historical Society.)

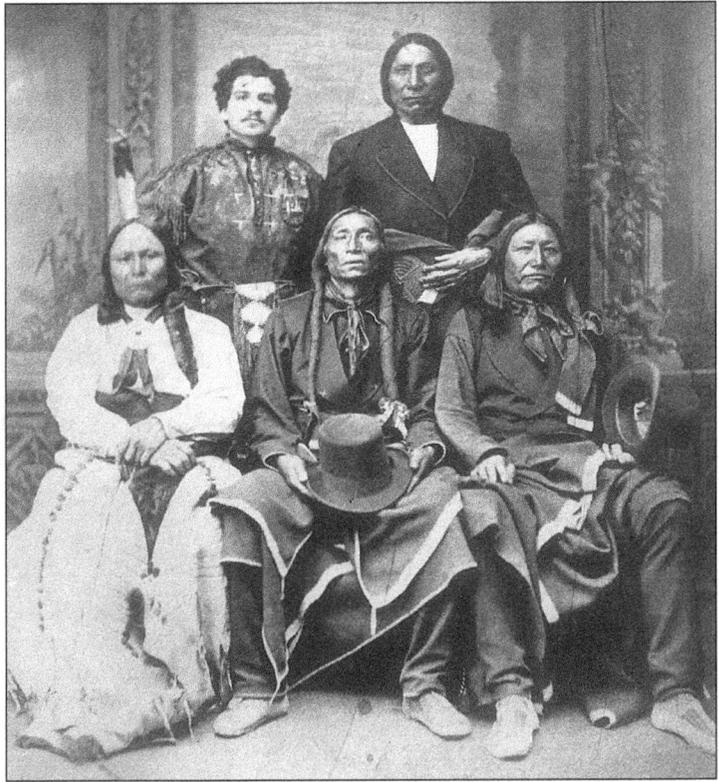

Mari Sandoz, 1955. At the height of her career, Sandoz attended a welcome-home dinner, which was arranged by the Gordon Chamber of Commerce. Her dress, as she noted on a copy of this photo, was "a favorite of all time, a brown Dior copy." It characterized the kind of stylish clothing marking Sandoz's later appearances. Following *Crazy Horse*, her career skyrocketed so much that she returned home frequently for numerous honors.(Photo by and Courtesy Reva Evans, *Gordon Journal.*)

A Buffalo Herd Near Crawford. While a sizeable portion of *The Buffalo Hunters* (1954) is set in Nebraska, it reaches far beyond Sandoz's region to cover the wholesale destruction of approximately 50 million buffalo in little more than 15 years by hide hunters who chased bison as far north as Canada and south into the interior of Texas. Included are tales of numerous outlaws taking part in the slaughters.

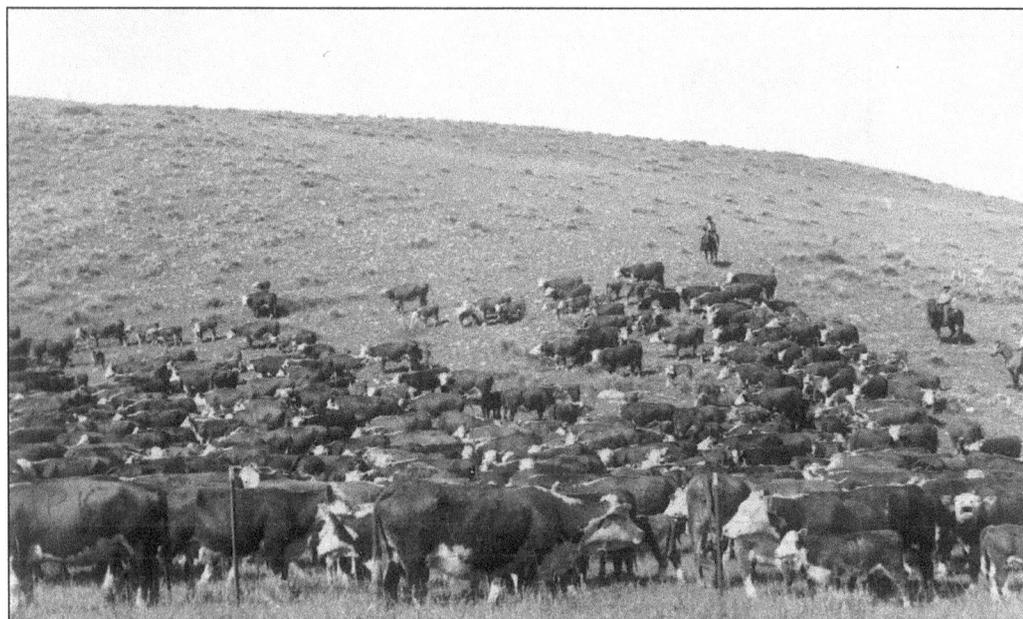

The Cattlemen (1958). Like *The Buffalo Hunters*, this book—the next in her series—with its story of man's ancient and deep identification with cattle in North America from 1541 to the modern period, touches in part also on Sandoz's native area. Still, to cover its scope, she traveled to archives and places, researching and investigating cattle ranches, cattlemen, and cowtowns from Nebraska's Ogallala to Texas's Amarillo and beyond.

116

"The Horsecatcher," (1957). This young adult novel is set in the pre-reservation range of the Cheyenne, which sometimes extended into Sandoz's home region through alliance. The work concerns Young Elk, a Cheyenne youth born into a great warrior family with an aversion to killing, yet skilled at catching the kind of mustangs from which the colt of these Cheyenne youngsters, shown near Lame Deer, descends.

"Winter Thunder," (1954). Like *The Horsecatcher* and occasional pieces she was selling to popular magazines, this novella belongs to the genre of fiction which Sandoz produced for financial support. Based on the 1948 experiences of Mari's niece, Celia Ostrander (right), as a rural teacher stranded with her pupils in a Nebraska blizzard, it evolves around a storm which raged through the sandhills area shown behind her and Caroline Pifer (left).

Robert Henri and Cozad, Nebraska. The life of an artist actually named Robert Henry Cozad—a painter who grew up in the south-central Nebraska town of Cozad—is the focus of Sandoz's 1960 novel, *Son of the Gamblin' Man*. In 1942, Sandoz began collecting information about the life of Cozad who, after his family fled Nebraska, painted under the shortened name of Robert Henri. (Courtesy Robert Henri Museum.)

The Robert Henri Museum. Located on 8th Street in Cozad's historic Hendee Hotel, the museum is based in the building which was once the family's home—a place providing lodging for settlers whom Robert's father John contacted. The novel is based on Robert's boyhood as the son of Cozad, who contracted for 40,000 acres of Pacific railroad land in 1876 for the establishment of his third community. (Courtesy Robert Henri Museum.)

John Cozad. After he established Cozad with settlers from Cincinnati, a bitter struggle ensued between them and the cattlemen. Cozad wound up shooting a local rancher named Alfred Pearson and then disappeared before the man died that same night. It was eventually discovered that he and his family had made a new, successful start on the East Coast—Robert as a painter and John in gambling. (Courtesy Robert Henri Museum.)

~An Indian Horse dance~

The Heyoka Dancer. This sketch is among Oglala artist Kills Two's drawings appearing in *These Were the Sioux* (1961). There (20 *ff.*), Sandoz spoke of witnessing her first rite during a River Place thunderstorm which introduced her to a *heyoka's* powers. The front horse-dancer here is a *heyoka*, wearing hail paint and flourishing a thunder bow which contains protective powers from these forces. (Courtesy Ayer Collection, Newberry Library, Chicago.)

119

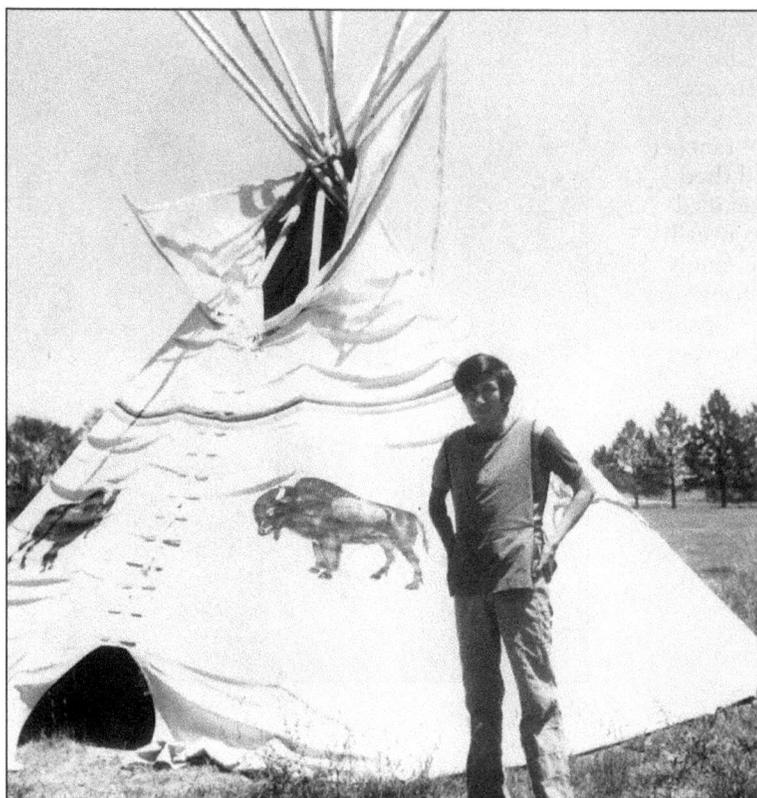

Buffalo and Mountain Sheep Symbols. The animal symbols on the tepee at Pine Ridge behind Paul Redcloud offer the kinds of pictographs that Young Lance, a Sioux youth, likes to draw in *The Story Catcher* (1963), another young adult novel that Sandoz wrote between 1959–62 as a means of support. Nevertheless, it offers some of her best fiction, reaching a level her allegorical fiction seldom does.

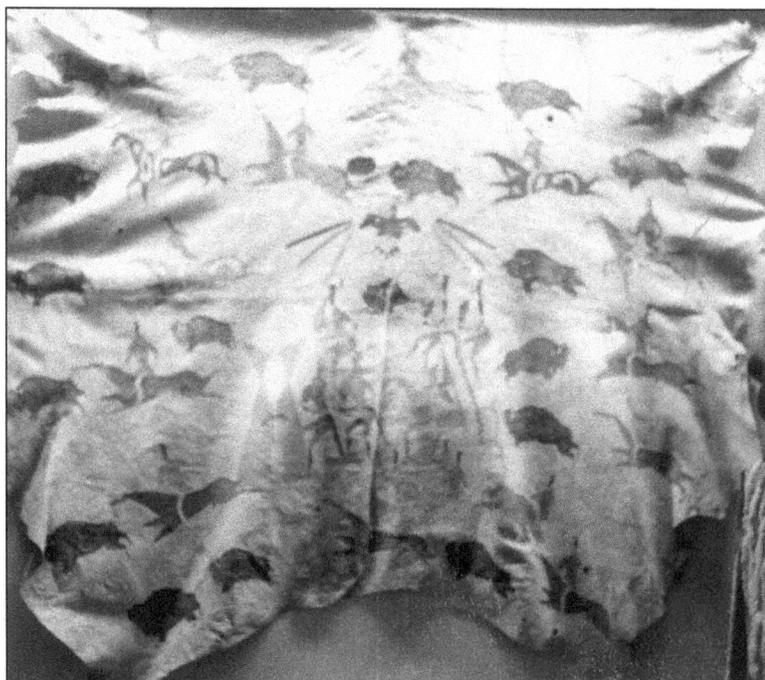

A Pictorial History on a Deerskin. A skin such as this one displayed in a Plains Indian exhibit is what Young Lance hoped to produce someday as a band historian recording the history of the Sioux. He knew that in such work, he would be following a calling as honored among the Sioux as were those of great warriors and hunters. Sandoz dedicated this novel to the pictographic historian, Amos Bad Heart Bull.

The Museum of the Fur Trade, Chadron. Here is another place in Sandoz's home region with a history that absorbed both her and her father. He often traded his beaver skins at the old trading post that succeeded the Bordeaux here. The post's history appears in *The Beaver Men* (1963), the last of Sandoz's titles for the Trans-Missouri series—her realization of a long-awaited goal.

A Model at the Plains Indian Museum, Cody, Wyoming. The mannequin wears a ceremonial costume of a type which Sandoz mentioned in *The Beaver Men*. Besides the history the book provides of Chadron trading posts and the trapping industry, it reports on the Sioux and Ponca who frequented a post which the French LaBoue traders established around 1830 in Sandoz's Lost Chokecherry Valley country. But again, the work extends across America and into Canada.

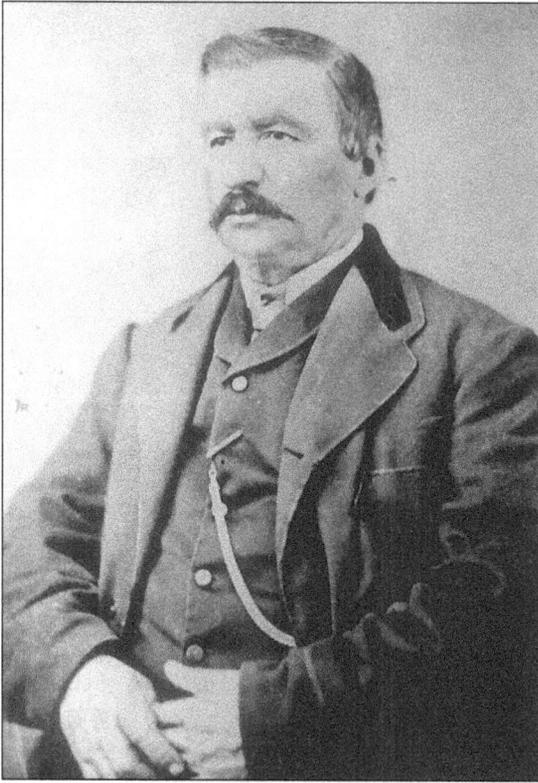

James Bordeaux. This French trapper opened the Chadron trading post below on Bordeaux Creek in 1837, operating it for American Fur Company at the Fur Museum site until 1849. He then continued serving the Sioux independently up through 1872. He married Swift Bear's sister. (*Cf. supra,* 115 top.) Their descendants captivated Mari, as she discloses in *Cheyenne Autumn* (v), by "sucking their long pipes," by "making the agreeing signs," and then voicing "Hous!" of approval. Again, in her *Crazy Horse* "Foreword" (*vii*), she stressed how such recollections shaped her creative process. (Courtesy Nebraska State Historical Society.)

Bordeaux Trading Post, 1837–1876. Still, the breed descendants who seem to have contributed most to Sandoz's writings were Bordeaux's children. Sandoz augmented her youthful fireside listening with the material in the Ricker Collection from his son, Louis, an interpreter at the Red Cloud and Spotted Tail Agencies. In various works, particularly in *Crazy Horse*, she also utilized the narratives that Louis's sister Susan Bettelyoun dictated to another Lakota historian, Josephine Waggoner, and which, through Sandoz's urging, Nebraska finally produced in 1988 entitled *With My Own Eyes*. (Courtesy Museum Fur Trade, Chadron.)

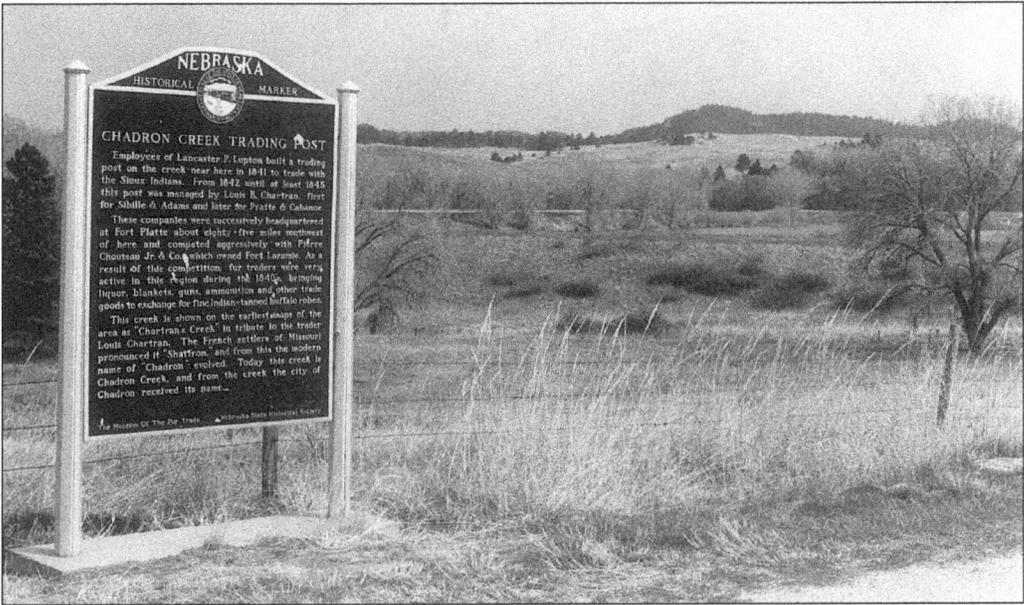

Marker about Chadron Creek Trading Post and Area's French Heritage. Among other half-breeds at the River Place possessing surnames of various well-known French traders and trappers were these: Janis, Charbonneau, Provost, Dorion, Bent, Merrivale, and Richard. Besides that, the sister of John J. Richard had also married "Big Bat" Pourier, yet another interpreter whom Jules knew. As before, Mari consulted the Ricker Collection and considered his gleanings from both Pourier and his daughter. More on this topic is provided in *Crazy Horse* (419) and *Cheyenne Autumn* (v).

Hobart Janis, Pine Ridge.
A modern-day descendant of the prominent Janis family of traders and trappers, who today are more Sioux than French, Hobart is the great-grandson of Nick Janis, the influential trader with a Sioux wife mentioned earlier. Once more, Sandoz found data for *The Beaver Men* in Ricker's interviews with both Hobart's great-grandmother—Nick Janis's widow—and his great-aunt, Maggie Palmer.

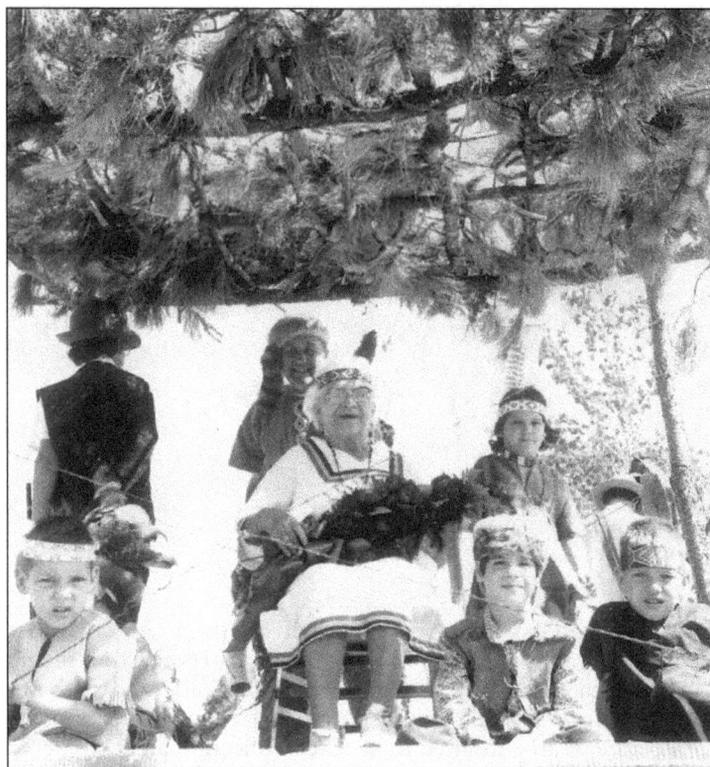

Bertha Horse's Heritage. Joe Horse's widow (*Cf. supra*, 98 bottom) reigned as Chadron Fur Trade festival queen in 1976, because she was the granddaughter of the Joseph Bissonnette, associated with James Bordeaux's historic post. Sandoz mentioned in *Hostiles and Friendlies* (89) the Oglala Sitting Bull's friendship with Bertha's father, and Joseph's son, Herbert Bissonnette—a trader and an interpreter with a Sioux wife. In *Crazy Horse* (418), Sandoz once more acknowledged assistance from Ricker's interviews. This time those he did with Herbert Bissonnette provided help.

A Sow at a Rushville Pig Farm. This mother could be the sow in *The Christmas of the Phonograph Records* who wreaks havoc with the treasured collection of Edison records Mari's father used his inheritance to purchase. Sandoz turned out the little book for the University of Nebraska Press in her last year, after a reoccurrence of breast cancer. Later it was reprinted and included as an offering in *Sandhill Sundays*.

"The Pictographic History of the Oglala Sioux." Sandoz's introduction to the work of her friend Helen Blish appeared the year after her death with pictographs like these exhibited at the Plains Indian Museum. The work featured the pictographs of Amos Bad Heart Bull (1869–1913), and served as a source for Sandoz's posthumously-published *Battle of the Little Bighorn*. The pictographs recorded He Dog's and other Sioux's memories of the encounter.

Father Peter Powell. This leading authority on the Northern Cheyennes is the author of the two-volume *Sweet Medicine*, which is considered the most comprehensive study available on the Cheyenne religion. As a young Episcopalian Seminarian, he first called on Sandoz (1953) while she was on the Wisconsin Writers' Conference. During the fruitful correspondence that followed, she gave him his first introductions to Northern Cheyennes. (Photo by John C. Powell, Courtesy Newberry Library, Chicago.)

Mari Sandoz Hall. Sandoz attended the dedication of this dormitory at UNL the year before her death. For the last 15 years of her life, the campus on which she had struggled to study bestowed upon her successive honors, including an honorary Doctor of Letters, an educational television series produced by student-friend Ron Hull and the University of Nebraska Press's posthumously-published *Old Jules Country*, her selected nonfiction.

The Love Library at UNL. Shortly before her death, Sandoz left all her manuscripts and papers, including a big collection of letters, research notes, and related files, to this library. Since then, the gift has served as the main source for Stauffer's biography and collection of letters, both published by the University of Nebraska Press, who have now besides issued all of Sandoz's books.

126

The Bust of Sandoz in the Nebraska Capitol Rotunda. Ten years after her death, Sandoz's honors included perhaps the highest laurel Nebraska can bestow upon a native—election to the state Hall of Fame. Her bust was sculpted by Mary Bryan Forsyth who, besides illustrating her *Love Song to the Plains*, was the granddaughter of Nebraska's famous statesman, William Jennings Bryan.

View of Authors in the Rotunda. The Sandoz bust stands at the center of this section honoring the Nebraska writers which the state has selected to pay homage to. Ironically, the capitol building where the bust is placed is still the one marked by "a high white tower," the description that caused the controversy following the publication of Sandoz's 1939 allegory, *Capital City*. (*Cf. supra*, 88 top.)

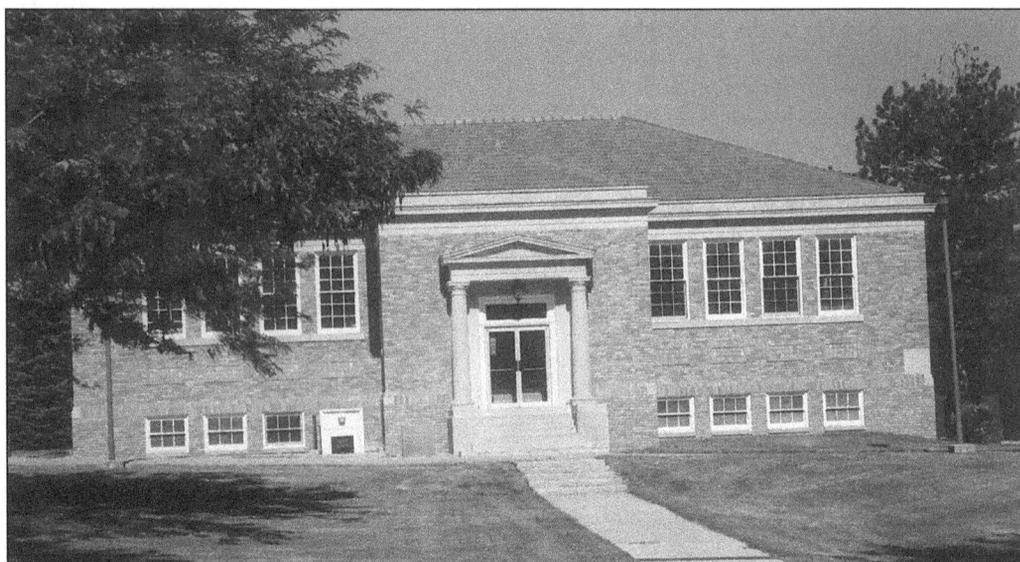

The Mari Sandoz High Plains Center, Chadron State. With its library and research facilities, the center—besides serving Sandoz's dreams for her region—will also be a place where visitors can acquaint themselves both with the work and legacy of this remarkable author of western Nebraska in the same way they are already able to do at the official centers for Willa Cather and John Neihardt. (Courtesy Mari Sandoz Heritage Society.)

Hillside View of Sandoz's Grave and Students. The students here are mainly Nebraska teachers from the first summer Sandoz workshop at Chadron State (1977). This vista recalls Mari's view from Indian Hill, where her earliest identification with Plains Indians began. Her writings as a native Nebraskan give testimony to her long-range power—with a visionary reach like that of the sightless Indian youth in her compelling story "Far Looker." Through her legacy of prose possessing this power and that reach, Sandoz maintains in this 21st century her lofty position in American letters.